THE ACROPOLIS
THROUGH ITS MUSEUM

© 2014 KAPON EDITIONS
ISBN 978-960-6878-61-9

KAPON EDITIONS
23-27 Makriyanni Str., Athens 117 42, Greece
Tel./Fax (+30) 210 9214 089
e-mail: info@kaponeditions.gr, www.kaponeditions.gr

PANOS VALAVANIS

THE ACROPOLIS
THROUGH ITS MUSEUM

Translation Alexandra Doumas

K

KAPON EDITIONS

INTRODUCTION

The Acropolis of Athens and its museum represent one of the most important duos in the history of civilization. Built parallel but with a time lag of 2,500 years, the one gazes at and complements the other, forming a pair the like of which is rarely encountered.

On the one hand, high up, the archaeological site. This precipitous rock upon which some of the most emblematic architectural creations were built. On the other, low down, the modern shell within which unique works of Archaic and Classical art are housed. At first, it did not know where to stand, so many were the antiquities uncovered in its foundations. Further up, it felt hemmed in by the apartment blocks and the buildings crowding out its space. But on the third floor it is liberated. It breathes freely. It rotates by 40 degrees to align itself exactly with the Parthenon, and becomes big enough to accommodate the frieze and the other sculptures of the temple. And so the couple was formed! Between them develops the south slope, which with the theatre of Dionysos, the odeums of Pericles and Herodes Atticus, the Asklepieion and the Stoa of Eumenes, constituted the first cultural centre in History.

And all these monuments bound with the city. The modern one, which still seems surprised by the new building. And the ancient one, which, stifled, is unable to declare its size and indeed its very existence.

The author and the publishers wish to thank sincerely all those agents and persons who contributed in so many ways to creating this book. We are grateful in particular to Professor M. Korres for permission to use his drawings, as well as to Th. Iliopoulos, K. Kazamiakis, A. Kokkou, D. Plantzos, K. Raftopoulos and T. Tanoulas for making available illustrative material, as well as to S. Mavrommatis for the new photographs of exhibits in the museum. Last, we thank O. Palagia and A. Kouveli for information and for all manner of assistance.

In addition, the author would like to thank all those colleagues who, through the studies and ideas expressed in recent years on the archaeology of the Acropolis, steadily supply him with fertile and creative food for thought.

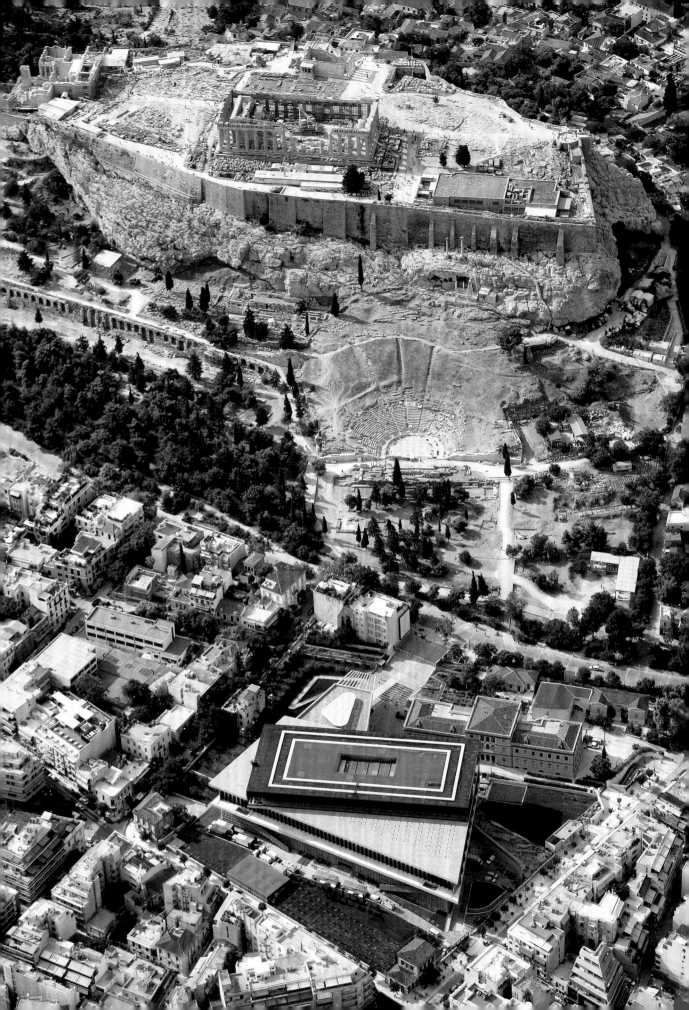

CONTENTS

3

ATHENS

The ancient city of Athens, the *asty* as it was called, was bound by a circular enceinte, built on the initiative of Themistocles, immediately after the Persian threat had been averted (479/8 BC). The circuit wall, 6.5 km. in perimeter, enclosed an area of some 200 ha., which included the Acropolis (4), religious centre of the city, the ancient Agora (2), political and administrative centre, and the entire settlement (1).

On the outskirts of the city were installations and buildings for political (e.g. Pnyx, 10), religious (temple of Zeus Olympios, 5) and athletics purposes (Gymnasium of the Lykeion, 3,

4

| 1. Residential areas 2. Ancient Agora 3. Lykeion Gymnasium 4. Acropolis 5. Temple of Zeus Olympios |

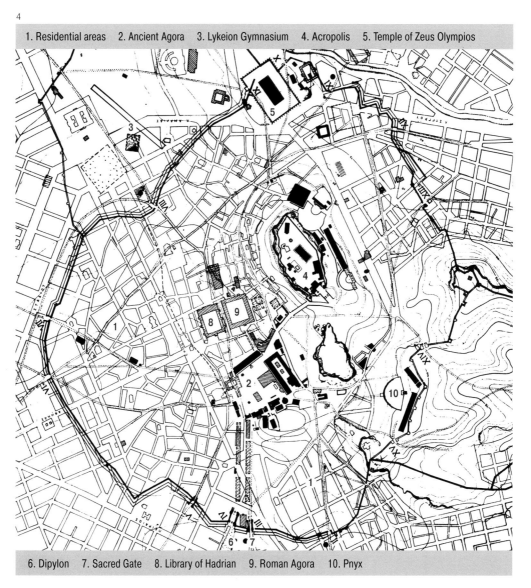

| 6. Dipylon 7. Sacred Gate 8. Library of Hadrian 9. Roman Agora 10. Pnyx |

Panathenaic stadium). In the period of Roman rule, a heyday for Athens, two other large buildings were erected in the city centre, the Roman Agora (9) and the Library of Hadrian (8).

There were **13-15 gateways** in the fortification wall, from which roads led to the 130 or so *demoi* of Attica, which together with the *asty* made up the city-state of Athens. The most important gates, the Dipylon (6) and the Sacred Gate (7), were on the northwest side and led to the Piraeus, Eleusis, northwest Attica and the rest of Greece. Outside the gates and along either side of the road arteries the cemeteries developed.

4. Map of Athens showing the ancient city in relation to the modern one. Marked are the circuitous course of the fortification wall, the main gates (I-XV) and the most important monuments (drawing J. Travlos)

5. 3-D model of the ancient city of Athens, as it was in Roman times (model J. Travlos - D. Giraux).

5

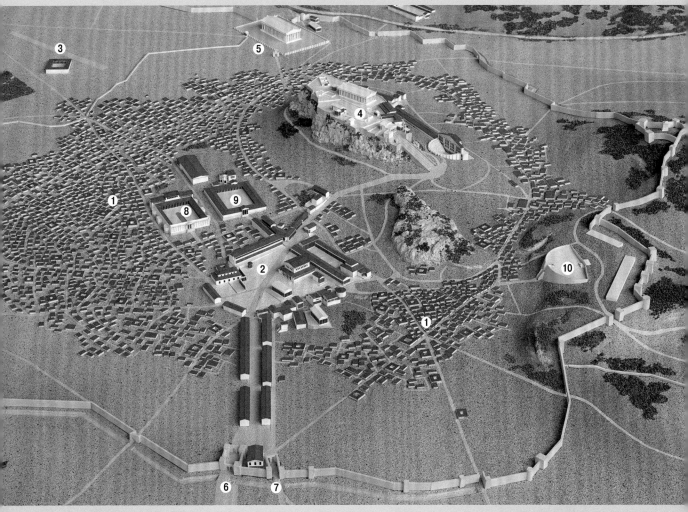

1. Residential areas 2. Ancient Agora 3. Lykeion Gymnasium 4. Acropolis 5. Temple of Zeus Olympios

6. Dipylon 7. Sacred Gate 8. Library of Hadrian 9. Roman Agora 10. Pnyx

Intra muros there were also residential areas, in which dwelt a mixed population: the free Athenian citizens living inside the city and in the surrounding *demoi* were no more than 15-20,000 men. Assuming that each family had on average four members, then the Athenians numbered 60-80,000. As many persons again must have been living in the rest of the Attic *demoi*, the more distant ones. To these should be added a large number of metics, that is, Greeks from other cities who were active professionally in Athens but did not have political rights, as well as a much greater number of slaves. Thus, **the total population of Attica** in antiquity may have been around 400-500,000 persons, with the obvious fluctuations at various times.

6. Hypothetical graphic reconstruction of the northwest part of the city, inside and outside the defensive wall. Visible are the two most important gateways, fortified with four mighty towers, which had been opened upon two very ancient road axes: The gateway on the left is the Sacred Gate (*Hiera Pyle*) (1), through which passed the Eridanos stream and the Sacred Way (*Hiera Hodos*) (2) that led to Eleusis and to the rest of Greece. The one on the right is the Dipylon (3), the largest gateway of the city with a wide road in front of it (6), on either side of which was the Demosion Sema, the official cemetery of Athens. The road continued, narrower, and turned in the direction of the Academy of Plato. Between the two gates stood the Pompeion (4), a large Classical building that functioned as a gymnasium, but also as the starting point of the procession of the Panathenaic festival and the place of safekeeping for its paraphernalia. *Intra muros* there were private houses with central court, some of them two-storeyed (5). *Extra muros* and parallel to the road arteries there were graves and workshops. Beyond was the Attic countryside with cultivated fields and olive groves in the Kephissos plain as far as the slopes of Mount Aigaleon (drawing K. Raftopoulos - Th. Iliopoulos).

6

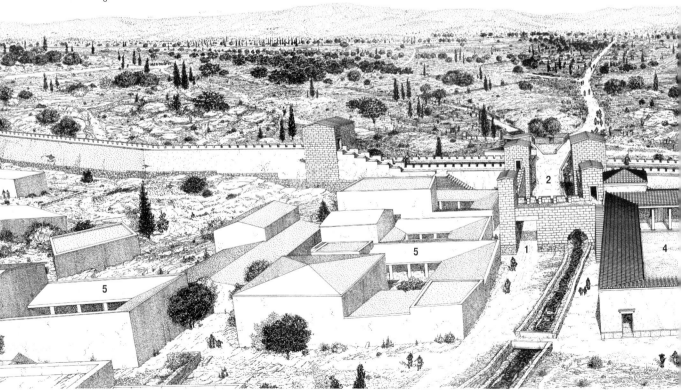

Athenà or Athèna?

The common name of the city and the goddess is certainly prehellenic, but it is not possible to determine whether the goddess gave the name to the city, as we learn from the later myth, or, more likely, whether the opposite is the case. The goddess is encountered for the first time as *Atana Potinija* (=Athenà Potnia), on a Linear B tablet from the palace of Knossos, which may mean revered Athenà or revered (goddess) of Athèna. It is impressive that she is referred to in exactly the same words by Homer (*Πότνια*

'Αθεναία and *Πότνι 'Αθάνα*), 600 years later. What is interesting for the close relationship of Athenà to Athèna is that every time the Athenians pronounced the name of their city it was as if they pronounced also the name of their goddess and vice versa!

The plural form of the name, **Athens** (Αθήναι = Athè-nai) is due to the fact that the early city was not a single settlement complex but was made up of several small townships that developed around the Acropolis (cf. Thebes, Mycenae, etc.).

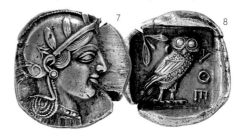

7-8. Athenian tetradrachm, *ca* 440-420 BC. On the obverse is the head of Athena and on the reverse an owl with an olive branch, attributes of the goddess and emblems of the city. Numismatic Museum, Athens.

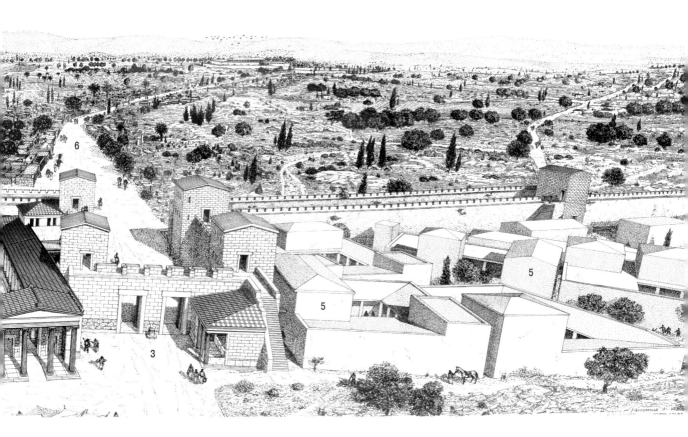

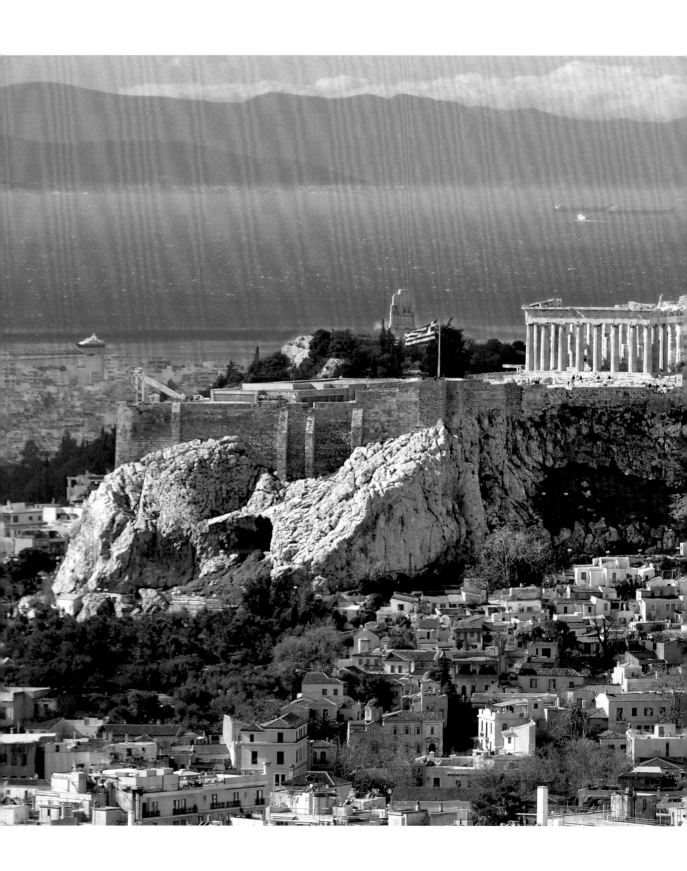

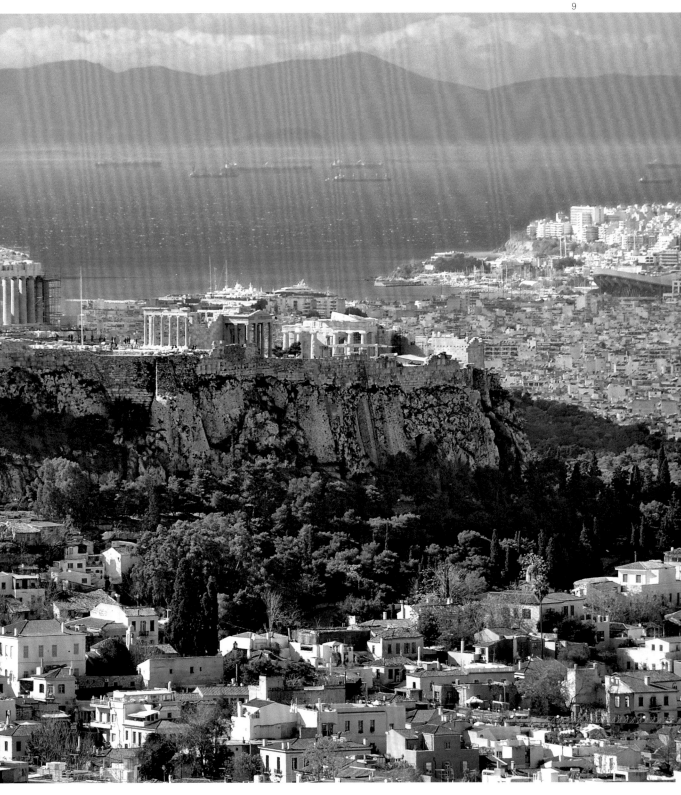

IN THE MUSEUM BASEMENTS

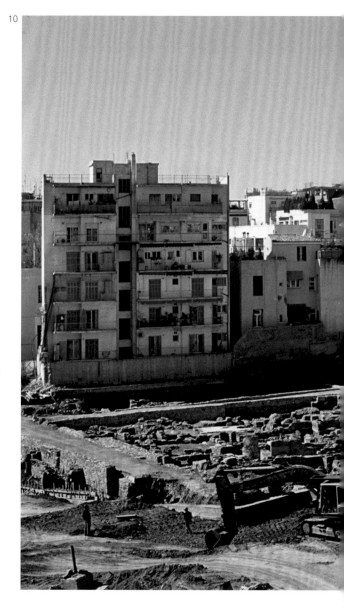

The site on which the Acropolis Museum stands is one of the most important quarters of the ancient city. As the smooth continuation of the south slope of the Sacred Rock, the mildest and most hospitable part for habitation, it was enhanced as principal area of settlement from the beginnings of Athenian prehistory and has been so ever since. The area includes also workshops and even graves. This diversity of uses in different periods became evident through the excavation that preceded the construction of the museum, in the course of which ruins of various periods were revealed, from the Late Neolithic (late 4th millennium BC) into the Byzantine Age.

Parts of the antiquities brought to light are preserved in the basements of the museum and are accessible as well as visible through the openings and the glass floors foreseen in the architectural design. In this way not only are the earlier phases of use of the space enhanced, but also provide an ideal 'substratum' and connecting link declaring the historical continuity from the past to the present, from antiquity to today, from the excavation to the museum. An actual as well as a symbolic continuum.

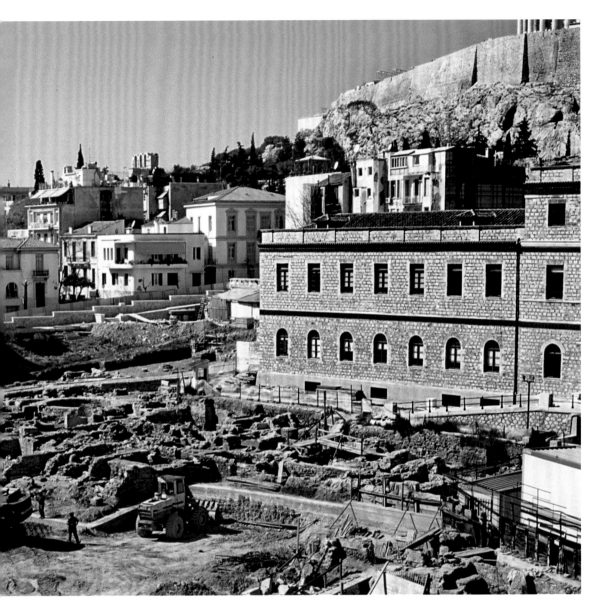

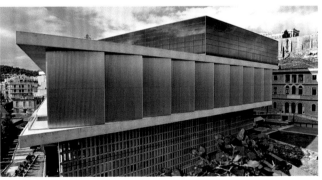

9. The Acropolis as seen from Lykabettos hill, with the sea of the Saronic Gulf in the background.

10. The site of the museum prior to its construction. The space is dominated by the Weiler building (right). In the foreground are the ancient building remains revealed in the excavations, which date from the Late Neolithic period into the Byzantine Age.

11-13. Three phases in the construction of the museum, from the southeast.

Uninterrupted human activity in the same place left behind successive levels of remains, in which the city's adventures are imprinted. Streets, houses, workshops, wells, cisterns, bathhouses and graves. All were found filled with thousands of objects, such as sculptures, vases, cooking vessels, lamps and coins, as well as remnants of domestic cult, which reveal to us facets of the Athenians' daily life. Changes in the use of the space in various periods (for settlement, craft-industrial, mortuary purposes) usually reflect too the **historical fortunes of the city**.

tissue decreased, the area was taken over by workshops, which usually developed on the outskirts of settlements.

The upper levels are better preserved, and so indeed are the later antiquities, those dating from the Late Roman and the Early Byzantine period. Visible in the elliptical opening in front of the entrance to the museum (fig. 16), are parts of the ground floor of a large residential complex with a circular, tower-like hall and a well at the edge. Arranged around the hall are reception rooms, courts and other remnants of a huge building which

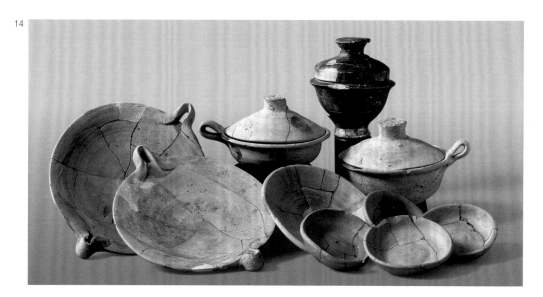

14

The existence of graves, mainly in the early periods, indicates that the urban tissue was limited to the summit and the south slope of the Acropolis. Later, when the city expanded, the area of the museum was occupied by houses. After devastations, such as by the Persians (480 BC), by the Roman general Sulla (86 BC), by the Heruls (AD 267) and the Visigoths (AD 396), when the population and the urban

is dated to the seventh century AD.

The history of the place is continued with the estate and the residence of the hero of the 1821 War of Independence, General Makrygiannis, which gave the area its present name. In 1836 the Weiler building was erected, which was the first military hospital of the new capital of the Greek State (fig. 10). Last, its contemporary history is completed in the 1930s, with the

housing here of the Gendarmerie regiment, until 1987, when the Acropolis Study Centre, the herald of the new museum, was housed in the Weiler building.

14. Assemblage of clay domestic vases from the excavation of an Early Hellenistic house in the foundations of the museum. The moveable finds from the excavations are exhibited in a long showcase next to the antiquities in the museum basements.

15. Multimedia projection of the Archaic korai on the fronts of the museum, during the evening of its inauguration on 20 June 2009.

16. Part of the remains dating from Late Roman and Early Byzantine times, as these appear in the opening of the floor in front of the museum entrance.

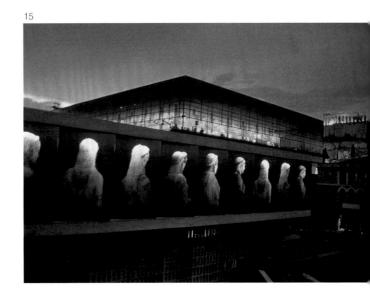

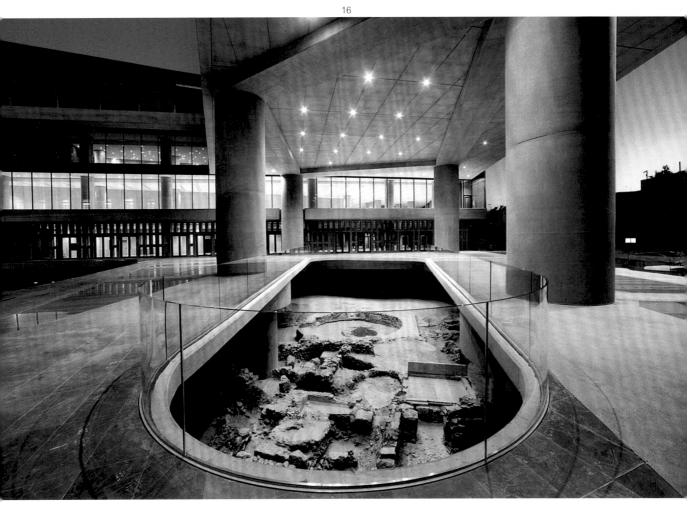

ASCENDING...
to the exhibition space and the slopes of the Sacred Rock

The creators of the architecturally impressive museum have subtly conveyed in this some features of the Acropolis landscape, so that the lead in to the exhibition simulates the ascent to the Sacred Rock. Thus, the gently-sloping wide passage leading up to the first floor of the museum symbolically reproduces the ascent to the Acropolis, which was always on its more accessible west side. In Archaic and Classical times this ascent was a ramp

(fig. 100), which was necessary for transporting on rollers the large volumes of materials, mainly marble, with which the monuments were built (fig. 153). In later periods this ascent was perhaps formed with many broad steps at wide intervals (fig. 107), while in the reign of Emperor Claudius, in AD 52, it underwent radical remodelling and a wide staircase in keeping with the spirit of Roman architecture was built.

17. The gently inclined ramp inside the museum. Displayed on either side are finds documenting the long history of settlement and worship on the slopes of the Acropolis, from the fourth millennium BC until the end of Antiquity.

17

The *engainion* of the Museum

As soon as visitors pass through the entrance barriers to the exhibition space, they see in the floor a group of small vases together with fine bones of small animals or birds. These are the remains of a sacrifice made when laying the foundations of a third-century BC house which was excavated on the site under the museum. According to ancient Greek beliefs, which were vestiges of sympathetic magic, for a building to stand firmly a little animal or bird had to be sacrificed and then buried under the foundations or the floor, together with vases full of offerings to the gods (fruits, water, milk, honey, etc.). People believed that in this way they appeased the chthonic deities and placed the stability and survival of the house under their protection. For symbolic reasons the remains of this foundation sacrifice were transferred to the present position, becoming the modern *engainion* of the new museum.

HOUSES AND MINOR SANCTUARIES

On either side of the passage leading to the first floor of the museum unfolds the exhibition of finds from the slopes of the Acropolis, which throughout antiquity were home to minor sanctuaries and, lower down, private houses. The choice of the slopes for the sanctuaries is due to the existence of caves and water sources, which the ancient Greeks believed were signs of divine presence. The sanctuaries were venues for popular cult and functioned in parallel to the official, state worship, which took place in the large temples on top of the Rock. The Athenians were famed in antiquity for their piety and their cult practices.

In the showcase set in the wall on the **right** side of the passage are displayed in chronological order, from the Late Neolithic period (end of 4th millennium BC) into Late Roman times (5th c. AD), clay vases and other domestic vessels from the houses built on the slopes of the Acropolis (figs 18-19). The area was safe and had a fine view, there was drinking water from the springs

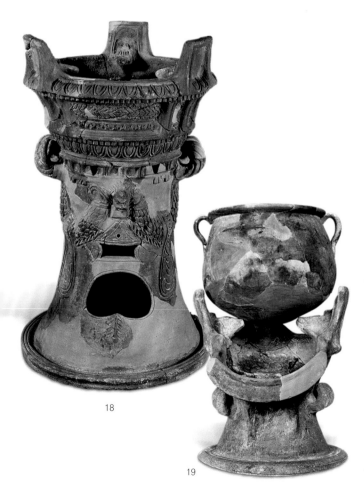

18

19

and it was close to the fields and pastures that spread all around. In other words, it was an ideal place for habitation. Exhibited too are tools and vessels from workshops, as well as objects associated with the life of men (symposium vases), women (items for the personal toilet and household utensils) and children (toys, etc.).

Several of the exhibits are from **graves** (figs 20-22), since parts of the slopes of the Acropolis had been used as cemeteries, particularly during the early periods.

18-19. Two clay braziers of the first century BC, from houses excavated on the south slope of the Acropolis. Filled with glowing charcoal, they were used not only for preparing food but also for heating. A cooking pot has been placed on top of the second (19), while the first (18) is decorated with diverse motifs.

20-22. Three vases of the Geometric period (1st half of 8th c. BC), which had been used as cinerary urns or as grave goods accompanying inhumation and cremation burials excavated on the south slope of the Acropolis. During this period a large part of the area was a cemetery.

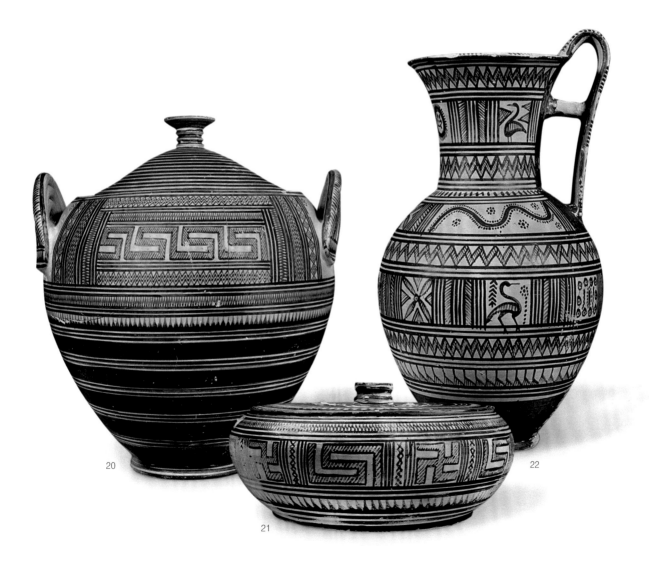

20

21

22

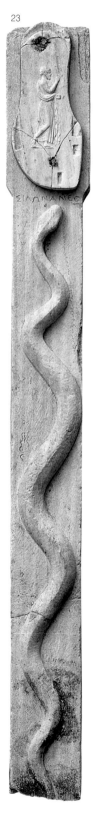

At the far end of the showcases are indicative finds relating **to domestic cult** (sculptures, figurines and small votive offerings), which come from shrines, small and large, inside these houses.

The most impressive were found in Dionysiou Areopagitou Str. at the level of the Herodeion, and are attributed quite confidently to **the shrine in the house-school of Proklos**, a Neoplatonic philosopher who lived and taught in Athens in the mid-fifth century AD. Among the finds from the household shrine were works of the fourth century BC, which means that at that time they were some 800 years old! Characteristic is a cuboid sacrificial altar-cippus from a grave, with relief representations on three sides (fig. 24). The most important side, and perhaps the criterion for its placement in the shrine of the school, is that on which the dead youth is represented seated in the midst of a circle of philosophers, with whom he converses, so alluding to his intellectual inquiries during his life.

The two **terracotta Nikai**, which welcome us on their high pedestals, today bereft of arms and wings, were found inside a well in front of the Herodeion (figs 26-27). Produced from the same mould, around 15 BC, and clearly copying Classical models, these will have adorned, as akroteria, the roofs of a building in the area.

On display in other showcases are finds from the many other **minor sanctuaries** located on the slopes of the Rock. Worship in the cave-sanctuary of Pan and the Nymphs, on the north slope of the Acropolis, began after the battle of Marathon, during which, so the Athenians

23. Relief votive stele from the sanctuary of Aphrodite Blaute. Represented are a writhing snake and a sandal, upon which the dedicator is portrayed. Below the sandal is the inscription ΣΙΛΩΝ ΑΝΕΘΗΚΕ (Dedicated by Silon). Dated to the mid-fourth century BC.

24. One of the three decorated sides of the funerary sacrificial trapeza found in the shrine of Proklos' school. Represented is the deceased in the midst of a circle of philosophers.

25. Relief plaque with wreaths, dedicated in the cave of Apollo Hyp' Akrai. According to the inscriptions, it was a votive offering of the secretary (*gramateus*) of the city, Eraton, from the *demos* of Bese, who mentions two other fellow archons, Trebellius Rufus and Eirenaios Sotos. Dated to the late first century AD.

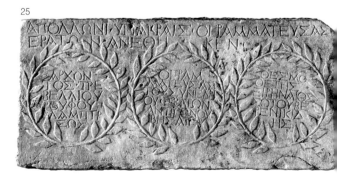

believed, the god appeared and spread 'panic' among the enemy. On the same slope, in the cave of Apollo Hyp' Akrai, that is, under the verge of the rock, it was customary for the Athenian archons to dedicate, at the end of their term of service, relief wreaths inscribed with their name, tokens of the impeccable execution of their political duties (fig. 25).

Exhibited in the space are finds from the sanctuaries of deities or hypostases associated with the **protection of married life and childbearing**. These bespeak people's anxiety to ensure the success and happiness of their marriage, as well as the importance that the state attached to serene family life and to having children, as basic factor of the smooth continuity of Athenian society.

The first exhibit is a tall marble stele with a writhing snake and a relief sandal at the top (fig. 23), which had been dedicated by a man named Silon to an hypostasis of the goddess Aphrodite, Aphrodite Blaute, who was protectress of family concord. Because the word *blaute* means sandal, it seems that either the sandal was a prating symbol of the deity or the depicted dedicator was a sandal-maker.

Exhibited next to it is a plaque with relief winged Erotai ('cupids') holding wine jugs and incense burners. It comes from the sanctuary of another hypostasis of Aphrodite, Ourania, also protectress of marriage, which was inside a cave on the north slope of the Acropolis. This sanctuary was also the provenance of two marble blocks which were its '*thesauros*', that is, its moneybox. According to the inscription carved on the side, Athenians who were about to marry put in its slot one Attic drachma, as '*proteleia*', that is, down-payment of sacrifice,

26-27. The two identical terracotta Nikai, which, as is deduced from the form of their feet, were represented as if landing on the roof of an edifice of the Early Roman period.

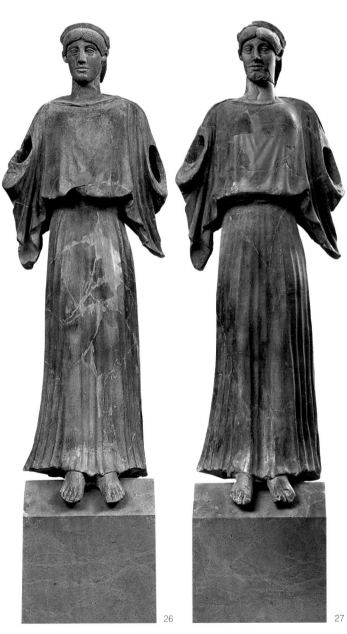

26

27

in order to secure a happy married life (fig. 28). When the priests wanted to open the '*thesauros*', they opened the double lock and, using a winch, lifted the stone lid that weighed 650 kilos, in the manner shown in the accompanying drawing. Last, an inscription with the honours awarded to the priestess Timokrite for her piety and her diligence in performing her duties, comes from the cave sanctuary of Aglauros on the east side of the Rock.

28. The two marble blocks that comprised the 'money box' (*thesauros*) in the sanctuary of Aphrodite Ourania, and a graphic reconstruction of the object's original form and its unlocking device (drawing K. Kazamiakis).

29. Inscribed boundary stone (*horos*) set up at the entrance of the sanctuary of Nymphe, which at once functioned as a signpost and a signifier of the sacred space.

30-31. Two terracotta plaques of the sixth century BC, votive offerings in the sanctuary of Nymphe. Represented on the first (30) are running deer, and on the second (31) a young woman offering shoots to a seated goddess.

32. Assemblage of clay spindle whorls, votive offerings of women to the sanctuary of Nymphe. The spindle, a tool for making thread, was also a symbol of good housekeeping and female virtue.

The sanctuary of Nymphe

Displayed in the showcase along the **left** wall are votive offerings unearthed between 1955 and 1960 in Dionysiou Areopagitou Str., left of the present stairway leading to the Herodeion. At this point there was an open-air sanctuary with altar, which operated from the seventh to the first century BC. It belonged to a Nymphe, as is recorded on a stone boundary marker (*horos*) of the second half of the fifth century BC, which is exhibited next to the entrance barriers (fig. 29).

This anonymous nymph was protectress of marriage and of childbearing, which is why Athenian men and women dedicated in her sanctuary a special vase, the loutrophoros, which was used to carry water from the Kallirrhoe fountain on the banks of the River Ilissos, for their nuptial bath, because they believed it brought fecundity. In dedicating the loutrophoroi in the sanctuary, they were seeking fertility and prosperity, as well as help in general in this new phase of their life as husband and wife. Most of the representations

28

29

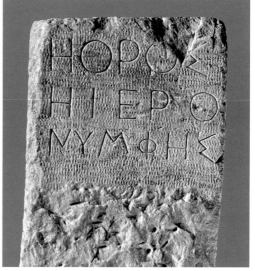

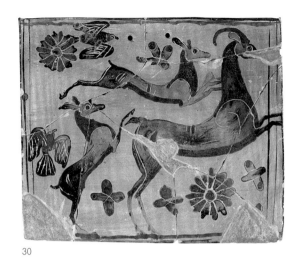

30

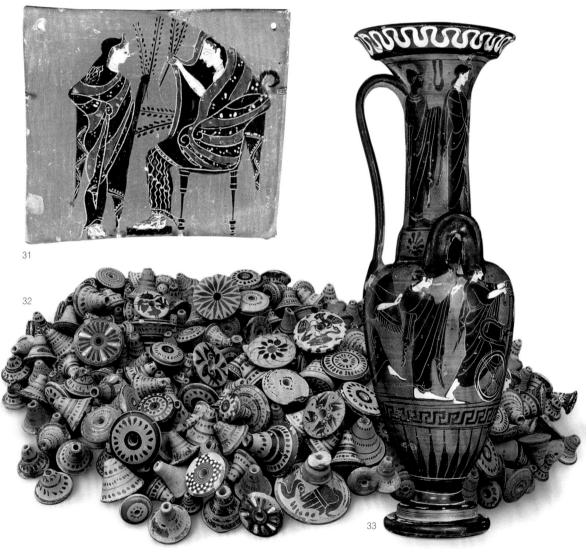

31

32

33

on the black-figure and red-figure loutrophoroi are of matrimonial subjects (fig. 33). On the lowest shelf in the showcase, are texts and vase-paintings relating to the whole procedure of the wedding ceremony in ancient Athens, which was purely social and not religious in character.

33. Black-figure loutrophoros hydria of 500 BC, dedicated in the sanctuary of Nymphe. Depicted on the body is the departure of the bridal procession with chariot, symbolically accompanied by gods and female friends of the bride.

34

34. Part of the restored upper storey of the almost 50-m. long stoa in the Asklepieion. On the façade there were 17 columns in the Doric order and in the interior a colonnade of 6 columns. This is one of the first two-storey stoas in Greek architecture and was used as an *enkoimeterion* (dormitory) for the sick, who hoped Asklepios would cure them while they were asleep. The second storey was created to cover the needs of the large number of patients, who could not be accommodated in the area of one storey.

35. Restored plan of the sanctuary of Asklepios, as it was in the first century BC. It consists of the propylon (1), which leads to the temple (2) and the altar of the god (3), in a paved square. In the north (back) part stands the two-storey Doric stoa (4), which functioned as an *enkoimeterion*. Left, there was a second, Ionic stoa with four rooms (5) that had couches next to the walls and served as *hestiatoria*, that is spaces for ceremonial meals associated with the cult of the god (drawing J. Travlos).

The Asklepieion

One of the most important sanctuaries on the south slope of the Acropolis was that of the healing god Asklepios, founded at a point on the rock where there was a spring of therapeutic water. The cult was brought to Athens from Epidaurus in 420 BC, on the private initiative of Telemachos, citizen of the *demos* of the Acharnaians. Details of this event are known from the text and the reliefs on the two-sided votive stele which he himself set up in the sanctuary and which is exhibited in the museum, incomplete but restored. Most of the monuments (temple, altar, stoas, etc.) were built in the fourth century BC, by which time the state had apparently assumed responsibility for the sanctuary.

The architectural layout of the Athenian Asklepieion (fig. 35), with the temple, the altar, the spring of medicinal water and the two-storey stoa, which was the dormitory (*enkoimeterion*) for the sick who hoped to see in their sleep the god or the cure (fig. 34), points to a conscious copying of the corresponding edifices, and therefore also the ceremonial of cult and the therapies applied in the Asklepieion of Epidauros.

The distinctive votive offerings in the Asklepieia were, like those placed today on

35

36-40. Characteristic votive offerings from the sanctuary of Asklepios:

36. The upper half of a face with inlaid eyes, a thanksgiving for a cure. It is placed in its original position in a cavity in a stone stele, which has been left rough intentionally, as a reminder of the sanctuary's natural rugged terrain.

37. Marble base from an *ex-voto* of a physician with relief representations of symbols of his profession: a medical instrument case with scalpels and two ventouses. In the ancient Asklepieia, practical medicine was practised alongside healing by sympathetic magic (e.g. the dedication of models of body parts).

36

37

miracle-working icons, diminutive **models of healed body parts**, predominant among which are eyes, not surprising in periods when spectacles did not exist. Remarkable are the inlaid eyes in a marble upper half of a face, which were preserved in a cavity of a stone stele (fig. 36). Another rare exhibit is the marble base of an *ex-voto* from a physician of the third century BC, on which is a relief representation of a case containing surgical instruments between two bell-shaped objects that are ventouses for cupping and are obviously attributes of the medical profession (fig. 37).

Exhibited on the wall are the many-figured reliefs representing families appealing to Asklepios and his daughters, often with the animals for sacrifice. In this way the dedicators reminded the god of their presence and offering, thus placing their own health and that of their family under permanent divine protection. The relief with names inside a wreath, on its bottom part, is a **votive offering of physicians** (fig. 38). Moving too is the small stele showing the poor carter Antimedon with his cart, offering something to the god, who had saved him from harm in an accident in which the cart overturned, as recorded in the inscription in the top right part of the relief (fig. 40).

38-39. Votive reliefs of the fourth century BC with representations of families or physicians coming to Asklepios, his wife Epione and his daughter Hygeia. The deities are shown inside the temple, always on a larger scale than the mortals.

40. The votive offering of the carter Antimedon, thanking the god for saving him from an accident. Late 5th-early 4th c. BC.

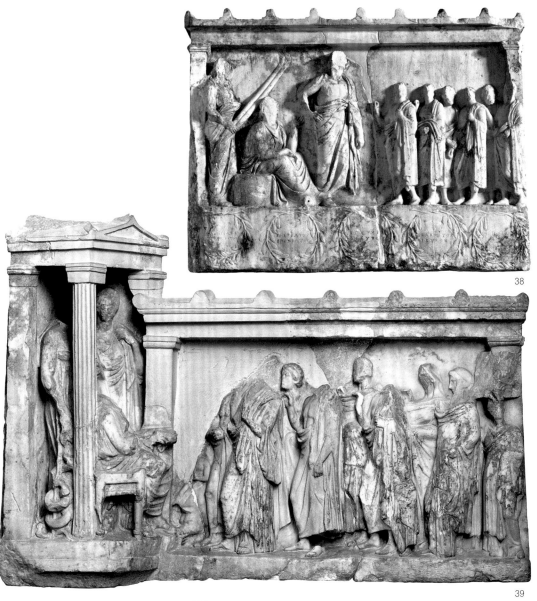

38

39

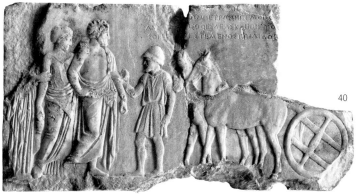

40

41

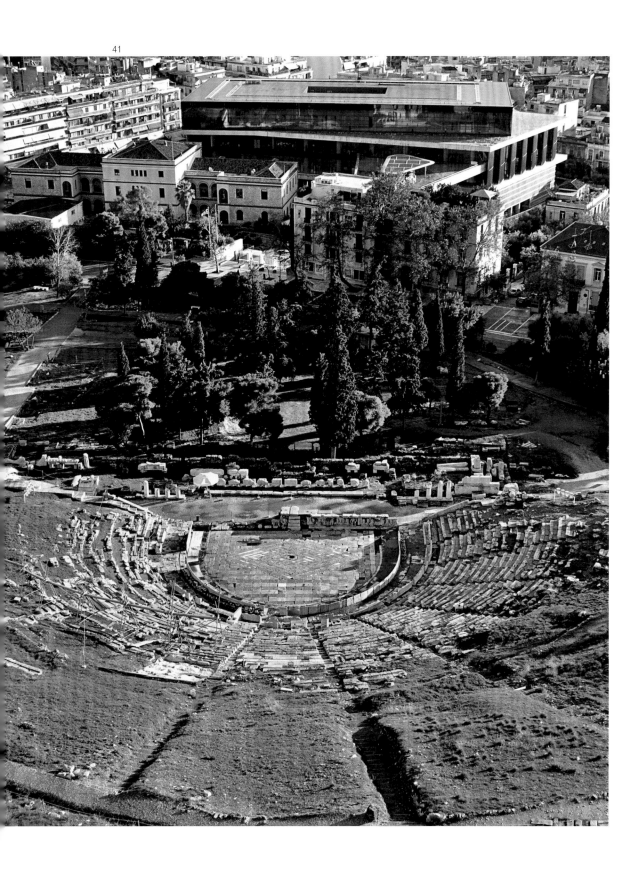

The sanctuary of Dionysos and the theatre

The left side of the passage concludes with finds from the sanctuary of Dionysos and the theatre on the south slope of the Acropolis, where, from the late sixth century BC, the first theatrical performances in history were staged, on the occasion of the Great Dionysia festival. Three depictions of Dionysos are displayed: one as a face-mask set on a column, one in relief and holding his attributes, a wine amphora and a wine cup (kantharos), and one as a child holding a theatrical mask, upon the shoulder of a Papposilenos, a comic figure of ancient dramatic poetry (fig. 43).

Displayed too are reliefs relating to theatrical performances: a stele with six actors' masks, probably from the decoration of the skene of the theatre (fig. 42), as well as marble reliefs with swirling dancing girls, which perhaps revetted the base of a statue or a choregic tripod (figs 47-48).

41. The theatre of Dionysos dominates the south slope of the Acropolis. Its beginnings go back to the late sixth century BC but the form of the cavea seen today dates from the second half of the fourth century BC and the skene building from Roman times.

42. Relief with six theatrical masks, symbols of performances of a tragedy. Perhaps they come from the decoration of the skene of the theatre in the second century BC.

43. Statue of Papposilenos with the infant Dionysos on his shoulder, holding a theatrical mask. The composition has been linked with a satyr play by Sophocles and the original was perhaps a dedication in the theatre of Dionysos after the victory of Sophocles' trilogy.

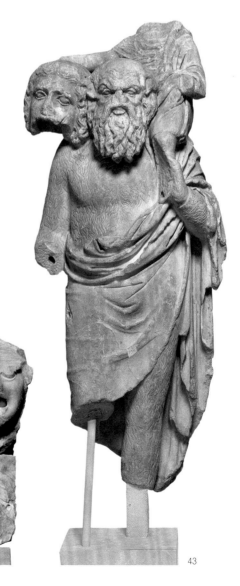

42

43

Tripods were prizes awarded by the city to the *choregoi*, wealthy citizens who financed the theatrical performances of the Great Dionysia and whose sponsored works had won first prize. Choregies were a simple and effective way for all people to enjoy the goods of culture and education. In reciprocation, the state conferred mainly honours, which were however a strong stimulus of social and political influence. It was customary for the prize-winners to place the tripods on high pedestals, around and above the theatre and in Tripodon St, thus immortalizing their contribution to the state and boosting their social prestige

44

45

46

44-45. Two of the most impressive monuments-bases of choregic tripods. Left, reconstruction of the monument of Thrasyllos, which was carved in the rock above the theatre in 320/19 BC. Right, the monument of Lysikrates, of 335/4 BC. The choregic tripod was placed on the top.

46. Old photograph, possibly taken by the Romaidis Brothers (1880-1890), showing sculptures of the mid-second century AD built into the so-called Bema of Phaidros, of the fifth century AD, in front of the skene of the theatre of Dionysos. The theatre ceased to operate after the destruction by the Heruls in AD 267

and the bema constructed by the archon Phaidros, 150 years later, was used by orators addressing the *ekklesia* of the *demos*, the citizens' assembly for which it was the venue.

47-48. Two marble reliefs with twirling dancing girls, which were found in the Dionysiac theatre in 1862. Dated to the first century BC, they decorated a monument, perhaps a base of a choregic tripod, inside the sanctuary of Dionysos.

49. Aerial photograph of the Acropolis from the southwest. Taken in 2003, in a period when all the restoration works were in full swing.

47

48

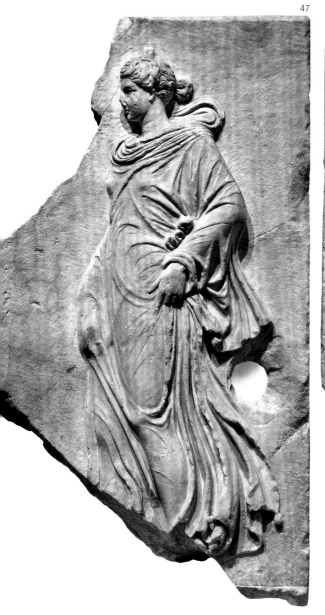

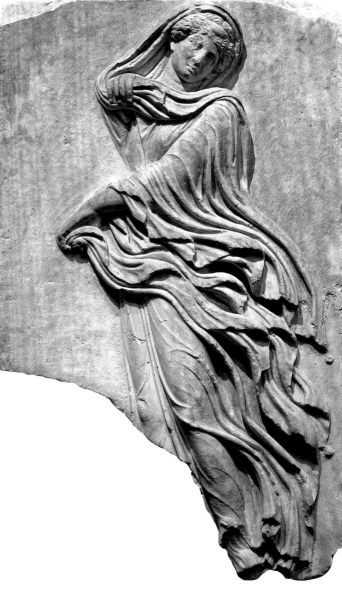

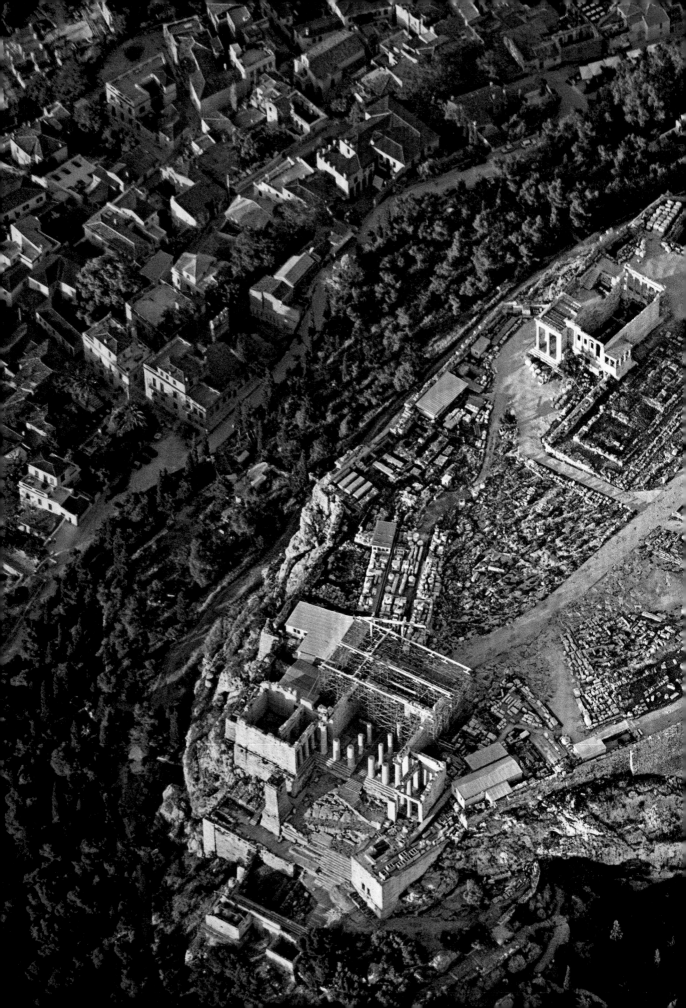

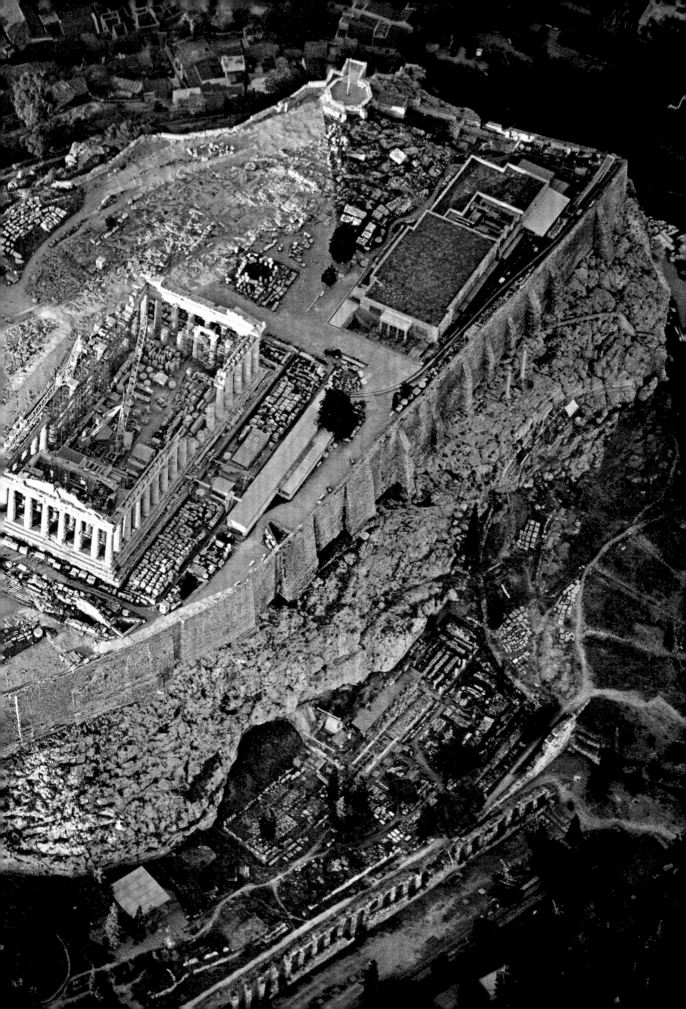

THE ACROPOLIS

PREHISTORY

The Acropolis, a rock 156.20 m. high and with a surface measuring approximately 250×110 m., that is, less than 3 ha., was from prehistoric times the centre of life in Athens. It seems that initially it was purely a settlement site, place of residence of the ruler and of some eminent members of the community, but certainly it will have functioned also as a refuge for the rest of the population in the event of danger. During the Mycenaean Age (1600-1100 BC), it is possible that a palace of the Mycenaean king was founded, although no secure remains of this have survived. Around 1250 BC, as at other sites in southern Greece (Mycenae, Tiryns, Gla of the Kopais), it was fortified with **Cyclopean walls**, 760 m. long and up to 10 m. high. These walls ran round the verge of the rock and had three gateways, on the west, the north and the south side. The main gateway to the fortress was the west one, on the right of which, for defensive reasons, a high and mighty bastion was built, on top of which the temple of Athena Nike later stood (figs 50-51). Parts of these fortification walls were kept visible in

50

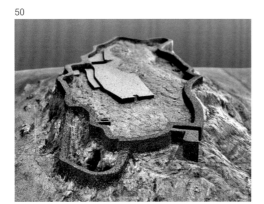

51

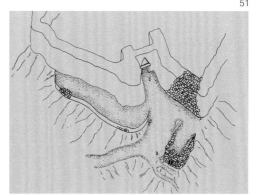

52

historical times, as monuments of the city's heroic past, while a few are still preserved in good condition. The picture of the Mycenaean rampart can be appreciated from the educational model in the museum, while exhibited in four showcases on the wall are finds dating from this period.

It seems that one of the Mycenaean kings was **Theseus**, who, if we accept the kernel of history in some myths, must have conquered his rivals and unified Attica under his authority, enhancing Athens as sovereign city. This was the first action in history that gave Athens precedence, which is why the Athenians considered the hero as *archegetes* and founder of their city-state.

Since the Mycenaean king was also high priest, the Mycenaean palace was also the seat of cult. One of the deities worshipped there was perhaps Athena, as we know that she is a Creto-Mycenaean goddess, protectress of citadels and palaces.

The first secure archaeological testimonies of the existence of a sanctuary on the Acropolis date back to the mid-eighth century BC. These are finds of figurines and, primarily, of bronze tripod cauldrons (fig. 53), which were dedicated to honour the gods, as well as to enhance the social status of the dedicator. A little later, in the Homeric epics (*Iliad* II 549, *Odyssey* x 81), direct testimonies of the existence of a temple appear. In about the same period it seems that the constitution of the whole of Attica as a single city-state took place. This led to the creation of a large **religious centre** for worship of the patron deity, with the participation of all the inhabitants, aim of which was the political unification of the population. So, the religious character of the

Rock, which was now the official cult centre of Attica, was reinforced from that time.

The sole, perhaps, secure remnant from a precursory temple, presumably of timber and mud bricks, built on the site of the Mycenaean palace, is a bronze cut-out sheet in the shape of a wheel, 0.77 m. in diameter, with the figure of Gorgo, a fantastical monstrous creature which, myth has it, turned to stone whoever beheld it (fig. 54). This piece is dated *circa* 600 BC and possibly adorned the centre of the pediment or the end of the central beam of the roof.

50-52. 3-D model of the Mycenaean fortification wall of the Acropolis, from the west (fig. 50), and graphic reconstruction of its main entrance (fig. 51, drawing I. Gelbrich), which will have resembled the Lion Gate of Mycenae (fig. 52). The palace will have stood on the flat crepis on the inside (fig. 50), similar in form but smaller in scale than corresponding palaces in other Mycenaean citadels.

53. Graphic reconstruction of a bronze tripod cauldron of the seventh century BC, which had been dedicated on the Acropolis. These finds, together with the figurines, constitute archaeological documentation of the existence of a sanctuary on the Acropolis (drawing M. Korres).

54. Drawing of the figure of Gorgo from a bronze-sheet cutout that possibly adorned the front of an early temple of Athena, *ca* 660 BC. These daemonic figures struck awe in the devotees and invigorated their faith in the power of the gods (drawing E. Touloupa).

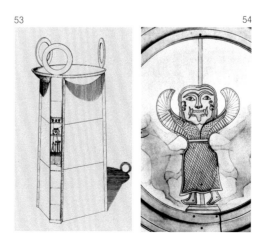

53 54

THE ARCHAIC ACROPOLIS

The earliest architectural remains of large temple buildings date from the first half of the sixth century BC, the time of Solon and of Peisistratos. These are mainly parts of pedimental sculptures which represent lions attacking bulls or Labours of Herakles. They were found either built into the fabric of the Classical fortification wall of the Acropolis, or buried to the south and southeast of the Parthenon. These remains have generated

55

much scholarly debate on the form of the Archaic Acropolis. One theory, which is also the most plausible, is that during the sixth century BC there were two large temples on the Sacred Rock: one is the Archaic Parthenon, which is frequently confused with that referred to in the inscriptions as the *hekatompedon* (of 100 Attic feet in length), and the second is that known as the *archaios neos* (old temple), the foundations of which still survive to the south of the Erechtheion (fig. 55). According to another theory, there was just one large temple, the *archaios neos*, while the rest of the architectural and sculptural members are attributed to a group of 5-6 smaller edicules (*oikoi*), which were perhaps intended for the cult of Athenian heroes, such as Kekrops and Erechtheus, as well as of the panhellenic hero Herakles (fig. 57).

56

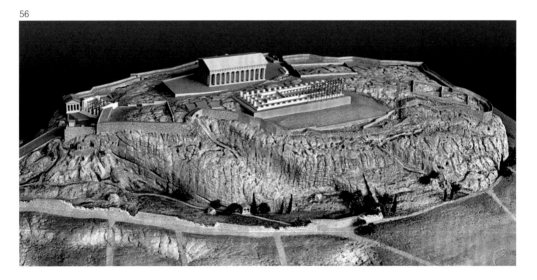

55-56. Representations of the form of the Acropolis in the first half of the sixth (55) and the beginning of the fifth century BC (56). Dominant in the first are the two large temples, the precursor of the *archaios neos* (left) and the Archaic Parthenon (right). In the second there is only the *archaios neos*, while on the site of the Archaic Parthenon building of the Preparthenon has commenced (drawing I. Gelbrich, model M. Korres).

57. One of the 'small' so-called pediments, recomposed from fragments found in the Acropolis excavation. Represented is the apotheosis of Herakles, who is received on Olympos by the enthroned Zeus and Hera, with his guide Hermes behind him. The frequent presence of Herakles on Archaic pediments from the Acropolis has been attributed to an initiative of the tyrant Peisistratos.

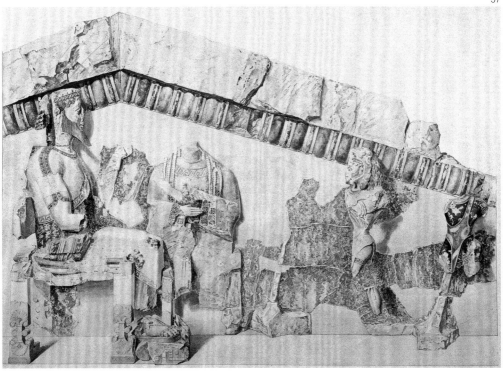

57

The pediments

The largest and most imposing pediment, which is approximately 20 m. long, welcomes visitors as they ascend the staircase. It seems to have belonged to the west front of the Archaic Parthenon (fig. 59). This large Doric temple of Athena, with a peristasis of 6×12 columns, was built around 580/70 BC and was perhaps inaugurated in 566/5 BC, at the same time as the reorganization of the major festival of the Panathenaia (fig. 58). The **poros limestone pediment** does not have a single subject but consists of three ensembles that have been recomposed from scores of fragments and restored. All three groups represent conflicts (figs 59-60): in the middle are two opposed lions attacking a bull, at the left edge Herakles wrestles with

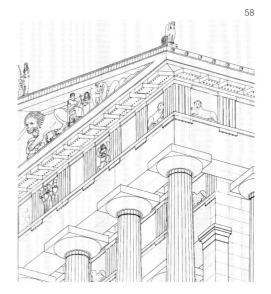

58

58. Reconstruction drawing of part of the northeast corner of the Archaic Parthenon. A lioness attacking a bull, the composition of the apotheosis of Herakles and the body of a serpent have been placed on the east pediment. Many of the Parian marble reliefs of the period *ca* 570/60 BC, found on the Acropolis, have been placed as metopes (drawing M. Korres).

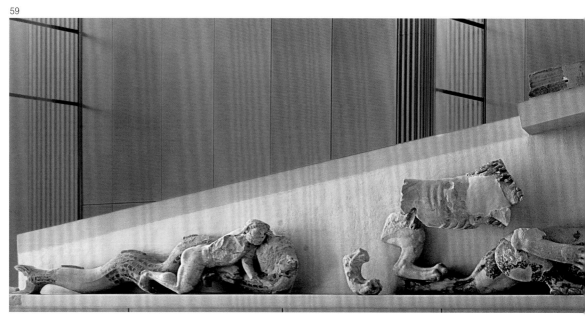

59

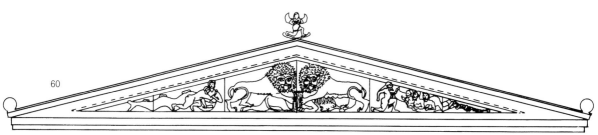

60

a sea creature, Nereus, and at the right most probably Zeus, whose figure is lost, struggles with Typhon or the three-bodied daemon, a creature with three winged torsos and serpentine tail (fig. 61). Each body holds a flame or lightning flash, water and a bird, which are interpreted on the basis of beliefs of the period, as symbols of the three natural elements (fire, water, air).

The sculptures from the east pediment of the same temple are exhibited separately on the right side of the hall beyond the staircase. Here too is a lioness attacking a bull calf and surrounded by two enormous snakes with polychrome scales, while a relief Gorgo was the central akroterion. Two

relief metopes of about the same period (with panther and four horses *en face*) have been ascribed to the same building (fig. 58).

It is not easy to interpret the composition of these pediments. In general, they are believed to show the effort of gods, heroes and men to subdue the elements of nature. At the same time, with these subjects they perhaps showed to devotees the majesty and the might of the gods, and reminded mortals of the consequences if they dared to doubt their power and dominance. We should bear in mind that this was the image that visitors to the Acropolis first beheld, as soon as they entered the sanctuary from the propylon of the Archaic period.

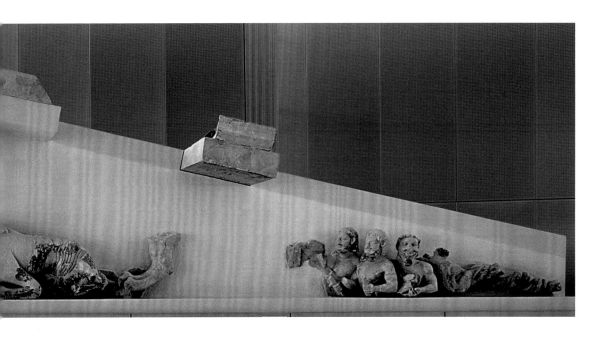

59. The surviving remnants of the poros limestone sculptures of the west pediment of the Archaic Parthenon, as recomposed from hundreds of fragments.

60. Graphic reconstruction of the overall image of the west pediment of the Archaic Parthenon (drawing Th. Wiegand - I. Beyer).

61. The so-called 'three-bodied daemon', on which the original coloration is preserved to a remarkable degree.

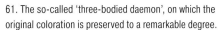

61

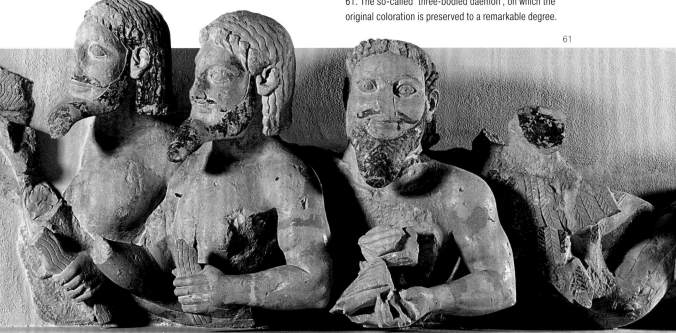

62-64. Parts of the east pediment of the *archaios neos* (Old Athena Temple), subject of which was the Gigantomachy. This is the first pedimental composition on the Acropolis sculpted entirely in marble and with a single subject, as well as the first appearance of Athena on large scale, depicted here with spear and aegis, attacking the giant Engelados (62). In the two cunei of the pediment (63, 64) are fallen giants (Reconstruction of the central group of the pediment by Mary B. Moore with the giant in the left corner added by D. Scavera. With the permission of Mary B. Moore).

65. Relief plaque with representation of a god (Apollo or Artemis) mounting a chariot. It has been assigned either to the sculptural decoration of the same temple or to the enclosure of the tomb monument of Kekrops, which pre-existed the Erechtheion.

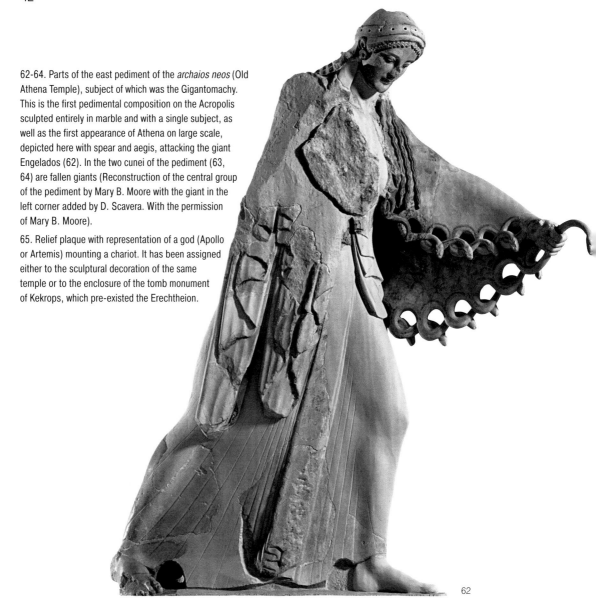

62

Exhibited on the north side of the Archaic gallery is one of the most important pedimental compositions of the period. It belonged to the main, the east front of the *archaios neos*, a peripteral temple in the Doric order with 6×12 or 13 columns, which was built either by the sons of the tyrant Peisistratos, *ca* 520 BC, or by the young Kleisthenian democracy, in the late sixth century BC (fig. 56). It is the first marble pediment on the Acropolis and the first with a single subject. Represented are scenes from the **Gigantomachy**, that is, the battle between the gods of Olympos and the Giants, who disputed their divine sovereignty. According to myth, a key player in the outcome of this conflict, which stands for the power of the gods and the punishment of those who doubt this, was Athena, who is represented turned to the right, with raised spear and outspread aegis, fighting against the giant Engelados, of whom only a foot survives (figs 62-63).

It used to be thought that the tall figure of the martial goddess was not in the middle of

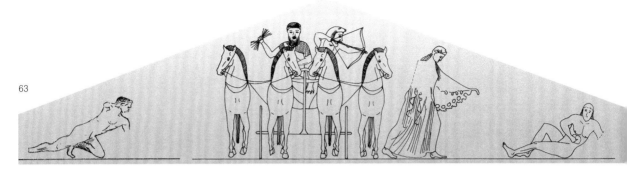

63

64

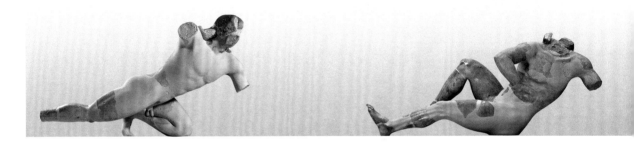

65

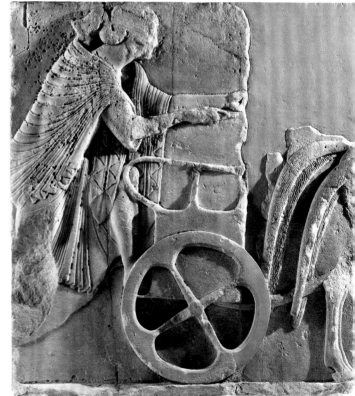

the pediment. This position was occupied by her father Zeus, who appeared on a four-horse chariot, of which two horses in half body have survived, together with his son Herakles (fig. 63). Represented alongside are other giants, defeated by other gods, the figures of which have not survived. This is a masterpiece by a gifted artist (Endoios or Antenor have been proposed), who for the first time attempted to solve the problems of including large figures in vigorous movement within the confines of the triangular space of a pediment.

Displayed next to the pediment are relief plaques with representations of a god mounting a chariot (fig. 65) and of Hermes with brimmed hat (*petasos*). These come perhaps from the sculpted decoration of the temple or, according to another view, from the funerary monument of Kekrops, which was located in the northwest corner of the temple and which was covered over by the Erechtheion in Classical times.

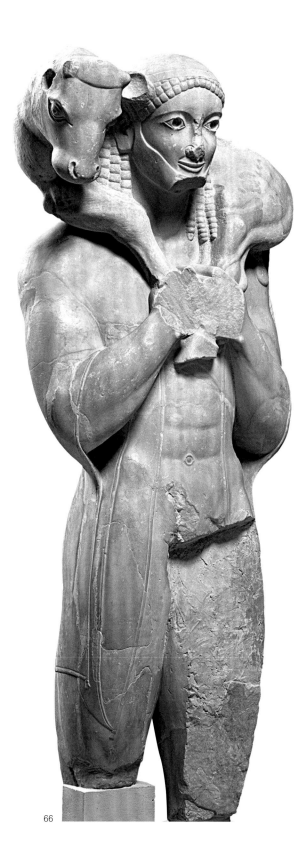

66

The *ex-votos*

During the sixth century BC the summit of the Acropolis was full of *ex-votos* of aristocratic clans of the city, an attestation of their faith in the goddess and the intense social rivalry between them. The sanctuary of Athena, as central sanctuary of all Attica, was the ideal setting for enhancing their prestige through dedicating expensive *ex-votos*. There are also less impressive *ex-votos*, mainly of merchants and craftsmen (fig. 68), since one hypostasis of Athena, Ergane, was protectress of manual workers. Among the others, particularly interesting are the **Calf-bearer** (*Moschophoros*), *ex-voto* of a wealthy stock-raiser (fig. 66), the **scribes**, perhaps public archons or **treasurers** of the sacred monies on the Acropolis (fig. 69), and the **hound** from the sanctuary of Artemis (fig. 105). The rest are mainly statues of horsemen, kouroi and korai. In addition to these, many small votive offerings graced the Sacred Rock, such as marble perirrhanteria (basins for holy water), while numerous bronze and terracotta figurines, vases and clay pinakes, which are exhibited in the surrounding showcases, had been dedicated to Athena, mainly by poorer devotees.

From the seventh century BC, but in Athens mainly in the early sixth century BC, **marble began to be used** to fashion the large statues of ancient Greek art, and slightly later to construct the temples of Hellenic architecture. Marble, which was abundant mainly on the islands (Paros, Naxos, Thasos, and elsewhere), was the material medium of artistic expression, sculpted with an array of bronze tools, which are displayed on a special panel and are no different from the tools of today's craftsmen.

66-69. Four of the most characteristic *ex-votos* of the Archaic period from the Acropolis:

66. The Calf-Bearer (*Moschophoros*), a rich provincial from Attica with the animal on his shoulders expresses the power and wealth of the arable farmers and stock-raisers.

67. The upper part of a votive statue of a sphinx, on the body and wings of which traces of pigments are preserved.

68. The stele of the potter holding kylikes, obviously products of his workshop. Several *ex-votos* of the late sixth century BC had been dedicated in gratitude to Athena by craftsmen and tradesmen whose affluence was due to their professional activities.

69. One of the scribes or treasurers of the sacred monies. According to a recent theory, if they are scribes they may be those who were the first to write down the Homeric epics, in the time of the Peisistratids. Another suggestion is that the figure is of a vase-painter at work.

68

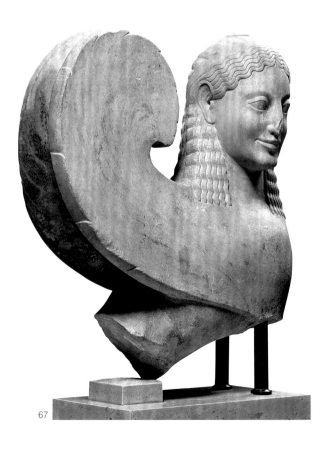

67

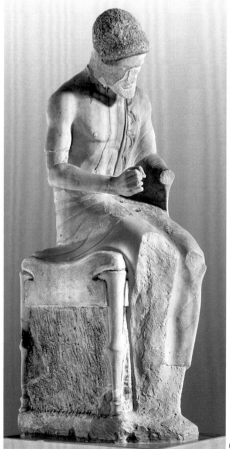

69

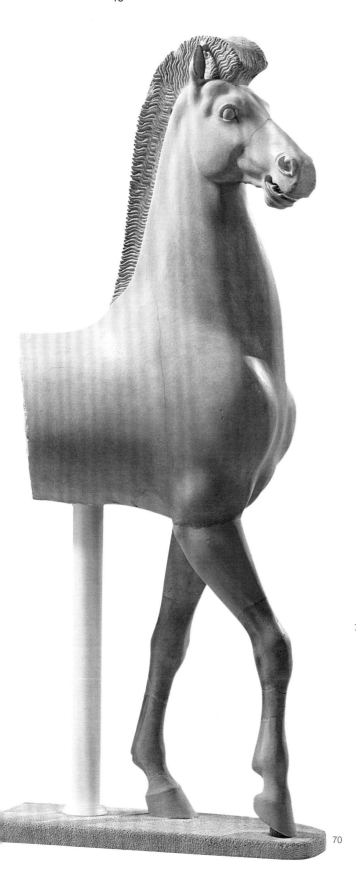

70

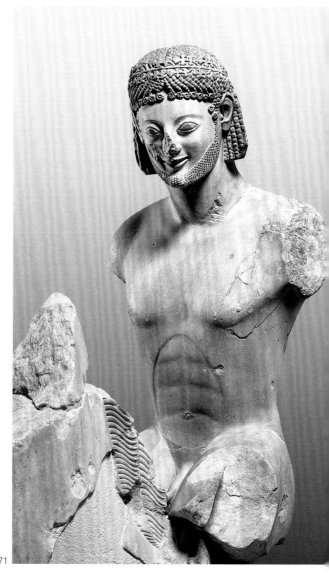

71

The horsemen

Owning and keeping horses was costly in antiquity and was the privilege primarily of the aristocrats. Thus, these handsome animals had been elevated as symbols of wealth and high social status. It is not fortuitous that the second social order in the hierarchy of the four tribes of the Solonian State was named *Hippeis*

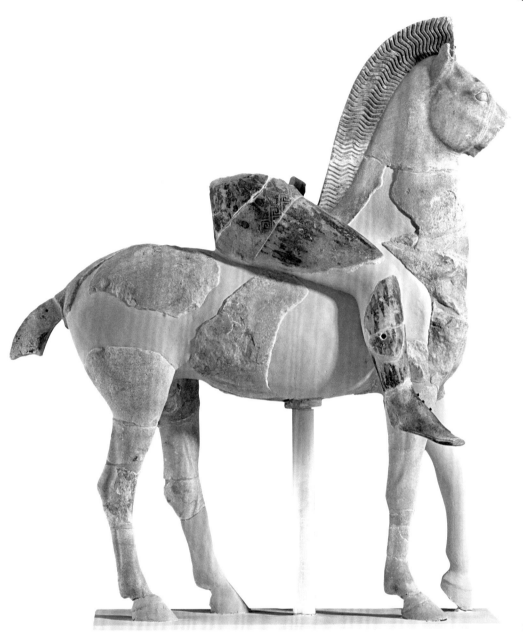

72

(Knights) and it is very probable that the marble statues of horsemen on the Acropolis were *ex-votos* of members of this class. The reasons for their dedication may have been several: from a social event to a victory in horse races at games, which is perhaps why some of the horsemen are represented crowned with a wreath.

70. The noble horse, ownership of which denoted bravery and high social class, is a common *ex-voto* in all periods. This particular example is dated to 490 BC.

71. The so-called 'Rampin horseman', named after the first owner of the figure's head, which is presently in the Louvre. Impressive is the elaborate hairstyle and the fillet in the hair.

72. The horseman with the coloured trousers (*anaxyrides*) is known conventionally as a Persian. However, its attribution to the general at Marathon, Miltiades, who for some years was tyrant in Persian-occupied Thrace, has also been proposed.

The korai

Much more numerous, about 200 judging by the surviving parts, were the statues of korai, who are represented holding an offering to the goddess and had been dedicated on the Acropolis in the years between 580/70 and 490 BC. Many are the interpretations of these figures, but the most likely seems to be that linking them with the habit of girls from wealthy Athenian families serving the cult of Athena for part of their youth, a habit encountered in many religions (e.g. the Dedication of the Virgin in the Temple). It seems that after the end of their term of service, their fathers – since most of the dedicators are men – dedicated statues of their daughters in the sanctuary, so reminding the goddess of their family's piety and their fellow citizens of their social prominence.

73. General view of the Archaic gallery of the museum from the east. Left, preserved on a tall, inscribed column, is the lower part of a statue of Athena.

74. King George I visits the spot where the korai were found, northwest of the Erechtheion, in 1886. From the periodical *Illustration,* 1886.

75. Kore no. 682 is tall, with meticulous hairstyle and dress, on which considerable traces of the original pigments are preserved. Like most of the korai, she wears a chiton and a himation, a fashion introduced to Athens from Ionia around 530 BC.

73

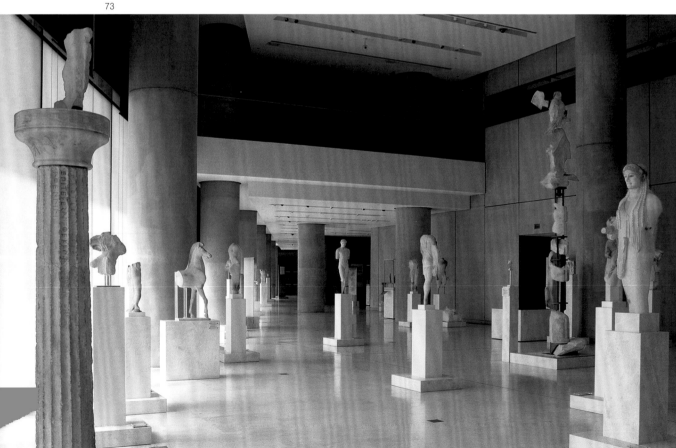

74

The discovery of the korai

Most of the Archaic *ex-votos*, principally the korai, were found buried in a deposit (*apothetes*) to the northwest of the Erechtheion, during the major excavations on the Acropolis in the years 1885-1890. It seems that they had been collected together and buried piously in this place by the Athenians after the burning of the Acropolis by the Persians in 480 BC. Traces of this conflagration are still visible on the statues exhibited in the museum.

The archaeologist Panagis Kavvadias, who had the good fortune of uncovering the deposit with the korai statues, writes: *'On the 24th of January (new calendar 5 February) 1886, late in the day the pick hit upon a veritable nest of statues, which one by one were removed from the ground the next day. These were fourteen statues, all of female type, of various sizes. On eight of them the head still survived, while they preserved, more or less, vivid colours. The pick performs miracles in this place'.* In the image, King George I visits the find-spot of the Archaic korai.

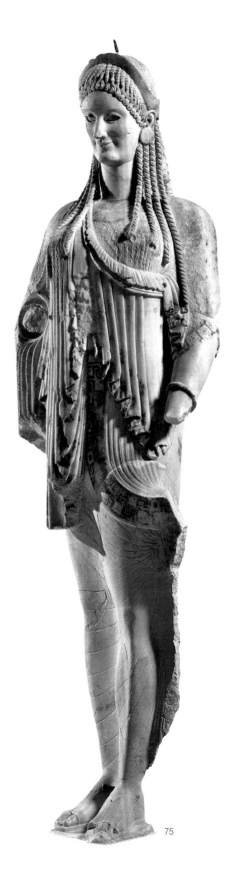

75

The most famous of the korai is the 'Peplophoros', so called because until very recently it was considered that she was dressed in a Doric peplos instead of the chiton which the others wear (figs 78-79). However, the latest research on the pigments preserved on this work give a new dimension, since they reveal that she does not wear a peplos but an ependytes (mantle), which is open in front to show off an inner garment (fig. 76) decorated with panels filled with real or imaginary animals. Because in ancient art such a garment with corresponding decoration is worn only by

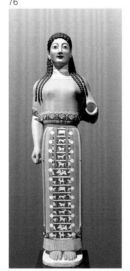

76

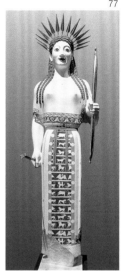

77

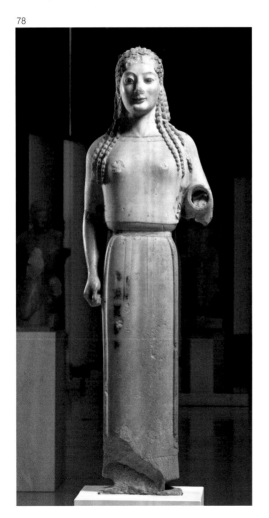

78

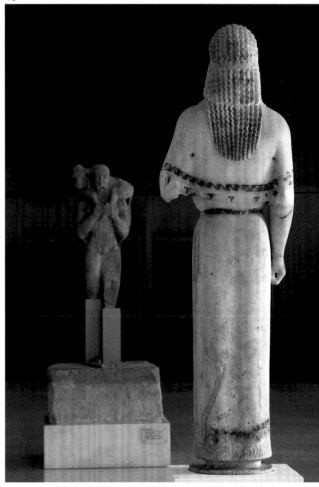

79

goddesses, it is possible that the statue is of a goddess (Artemis?), as has been proposed lately (fig. 77).

Colour was an inextricable element of all ancient Greek architecture and sculpture, and there is explanatory material on this issue (e.g. panel with the pigments used by the ancient Greeks) in the museum. Presented too are architectural members, such as an Ionic column capital, and inscriptions, the letters of which are picked out in strong colours, as on the base of the *ex-voto* of Onesimos. However, the most impressive coloured works were the sculptures themselves, an image of whose original aspect is given today by the replica of the 'Peplophoros', which is exhibited alongside the original work.

Important too is the kore by the sculptor Antenor, standing on its original pedestal with precious inscription (figs 80-81). It was an *ex-voto* of Nearchos (the potter or from the *demos* of Kerameoi) as 'first fruit' (*aparche*) of his work, that is, as an offering to the goddess of his first profit.

These statues stood in the open air, on high pedestals or columns, in much the

76-79. Two renderings with coloration and two views of kore no. 679, dubbed 'Peplophoros' because her attire differs from that of the other korai. Latest research has offered the possibility of representing the statue's original painted embellishment, enabling us to enjoy the true picture of Archaic sculpture.

80-81. Kore no. 681 is known as the kore of Antenor, after the sculptor who created the statue. It has been placed upon its ancient pedestal, which is inscribed with the names of the sculptor and the dedicator, as well as the reason for the dedication. In the graphic reconstruction next to the work (drawing Fr. Studniczka), the metal rod preserved on the head is rendered as a sharp metal sheet, which, according to the most plausible explanation, the korai carried in order to prevent them being soiled by birds.

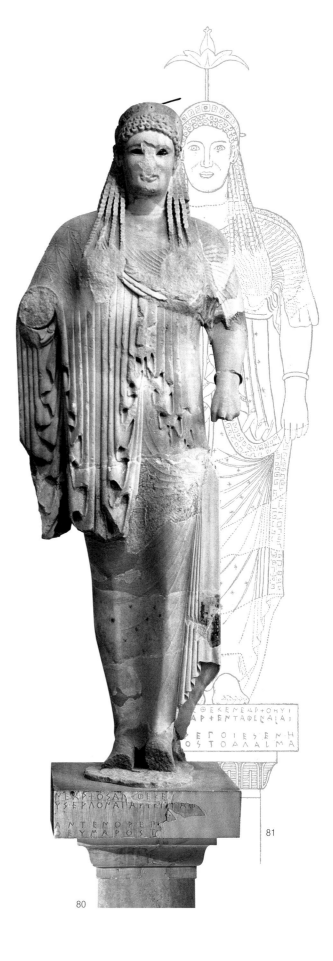

80

81

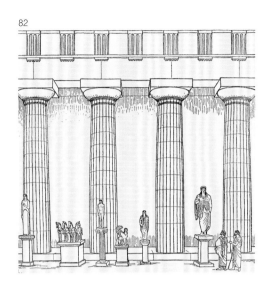

82

same way as they stand in the museum. All of them had **bases with inscriptions** recording the names of the dedicators and in many cases of the sculptors too, who, proud of their work, endeavoured to promote their artistic personality. Characteristic is the frequent mention in the inscriptions of the noun 'άγαλμα' (*agalma*), which derives from the verb 'αγάλλομαι' (*agallomai* = to rejoice), meaning that purpose of the work was to delight the goddess. Simultaneously, however, the beholders were delighted too. Both the ancient Greeks who enjoyed these

83

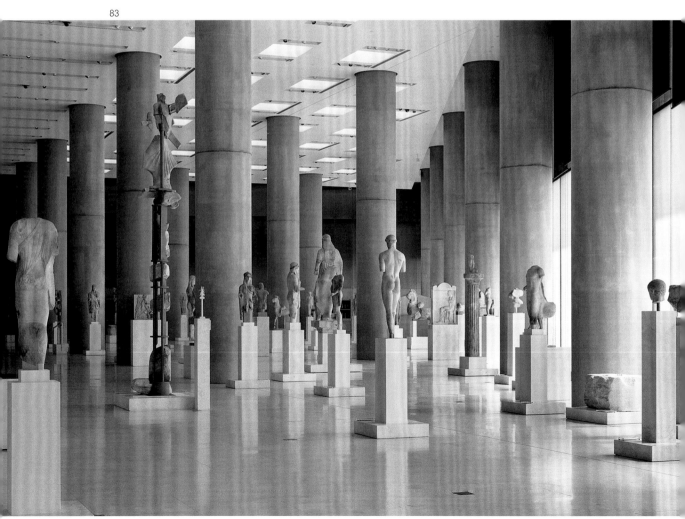

works placed orderly on the Rock, against the backdrop of the sky or temple columns (fig. 82), and we today who admire the very beautiful statues placed between the robust pillars of the museum (figs 73, 83).

One other characteristic word that appears in the dedicatory inscriptions is 'απαρχή' (*aparche* = first fruit), which is encountered on votive offerings of persons of the middle and lower social classes. It denotes that the work was paid for with the first money earned by the dedicator from some profitable venture (trading journey/voyage, craft industry, entrepreneurial activity) and that he felt the obligation to offer it as first thanks to the goddess.

The most dynamic element of delight in Archaic art is expressed by the so-called '**Archaic smile**' (figs 84-85). This is not actually a smile (it appears also on funerary statues) but is considered as an attempt by the Archaic sculptor to impart vivacity and expression to the faces of the figures, together with the broad forehead, the large almond-shaped eyes and the pronounced cheekbones.

82. Hypothetical drawing by F. Krischen showing well-known Archaic *ex-votos* from the Acropolis in their putative original position on the rock, set up along the Sacred causeway linking the Propylaia to the altar of Athena. Behind them is the colonnade of the Archaic temple of the goddess.

83. View of the Archaic gallery in the museum. As they stand on high pedestals, these works give us a panorama of Archaic sculpture, which found its noblest expression in Attica, primarily on the Acropolis.

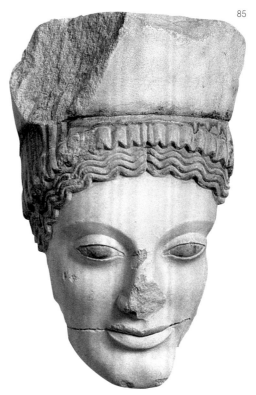

85

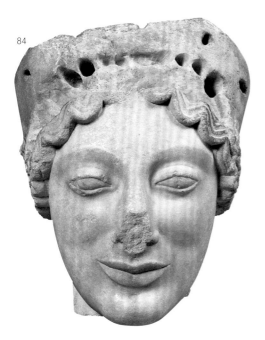

84

84-85. The heads of two korai with pronounced Archaic smile. Right no. 696, the kore with polos, that is the high crown in her hair, and left no. 643, with the smooth flesh and half-closed eyes, in a profound expression of grace and femininity. The holes in the hair point to the existence of additional ornaments or a metal wreath.

86-87. Kore no. 680, with the fruit in her right hand, as an offering to the goddess, and kore no. 675, known as the 'Chian', because it has been associated with the Chian workshop. Most korai hold an offering (fruit or bird) in the hand extended to the fore, while with the other they draw up their garment, in a gesture of female coquetry.

88-89. Two views of kore no. 685, one of the last of the Archaic period (*ca* 500/490 BC). Both hands are extended to the fore, leaving the garment clinging to her body. The Archaic smile has almost disappeared from her lips.

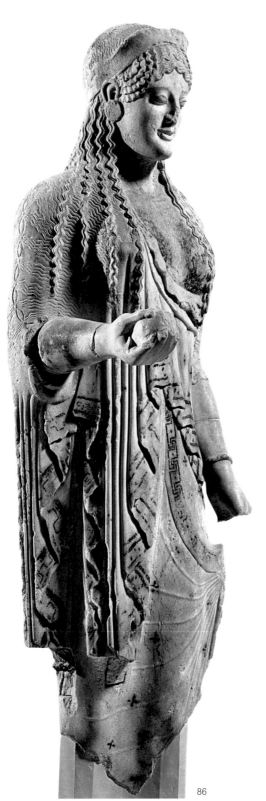

86

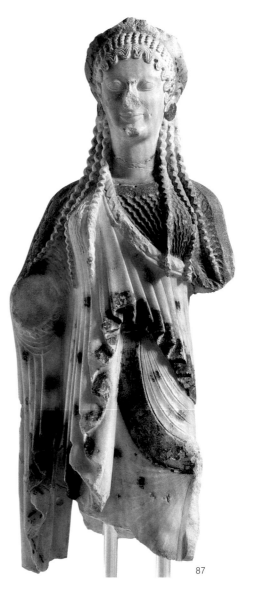

87

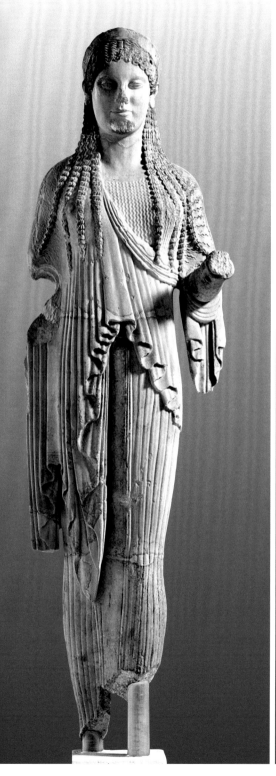

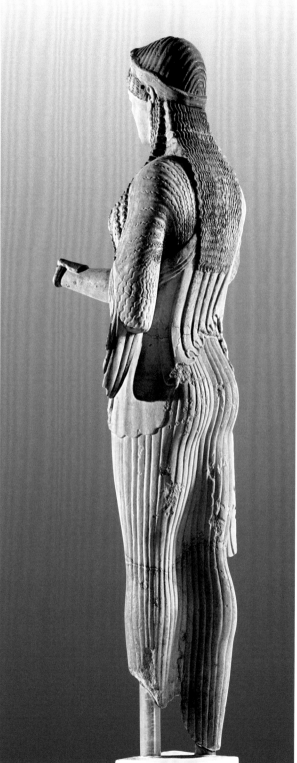

THE ACROPOLIS DURING
THE PERSIAN WARS

A strong aura of history emanates from
the exhibits associated with this dramatic
period for the ancient Greek world. The
Nike of Kallimachos is linked with **the
battle of Marathon** (490 BC). According to
Herodotus' description (6.109-111), before
the battle there was dissent between the ten
Athenian generals as to whether or not to
launch a direct attack on the Persian forces.
Then Miltiades, proponent of the first option,
called upon the polemarch Kallimachos
and with a fiery speech persuaded him
to vote in favour of his proposal. In the
ensuing battle, Kallimachos, commander

of the right flank, fell fighting heroically.

In his honour this monument was
dedicated on the Acropolis, a figure of Nike
upon a tall Ionic column (fig. 92). The
epigram incised down the length of the
column extols his bravery. The monument,
originally 5 m. high, had been set up to the
northeast of the Preparthenon and, by irony
of fate, was destroyed by the Persians when
they put the Acropolis to the torch in 480 BC,
shortly before the naval battle of Salamis.

Next to the *ex-voto*, in a horizontal
showcase, are exhibited statues bearing
the **scars of the Persian destruction**,
as well as a hoard of 62 coins of the time,
which were minted from silver extracted
from the Laurion mines. It was the

90

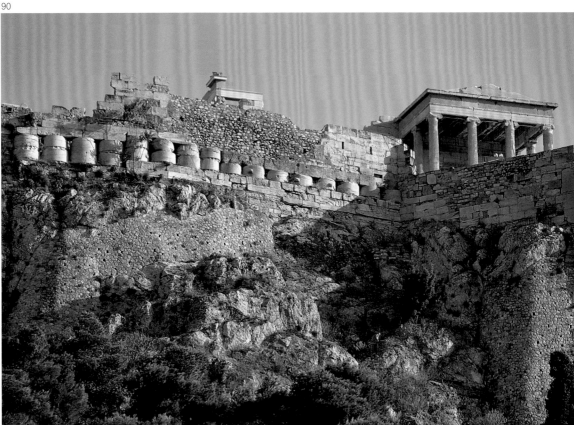

exploitation of these mines which enabled Themistocles to build the fleet that vanquished the Persians at Salamis.

The **Preparthenon**, building of which began after the battle of Marathon, was to be the first entirely marble temple in mainland Greece, which was due to the discovery a few years before of the marble sources of Pentele. Still unfinished (fig. 56), it was destroyed by the Persians. Themistocles incorporated the half-worked column drums of this temple, together with parts of other devastated Archaic buildings, in the north fortification wall of the Acropolis, so that they could be clearly seen from the Agora, as constant reminders of the struggle against the barbarians (fig. 90).

91

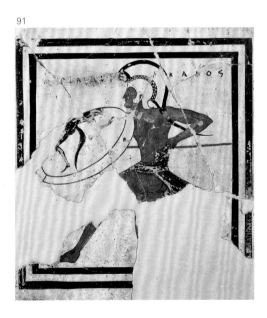

92

90. View of the north defensive wall of the Acropolis with column drums from the half-finished Preparthenon, which was destroyed by the Persians, built into its fabric and visible to this day.

91. Terracotta plaque or metope with representation of a fully-armed hoplite running to the left (510-500 BC). This is a rare example of great painting from the Late Archaic period. Although the figure is usually interpreted as a competitor in the race for armed runners (*hoplitodromos*), his image differs little from that of the Athenian foot-soldiers who ran 8 stades (1,500 m.) in panoply, in order to fight the Persian army at Marathon.

92. Graphic reconstruction of the column and Nike of Kallimachos, the *ex-voto* erected on the Acropolis to commemorate the Athenian polemarch who fell in the battle of Marathon (drawing M. Korres).

93

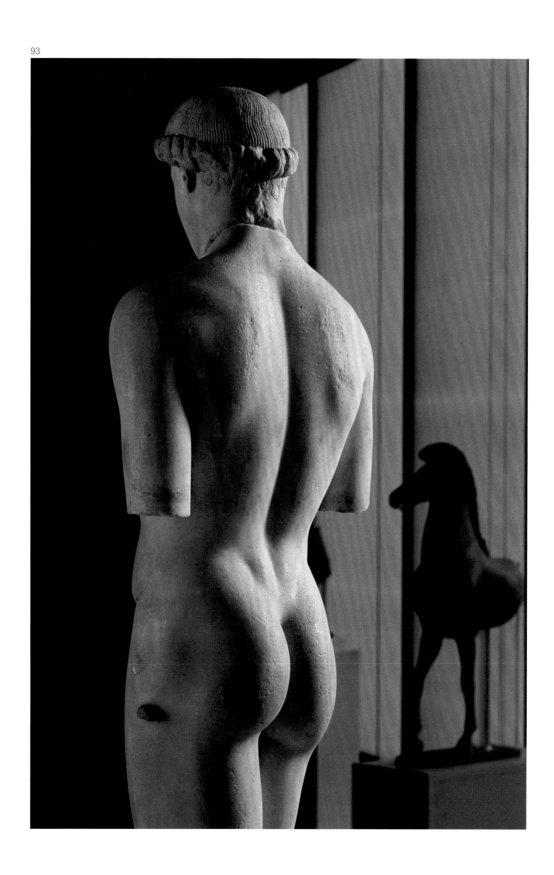

Works in the 'Severe Style'

At the far end of the Archaic gallery are a few works dated to the years 480-450 BC, the interlude between the Archaic and the Classical period, which has been called conventionally the 'Severe Style' because of the facial expression of the statues, which have now lost the Archaic smile. These are renowned sculptures, such as the **Kritios Boy** (figs 93-94), the Blond Youth (fig. 96), the Euthydikos kore, the Angelitos Athena sculpted by Euenor, and behind these, the relief of the **Pensive** or **Mourning Athena** (fig. 95). These works are of dual importance: historical, because they declare that immediately after the Persian destruction the practice of dedicating *ex-votos* on the Acropolis continued unabated, and artistic, because they demonstrate the great steps made in art in this period, with the breaking up of the Archaic formats and the conquest of new, more natural, figures, which soon led to the climax of the Classical period.

At this point it is worth mentioning one more renowned statue of the period, of

93-94. The Kritios Boy, a characteristic statue in the 'Severe Style', is a landmark work in the history of sculpture. Dated shortly after 480 BC, it breaks through the Archaic scheme of the kouros, which had remained unchanged for over 100 years, and with the freer and more natural movement of the body opens the way for the new achievements of the Classical period. It owes its name to its similarity to the young Harmodios, one of the tyrannicides, whose statue was created in the same period by the sculptors Kritios and Nesiotes. The statue group of the tyrannicides is known to us from copies made in the Roman period.

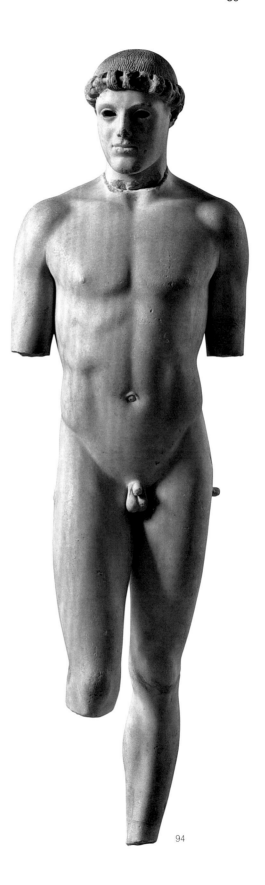

94

95

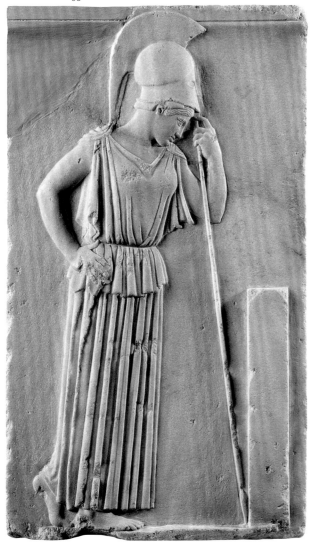

96

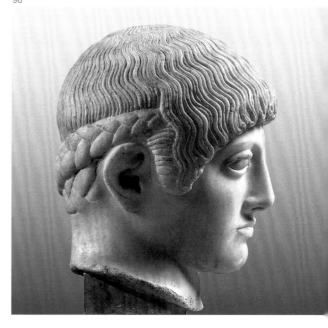

95. The relief of the so-called 'Mourning Athena', who stands pensively in front of a stele. Various interpretations of the scene have been proposed. The work is noteworthy for its seriousness and introspection, expressing the *Zeitgeist* that was generalized after the Persian Wars.

96. The head of the 'Blond Youth', thus named after the yellow pigment preserved on the hair when it was found, is also dated to the period of the 'Severe Style'. Interesting is the hairstyle, consisting of two braids whose ends were tied on the forehead and then covered by combing the hair to the front.

which all that has survived is part of the crowning of its pedestal from a repair in Roman times. This is the large bronze statue of **Athena Promachos**, work of Pheidias, which had been set up *ca* 460 BC, in the area between the Propylaia and the Erechtheion (fig. 97). It stood 7-9 m. high and tradition has it that the tip of the spear and the crest of the goddess's helmet were visible from the sea. The statue was created from the booty of the battle of Eurymedon

(467 BC), but was a thank-offering for the victory in the battle of Marathon and must have been erected on the initiative of Kimon son of Miltiades, in an effort to reinstate the memory of his father, who died in prison. It was the first public work commissioned from Pheidias by the Athenian State. The statue was perhaps made on the south slope of the Acropolis, directly above the Herodeion, where a bronze foundry of the period has been excavated.

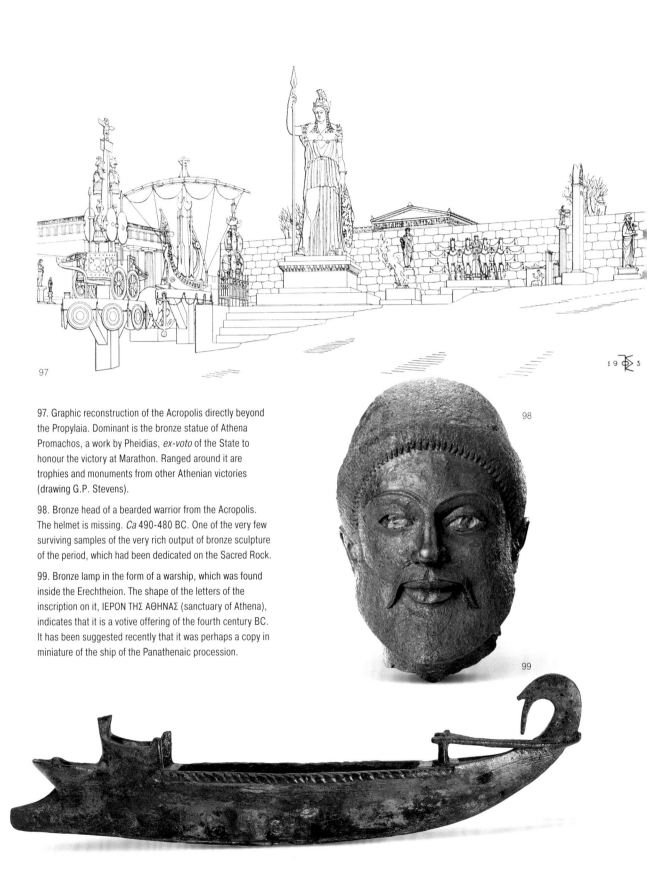

97. Graphic reconstruction of the Acropolis directly beyond the Propylaia. Dominant is the bronze statue of Athena Promachos, a work by Pheidias, *ex-voto* of the State to honour the victory at Marathon. Ranged around it are trophies and monuments from other Athenian victories (drawing G.P. Stevens).

98. Bronze head of a bearded warrior from the Acropolis. The helmet is missing. *Ca* 490-480 BC. One of the very few surviving samples of the very rich output of bronze sculpture of the period, which had been dedicated on the Sacred Rock.

99. Bronze lamp in the form of a warship, which was found inside the Erechtheion. The shape of the letters of the inscription on it, ΙΕΡΟΝ ΤΗΣ ΑΘΗΝΑΣ (sanctuary of Athena), indicates that it is a votive offering of the fourth century BC. It has been suggested recently that it was perhaps a copy in miniature of the ship of the Panathenaic procession.

THE CLASSICAL ACROPOLIS

The Persian Wars are a turning point in the history of western civilization. After the resounding victories over the Persians, Athens was totally destroyed but incredibly dynamic and within a few years it emerged as the leading city and **intellectual and artistic hub of the Hellenic world**. This was due to a rare coincidence of propitious circumstances in the annals of history. The coexistence of visionary leaders, a politically mature population due to the development of democracy, abundant economic resources and talented artists led, in the fifth century BC, to the creation of wonderful works and splendid cultural achievements. The designating of the period as 'Classical' denotes the elevation of the city and its creations as a model, a paradigm, against which all civilizations before and after were to be evaluated.

The most characteristic expression of this period is the architectural works. In the middle years of the fifth century BC, after the transfer of the treasury of the Delian League from Delos to Athens, and the contracting of peace with the Persians and the Lacedaemonians, the preconditions were created for the Athenian State to implement an ambitious building project, which included a total of **12 temples** and other monuments throughout Attica. It goes without saying that epicentre of this architectural activity was the Acropolis, which had lain devastated for thirty years.

The new fortification wall that girt the Sacred Rock extended the surface area of the summit from 0.25 to 0.34 ha. The ground was levelled by bringing over 200,000 tonnes of earth and the terraces on which the new buildings were to stand were created.

The programme was planned by **Pericles** himself and his inner circle of politicians and artists. It foresaw the construction of three temples in honour of

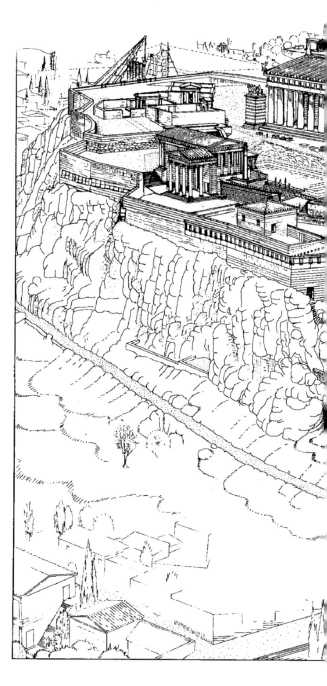

the three hypostases of the patron goddess Athena (Polias, Parthenos, Nike) and one monumental propylon. Its implementation lasted, with interruptions, the entire second half of the fifth century BC. The architectural programme had **multiple objectives**. First of

100. Graphic reconstruction of the monuments of the Acropolis from the northwest. The buildings, works of the Athenian State during the second half of the fifth century BC, were intended to honour the city's patron goddess, Athena, and to extol and enhance the heroic past and the achievements of the Athenians, as they pressed their claim to panhellenic hegemony (drawing M. Korres).

100

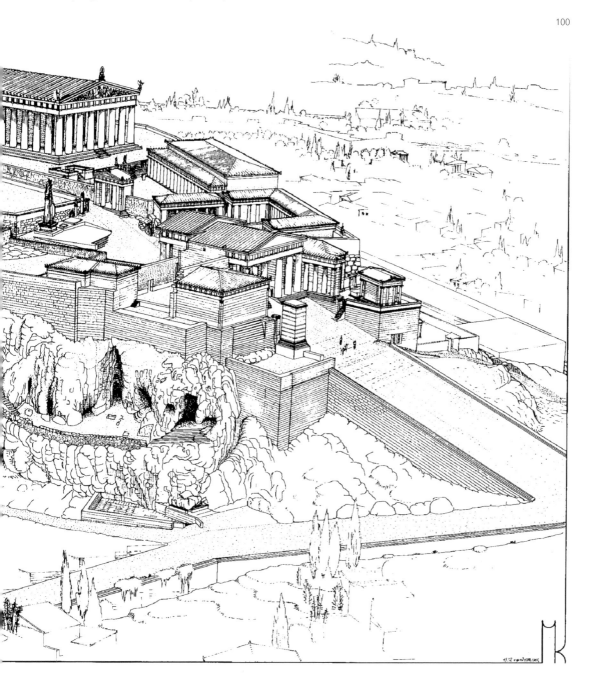

all, it was a manifestation of the Athenians' piety and their gratitude to Athena and to other deities, who had made a maximum contribution to the military victories on land and sea, securing the repulsion of the Persian threat. Second, the projects were intended to restore the image of the city's religious centre, which could not possibly remain in the state in which it had been left by the Persians. Third, it aimed at putting art, monumental architecture and sculpture in the service of political propaganda. That is, through the magnificence of the new buildings and through the messages of the sculpted decoration, Athens desired to make known throughout the ancient world its demand for hegemony and to enhance itself as leading city.

For works to proceed, it was decided to release immediately 5,000 talents from the public treasury, as well as to withdraw annually another 200 talents for the next 15 years. This **money** had been accumulated from the Persian booty, mainly from the naval battle of Eurymedon (467 BC), from the incomes from the Laurion mines and, only a small part, from the contributions of the allied cities. The first monuments, the Parthenon (447-432 BC) and the Propylaia (437-432 BC), were constructed in a relatively short interval of time and Pericles himself was fortunate in inaugurating them. The Erechtheion (421-415 and 410-406 BC) and the temple of Athena Nike (432 or 426-424 or 421 BC) took shape gradually, in the lulls in the hostilities of the Peloponnesian War.

Pericles son of Xanthippos from the *demos* of Cholargos
Περικλής Ξανθίππου Χολαργεύς

The leader of the Athenian Democracy and creator of the so-called 'golden age', as he was represented posthumously by his contemporary the sculptor Kresilas (fig. 102). For 32 years (461-429 BC), Pericles was *strategos* (=general) and key-player responsible for the leading role of Athens in the military, political and artistic domains. Born into an aristocratic family in 495 BC, he was involved from his youth in public affairs and in 461 BC assumed the leadership of the democratic faction. He was largely instrumental in consolidating the fledgeling Athenian Democracy, enhancing Athens as a naval empire and the greatest power of the period. His achievements include the major works of Athenian architecture, mainly on the Acropolis, which established Athens as the artistic and intellectual centre of antiquity, as well as symbol of Classical art for eternity.

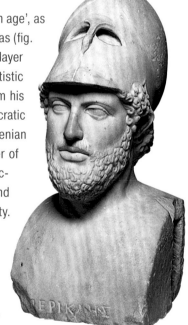

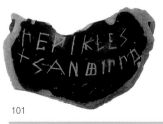

101. Potsherd from an ostracism, incised with the nomen and the patronymic of Pericles. Museum of the Ancient Agora, Athens.

102. Portrait of Pericles. He is shown with helmet because he was a general (*strategos*), but his face is handsomer than it was in reality, in order to convey his political and moral virtue. British Museum, London.

101

102

MONUMENTS OF THE SACRED ROCK OUTSIDE THE MUSEUM

Apart from the large and important buildings on the Sacred Rock, components of which are exhibited in the museum, there were on the Acropolis other smaller buildings of religious and practical character, as well as open-air sanctuaries.

The **sanctuary of Artemis Brauronia** was located directly to the right of the Propylaia and abutting the south wall of the Acropolis (5). It was a Π-shaped building comprising porticoes and closed spaces, which surrounded a court in which a small temple stood. Peisistratos had brought the cult of Artemis here from her great sanctuary at Brauron, in the framework of enhancing the

Acropolis as religious centre of all Attica. Here, as in Brauron, Artemis was worshipped as protectress of women in pregnancy and parturition. The young female devotees sacrificed and deposited votive offerings (mainly their garments) in order to secure the goddess's favour and protection in the most difficult moments of every woman's life. And this in a time when the female mortality rate during childbirth and the percentage of infant deaths, were very high. The few antiquities from this sanctuary which are displayed in the

103. 3-D model of the Acropolis as it was in the fifth century BC (model M. Korres).
1. Propylaia, 2. Temple of Athena Nike, 3. Parthenon, 4. Erechtheion, 5. Sanctuary of Artemis Brauronia, 6. Site of the Chalkotheke, 7. Sanctuary of Pandion, 8. Sanctuary of Zeus Polieus, 9. Arrhephoreion, 10. Sites of honorific statues of Attalids.

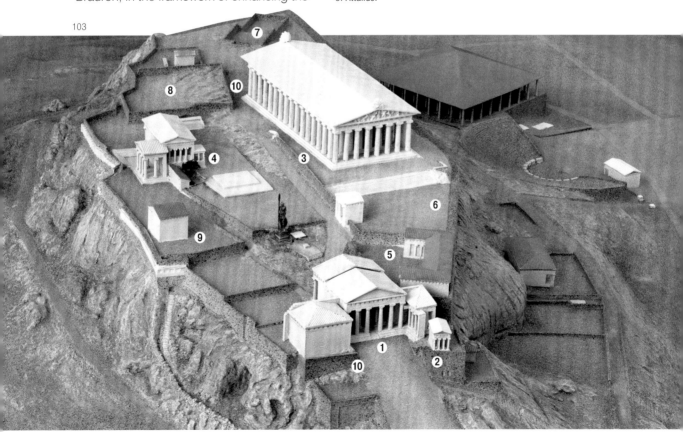

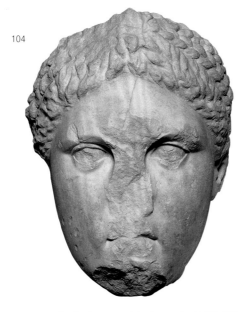

104

museum include a marble hound of 520 BC, very probably an *ex-voto* to Artemis as goddess of the hunt (fig. 105), as well as the head of a cult statue of the goddess, an original work by the sculptor Praxiteles, dated *ca* 330 BC (fig. 104).

Directly to the east and likewise abutting the south wall of the Acropolis was the **Chalkotheke** (6), an oblong storeroom with one or three entrances and six internal columns, the façade of which was arranged as a stoa with 18-20 columns. Dating probably from the early fourth century BC, it was used, as we know from inscriptions, for the safekeeping of bronze votive offerings to Athena, as well as of weapons, such as catapults, indicating

that it functioned also as an arsenal, useful for the defence of the Acropolis!

To the east of the Parthenon, under the old museum, the remains of the **open-air sanctuary** of the mythical king of Athens, **Pandion**, are preserved (7). These consist of two square spaces and one propylon. The Moschophoros and the head of Athena from the marble pediment of the Gigantomachy were recovered from the fill of the foundations.

To the northeast of the temple, cut in the rock are the beddings for the foundations of the **sanctuary of Zeus Polieus** (8), protector of the city, counterpart of Athena Polias. This was the venue for the very ancient festival of vegetation and the renewal of nature, known as the Diipoleia or Bouphonia, during which an ox was sacrificed and a mock trial was held, not of the *bouphonos*, the priest who had slaughtered the animal, but of the axe used for the sacrifice.

To the west of the Erechtheion and abutting the north wall of the Acropolis there was one other small building of the second half of the fifth century BC. Of rectangular plan and with a distyle or tetrastyle *in antis* prostasis, it is of interest not for its architecture but for the rituals that took place there (9). This was in all probability the **Arrhephoreion**, the residence of the girls 7-11

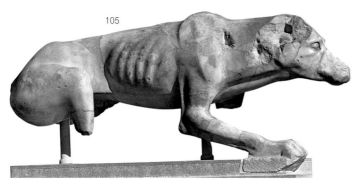

105

104. The head or the cult statue of Artemis Brauronia, which was over 3.50 m. high, an original work by Praxiteles.

105. Statue of a hound, found in the sanctuary of Artemis Brauronia.

106. Graphic reconstruction of the 9-m. high pedestal at the northeast corner of the Parthenon, on which stood a four-horse chariot or *quadriga*. Erected originally in honour of Attalos II, it was subsequently dedicated to a Roman emperor (drawing M. Korres).

years old (age of innocence) who for a short period of their life served the goddess Athena, taking part in various rituals. In one of these, the Arrhephoreia, they received from the priestess of Athena in the Erechtheion certain sacred objects (probably dough models of snakes and phalluses, as well as pinecones), placed inside a covered basket, without seeing them. They carried these outside the Acropolis, to the sanctuary of Aphrodite on the north side, passing along a secret staircase inside the wall, which is dated to Mycenaean times. There they received other occult symbols, which they delivered to the chief priestess. These were rites associated with the age-old cycle of rustic ritual performances aimed at ensuring the fertility of the soil and of life. The secret objects were fertility symbols, which no one should see, and the nocturnal celebration had to be kept secret so as not to lose its potency.

Dated to Hellenistic times are two **high honorific pedestals** (10), which were topped by *quadrigae* (four-horse chariots) and had been erected by the city in honour of the kings of Pergamon Eumenes II and Attalos II, who were generous benefactors of Athens. Both are in conspicuous positions, bespeaking the great honour bestowed upon the monarchs or demanded by them. The first pedestal stood on the ascent in front of the Propylaia. Of grey Hymettan marble, so as to be projected against the white Pentelic marble backdrop of the propylon, it was founded in 178 BC, when the king of Pergamon was victorious in the chariot race of the Panathenaic Games. However, at the end of the first century BC a new inscription on the monument dedicated it to the son-in-law of Augustus, Marcus Vipsanius Agrippa,

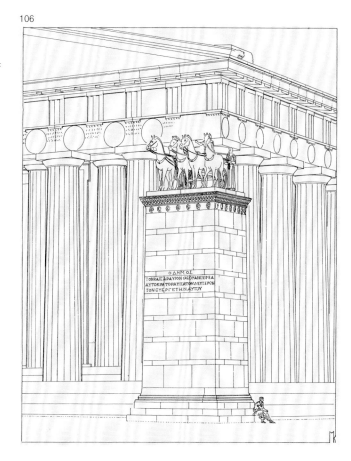

106

likewise a great benefactor of Athens. The second pedestal stood exactly next to the northeast corner of the Parthenon (fig. 106). Founded in honour of Attalos II, it too was later ascribed to one of the early Roman emperors, perhaps Nero.

Last, the only notable work that took place on the Acropolis in Roman times was the building of a small circular monopteral (without walls) temple with conical roof, dedicated to the goddess **Roma** and to **Augustus**. It stood on the projection of the long axis of the Parthenon, was 8.60 m. in diameter and had nine Ionic columns, copies of those of the Erechtheion. According to the inscription on the epistyle, it was apparently founded in 20/19 BC.

THE PROPYLAIA

The Propylaia are an architectural construction devoid of sculpted decoration, which is why they are represented in the museum by an educational model of the building, by two coffers from the ceiling and by parts of two Ionic column capitals. The only sculptures are the Roman copies of a stele of Hermes Propylaios, a work of Pheidias' pupil Alkamenes, which stood inside the building. Construction of the Propylaia, to plans by the architect Mnesikles, commenced in 437 BC, when building works on the Parthenon had been completed. There are so many features in common with the large temple that it has been suggested that Mnesikles was a pupil of Iktinos and that the same building team worked on both monuments. The great success of the architect is that he managed to impart the splendour of a great temple to an entrance building.

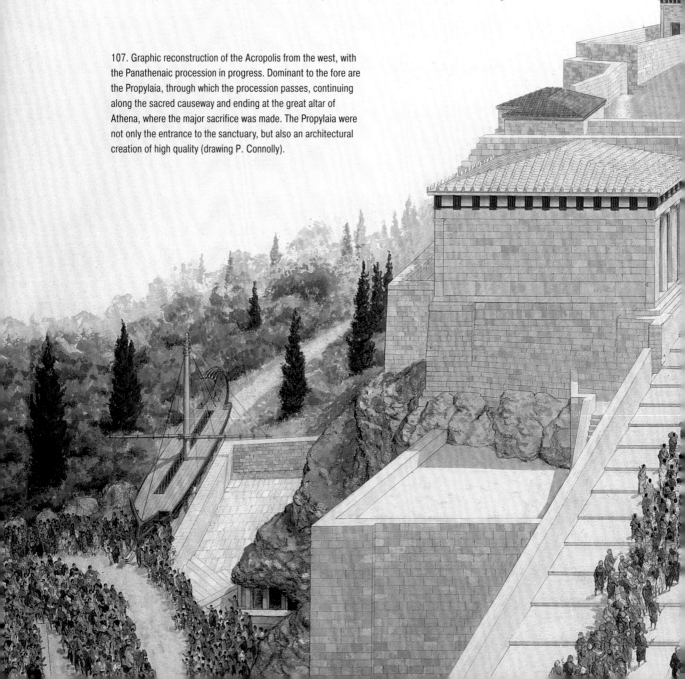

107. Graphic reconstruction of the Acropolis from the west, with the Panathenaic procession in progress. Dominant to the fore are the Propylaia, through which the procession passes, continuing along the sacred causeway and ending at the great altar of Athena, where the major sacrifice was made. The Propylaia were not only the entrance to the sanctuary, but also an architectural creation of high quality (drawing P. Connolly).

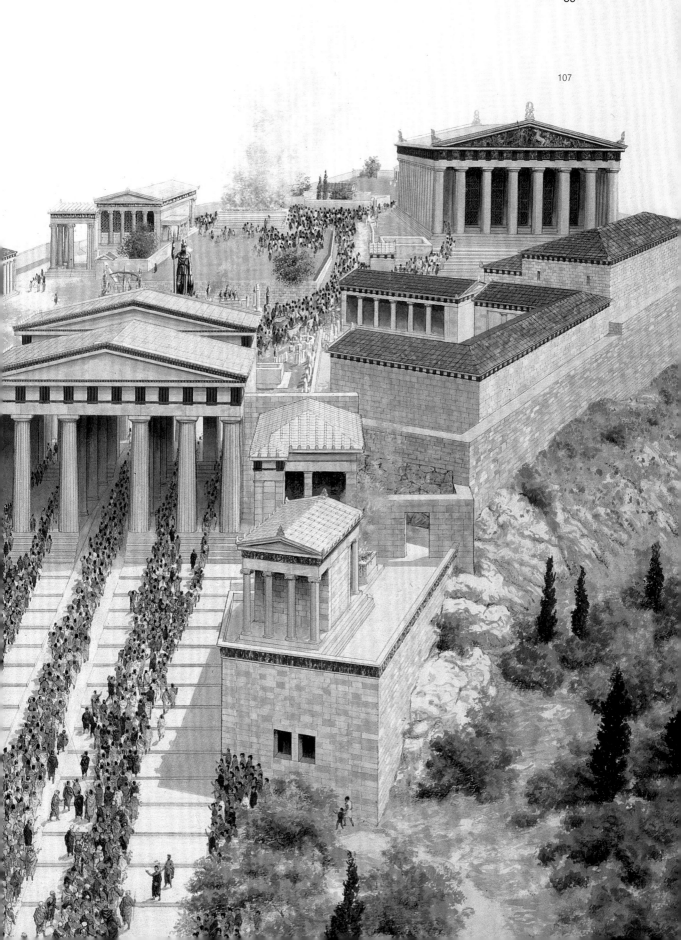

107

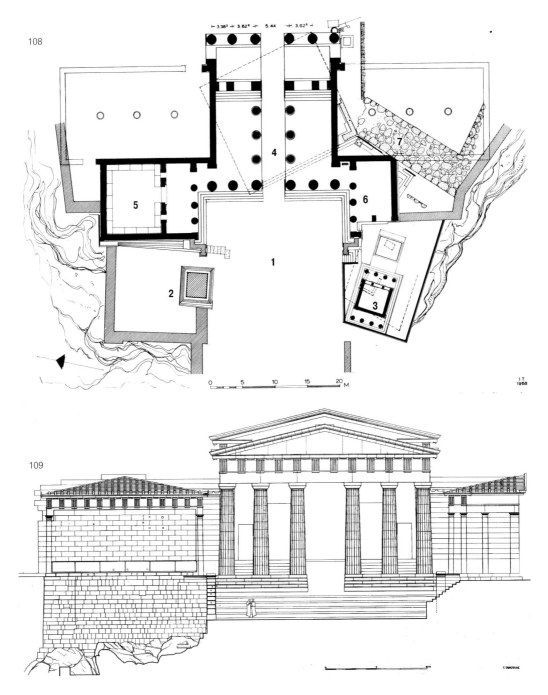

108. Plan of the Propylaia and of the temple of Athena Nike:
1. Ascent, 2. Pedestal of Agrippa, 3. Temple of Athena Nike,
4. Central corridor of the Propylaia, 5. Pinakotheke,
6. Tristyle prostasis giving access to the temple of Athena
Nike, 7. Cyclopean Mycenaean wall. The broken line
denotes the positions of the pre-Classical buildings
(drawing J. Travlos).

109. Graphic reconstruction of the Propylaia from the west.
The central building is elevated and in the form of a hexastyle
temple. The five doors of unequal height can be distinguished in
the intercolumniations (drawing T. Tanoulas).

110. View of the Propylaia and the temple of Athena Nike,
during the recent restoration works, which have considerably
improved the image of the monuments.

The **originality of the design** lies in the fact that for the first time in the history of architecture three different buildings were synthesized in a monumental ensemble of Π-shaped plan, thus creating an entrance building in the scheme of an open embrace welcoming the visitor. The central and largest building consists of two spaces at different levels, due to the downward slope of the ground, which had hexastyle temple-shaped façades with Doric columns copying those of the Parthenon (figs 109, 114). At the junction of the two spaces, five symmetrical doorways of differing height were opened. Because there were several doorways, the building is referred to in the plural (propylaia, as opposed to propylon). In the west part was a passage with three Ionic columns on each side, which perhaps copy the lost Ionic columns from the west apartment of the Parthenon (fig. 112). The second building is a small hall with tristyle prostasis to the left as one enters, in the interior of which were paintings, which is why it was named **Pinakotheke**, and 17 couches. Evidently this functioned as a leisure space (*lesche* = club) for official visitors and/or a banqueting hall for ritual repasts during the festivals on the Acropolis (fig. 111). Last, the third building, opposite the Pinakotheke, was an antechamber, also with tristyle prostasis, that was an access corridor to the temple of Athena Nike, even though this could be reached by climbing the small staircase before reaching the Propylaia. The entire central part of the Propylaia had a ceiling

110

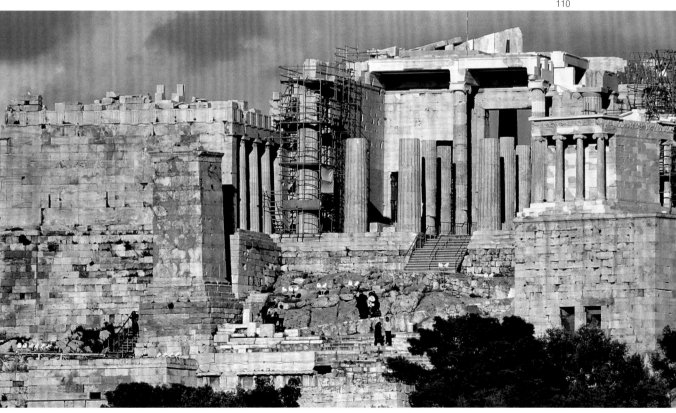

with coffers of exquisite craftsmanship, decorated with gilded stars on a blue ground. Many of these were restored and placed in position during the last reconstruction of the monument (fig. 113), together with two Ionic column capitals of superb art. So, on passing through the Propylaia we have the experience of passing through the sole roofed monument on the Acropolis today.

What makes Mnesikles' monument even more important is the fact that it succeeded in remodelling completely the steep terrain in this particular place, and the end result is a building that is integrated, harmonious and functional. And this, despite the fact that the original design was never realized, neither the plan, which made provision for two more halls on either side of the central building, nor the construction. In fact, several parts remained unfinished, in a manner that does not suggest sudden abandonment of the project but rather an attempt by the Athenians to 'tidy up' the works on the Acropolis, perhaps because of the outbreak of the Peloponnesian War in 431 BC.

111

112

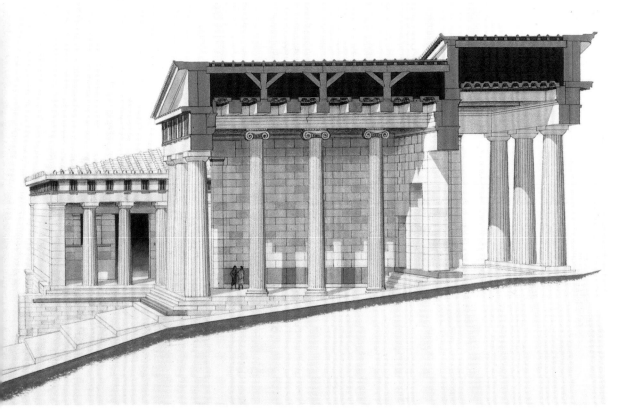

111. Graphic reconstruction of the interior of the Pinakotheke, a large hall on the left of the Propylaia. It was called Pinakotheke, which means picture gallery, by the traveller Pausanias, who visited it some 600 years after its construction and describes some paintings that still survived. At either end there were 17 couches, indicating that it was used for official banquets organized by the Athenian State (drawing J. Travlos - P. Connolly).

112. Longitudinal section of the Propylaia, showing the two parts, east and west, at different levels, as well as the Ionic columns that not only support the ceiling but also form the central corridor of the building. On the left, the prostasis of the Pinakotheke (drawing P. Connolly).

113-114. View of the east (inner) side of the Propylaia and of part of their interior, after the recent restoration, which protected the monument from earlier damages and filled in several missing parts.

113

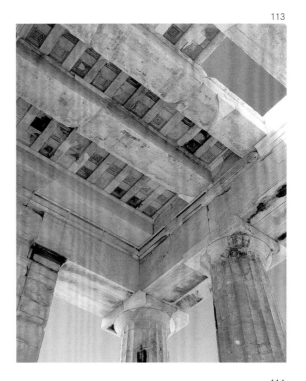

114

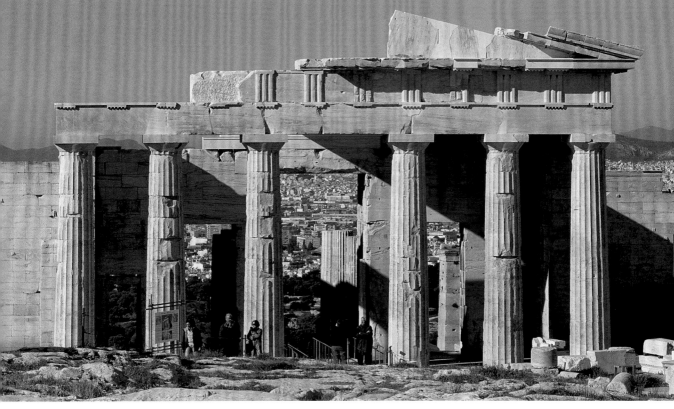

THE TEMPLE OF ATHENA or WINGLESS NIKE

Nike (Victory) is one of the hypostases by which Athena was worshipped on the Sacred Rock. It was Athena Nike who stood by the Athenians in time of war, the victory-bringing goddess who clinched their military successes. The name of the temple as of Wingless Nike was coined in antiquity, due to a misunderstanding of the fact that the cult statue of Athena was, of course, without wings. During Roman times, however, when the name temple of Nike held sway, the lack of wings on the statue was interpreted as due to their removal by the Athenians, to prevent Nike ever leaving their city.

115

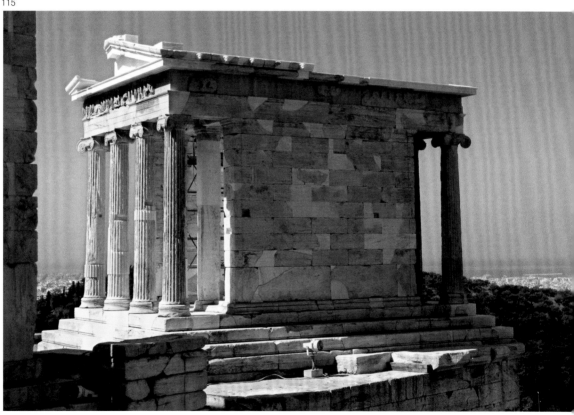

116

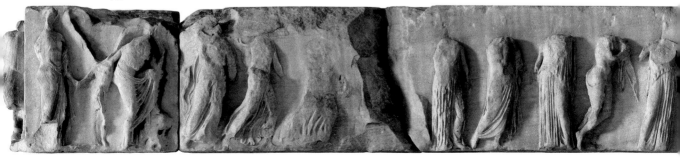

The temple was built on top of the bastion of the **Cyclopean Mycenaean wall**, which was the most important strategic point of the Acropolis. Concurrently with the founding of the Propylaia, the Cyclopean bastion was revetted with the high isodomic masonry we see today, leaving two openings through which the earlier wall is visible, perhaps as a reminder of the city's heroic past (fig. 107).

Worship in this particular space is documented from the time of Peisistratos, by a simple little temple. This was destroyed by the Persians and was probably replaced in the time of Kimon by another small temple, which housed the cult statue.

In 450/49 BC, the Boule of the Athenians took the decision to commission the construction of a new temple from Kallikrates. The terms of this agreement are preserved in an inscription on display in the museum. However, the start of the project was delayed for some 20-25 years because precedence was given to the Parthenon and the Propylaia. Nonetheless, during the years of the Peloponnesian War, construction of the temple was considered necessary, for reasons of political propaganda. The size and form of the new temple seems to have been the outcome of negotiation between rival political factions or priesthoods,

115, 117. Two views, from the northeast and the west, of the temple of Athena Nike, after completion of the recent restoration works. The frieze was transferred to the museum and a replica placed on the monument.

116. The frieze of the temple of Athena Nike is the unique monument on the Acropolis on which historical events are represented, that is battles between Greeks and Persians, as well as between Greeks and Greeks. However, on the east side (here) the subject is mythological, an assembly of gods or the birth of Athena.

117

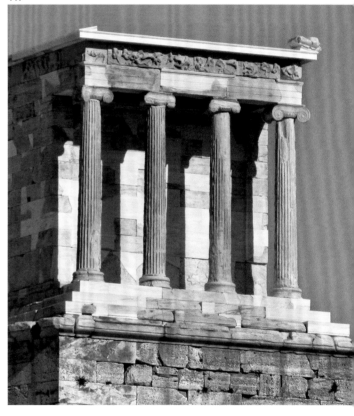

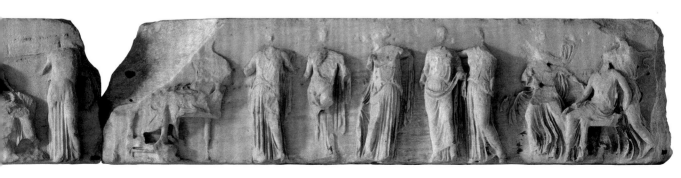

which led the architects to compromise by modifying their plans: Mnesikles abbreviated the right wing of the Propylaia, while Kallikrates reduced the length of the Athena Nike temple by cancelling the pronaos, and created a tetrastyle amphiprostyle Ionic cella. The columns, here monolithic and 4 m. high, closely resemble the Ionic columns of the Propylaia, even though only half their size.

The temple of Athena Nike was the first temple built in the Ionic order in Ionian Athens. It is clear that the architectural orders by no means corresponded absolutely to the tribal division of the ancient Greeks and the monumentality of Athenian architecture was expressed flawlessly by the Doric order. However, it was impossible to impart this monumentality to a temple of such small dimensions. So, it was decided to distinguish the temple by other means, such as the

grace and the delicate decoration of the Ionic order. This order was perhaps opted for so as to enhance the sculpted decoration (frieze instead of metopes in relation also to the parapet), which was a basic concern of the building's designers. This view is boosted further by the fact that it is one of the very few Ionic temples with pedimental sculptures.

The **sculpted decoration** served the ideological objectives of Athenian policy, namely (a) to honour Athena Nike and to emphasize her presence in the city, and (b) to endorse Athens by representing its martial victories, aim of which was to project its contribution to the successful outcome of the Persian Wars and its ensuing claim to panhellenic hegemony. Indeed, here this is declared not only by mythological references, as on other buildings, but also, for the first time, by historical ones too. Mythologically, the enhancement of the city is expressed on the

118

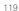

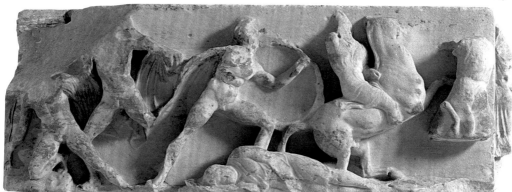

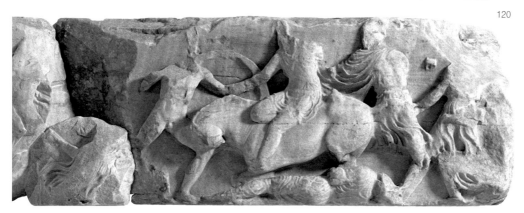

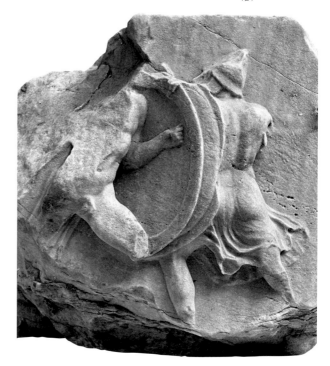

118. The part of the museum in which the sculpted decoration of the temple of Athena Nike is displayed. On the left are plaques from the parapet and at the far end is the south frieze. Exhibited in the showcases on the wall at the back, to the left, are other parts of the sculpted decoration, among them the pedimental sculptures.

119-121. Scenes from battles between Greeks and Persians, as represented on the south, and between Greeks on the west (121) side of the frieze of the temple of Athena Nike. If this is the battle of Plataia, then depicted in fig. 120 is the death of the commander of the Persian cavalry, Masistios, an Athenian feat which contributed decisively to the Greeks' victory. In fig. 121 is a scene of remarkable originality in its artistic conception, of two combating opponents with their shields.

two pediments; on the basis of the most recent research, it seems that the Gigantomachy featured on the east pediment and the Amazonomachy on the west, two battles in which the Athenians' role, through Athena and Theseus respectively, was decisive. Parts of the pedimental sculptures from the temple are exhibited in showcases.

Direct historical references can be deciphered in the **frieze**, 26 m. long and 0.45 m. high, which is made up of 14 stone blocks and runs round the building. Its subjects are the most controversial issue with respect to the temple. Dated *ca* 420 BC,

that is, in the throes of the Peloponnesian War, it is only logical that it was used also as an agent of anti-Spartan propaganda. Depicted on the south side is a battle between Greeks and Persians, most probably the battle of Marathon, in which the Athenians' role in warding off the Persians is extolled. Another view is that this is the battle of Plataia, although this is considered a mainly Spartan victory and it is unlikely that it would have been represented in Athens during the Peloponnesian War. If, nonetheless, it is the latter, then it was chosen to put particular emphasis on the episode in which the

122

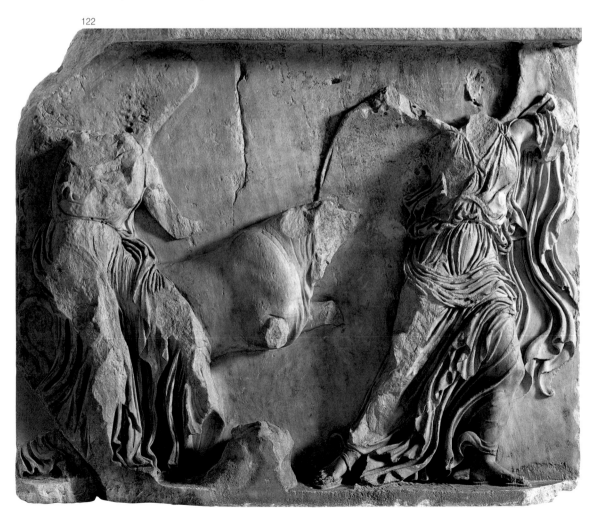

Athenians killed the commander of the Persian cavalry, Masistios, which deed was of major significance for ensuring the Greeks' victory (figs 119-120). Represented on the north and the west side is a battle between Greeks. Scholars have made numerous proposals as to the identification of this with one of the battles fought by the Athenians in the second and third quarter of the fifth century BC. On the east frieze is the subject, familiar from the Parthenon, of the assembly of the gods, with Athena standing between Zeus and Poseidon, or, according to a more recent assessment, the birth of Athena (fig.

116). The apotheosis of victory continued on the akroteria of the temple, where gilded, smaller than life size, Nikai were placed, similar to those on the Parthenon, and not, as was previously thought, a statue group of Bellerophon, Pegasos and Chimaera. A recent theory postulates that shields of the Lacedaemonians, from the battle of

122-124. Relief plaque and isolated figures of Nikai from the parapet of the temple of Athena Nike. The winged figures drive bulls to sacrifice or erect trophies with Persian or Greek weapons. Perhaps the trophies on each side of the parapet are related to the battles represented on the corresponding sides of the frieze.

123

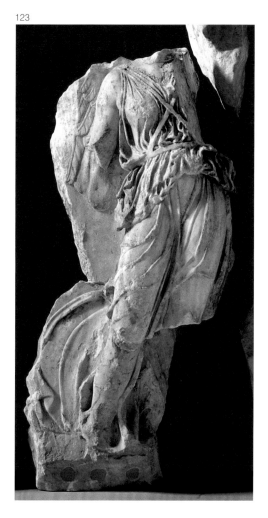

124

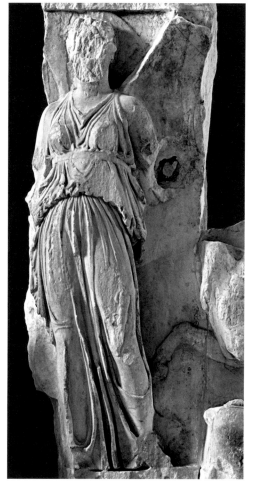

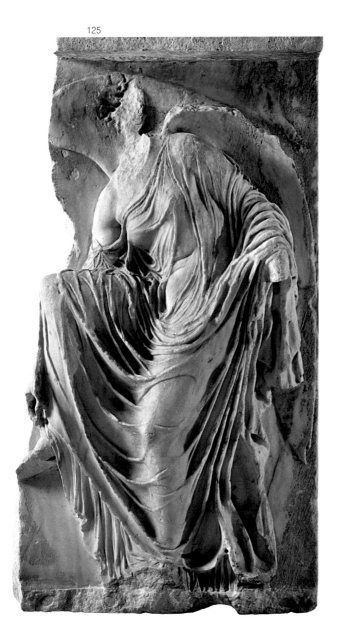

125

125. One of the most famous works of art from the Acropolis: The Nike bends over to loosen her sandal. The relation between body and garment here finds its perfect expression and equilibrium. Although the figure is dressed in a chiton, it is as if she reveals her naked body beneath. Such a successful balance between body and garment is perhaps unrivalled in the entire history of art.

126. View of the Erechtheion from the southeast. Left, the foundations of the *archaios neos*, which was destroyed by the Persians and to which the Erechtheion was both cultic and symbolic successor.

Sphakteria (424 BC), the sole battle in which Spartans had been taken captive, may also have been placed on the top of the Nike tower. These, certainly visible from all angles, will have been yet another indication of the Athenians' military might.

The sculpted decoration is completed by **the relief parapet**, 41 m. long and approximately 1 m. high, which was placed at the edge of the tower *ca* 410 BC, for safety reasons (fig. 107). Here the representation is on the outer side, which means it was seen by those ascending to the Acropolis, as complement to the sculpted decoration of the temple. A series of about 50 winged personifications of Nike (Victory) set up trophies with Greek or Persian weapons and prepare a sacrifice for Athena, who is seated (figs 122-124). This representation denotes the actual sacrifice of a bull, which took place in front of the temple on the occasion of the Panathenaic procession, or the 'bouthysia' (bull sacrifice) in the sanctuary of Zeus Polieus, which was also on the Acropolis.

These reliefs compose an unprecedented sculptural ensemble, which appears to have been executed by at least six sculptors, among them Pheidias' pupil Kallimachos and Paionios, known from the statue of Nike in Olympia. Even today we are left ecstatic by the youthful figures with their unusual gestures and movements, the lissome bodies and the flimsy garments. Best known of all the figures is the '*sandalizousa*', the Nike who lifts her leg to loosen her sandal, so as to step barefoot onto the altar (fig. 125). With a human, everyday gesture the figure gives the sculptor the opportunity to display the virtues of her body, as well as his own unsurpassable artistic prowess.

THE ERECHTHEION

The Erechtheion, although outshone by the Parthenon, was in fact the most important temple on the Acropolis, because in it was housed the very ancient wooden effigy (*xoanon*) of the goddess which, every four years, was robed with the new peplos in the Panathenaia festival. It seems that due to the difficult historical conjuncture the Erechtheion was built gradually, in the interludes in the Peloponnesian War, from 421-415 BC and from 410-406 BC. It is a curious and highly complex building, of dimensions 21×11 m., which, although a temple, lacks symmetry and is non-canonical. It comprises three different volumes, which stand on four levels, and has four fronts with different roofs and colonnades. Despite the spatial and architectural difficulties, the architect, possibly Mnesikles, not only managed to give the building cohesion, but also to enhance it as one of the most elegant works of ancient Greek architecture.

The peculiarity of the Erechtheion is due to many factors, which were also strict constraints for its creator: (a) It was built at the north edge of the Rock, next to the fortification wall, obviously in order to leave free the central space of the Acropolis, where thousands of devotees gathered to attend the sacrifice of the Panathenaia (fig. 107). (b) On the site on which it was built there is a height difference of over 3 m. (c) The temple had to house several cults of Olympian gods, such as Athena Polias, Zeus, Poseidon and Hephaistos. These cults were associated with the 'sacred signs', that is,

126

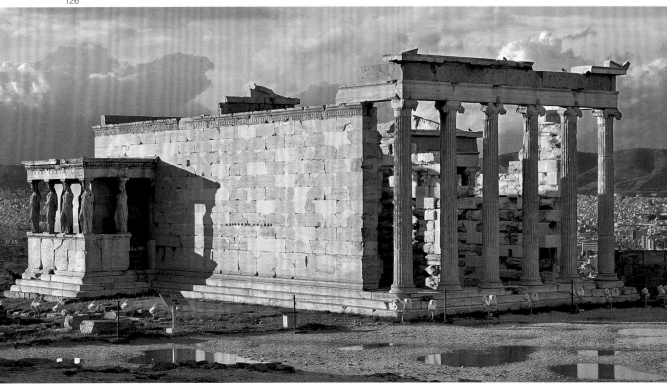

the indications of divine presence on the Sacred Rock, such as the olive tree of Athena, the traces left by the trident and the water of Poseidon, the marks from the thunderbolt of Zeus that killed Erichthonios, and so on. These can be seen most clearly in the north prostasis, for example, the absence of one coffer in the ceiling, leaving a hole through which the thunderbolt passed, the absence of a paving slab in the floor, so that its signs on the rock are visible. (d) The graves of earlier kings, *archegetai* and heroes from the city's mythical or prehistoric past, such as Kekrops, Erechtheus, Boutes and others, had to be incorporated in the edifice, since their presence proved that from primordial times the Athenians were autochthons. It is

interesting that fragments of inordinately large clay funerary vases of the Geometric period, of Dipylon type, found in the excavations on the Acropolis, have been correlated with the specific graves.

127. Hypothetical reconstruction of the Erechtheion from the northwest, with the sacrificial procession in progress. Remarkable is the role of colours in enhancing the architectural work and particularly the frieze, which girded it high up, unifying the different parts of the complex composite edifice (drawing P. Connolly).

128. Graphic reconstruction of the Erechtheion from the southwest. Clearly visible is the difference in level between the various parts of the temple, as well as the way in which the porch of the Karyatids extends one part of it southwards. This was done so that the building covered the tomb of Kekrops, the position of which is indicated by the tall stele with palmette finial next to the sacred olive tree (drawing M. Korres).

129. Drawing of a building inscription of the Erechtheion.

127

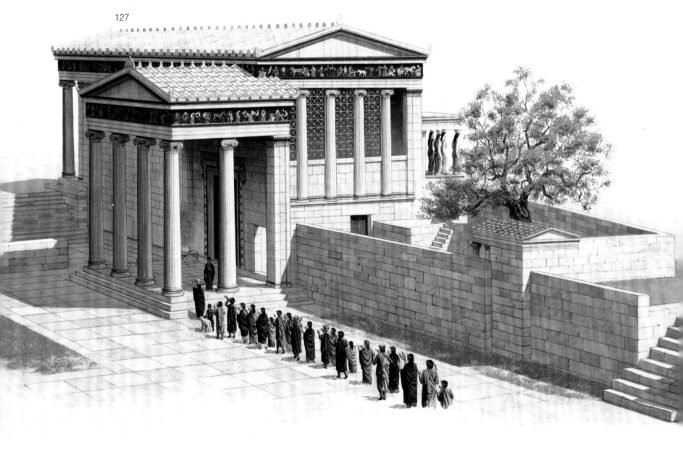

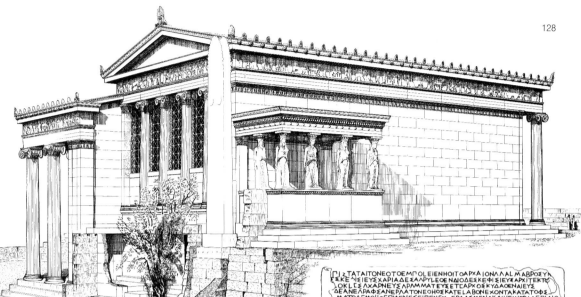

128

The building inscriptions of the Erechtheion

Inscriptions that were set up on the Sacred Rock and are now displayed in the museum, give a detailed description of the state of the building that the responsible archons took delivery of in 410/9 BC, and then of the fees they paid for its completion (fig. 129). Among the most interesting parts of one other inscription with the expenses incurred in the year 408/7 BC, there is reference to the payments for specific tasks, such as the fluting of one column, as well as the remuneration of the sculptors who carved the individual figures of the frieze. We read, for example: *Phyromachos from Kephisia [received] 60 drachmas for the man leading the horse. Praxias from Melite [received] 120 drachmas for the horse and the man behind it.* From study of the data in the inscription it emerges that there is no reference anywhere to the known great creators. Moreover, statistical analysis of the names recorded shows that of the 110 persons working in the specific period only 30% were Athenians, while 50% were metics and 20% slaves.

129

All these old remains had to be included in a single magnificent building, in order to acquire emblematic character, as the ideological and artistic needs of the period demanded. At the same time, the new temple should resemble in its internal arrangement its precursor, the *archaios neos*, which had been razed by the Persians and which obviously served the same needs. So, the cella was divided into two transverse parts (fig. 130). The east, which had a hexastyle Ionic façade and two windows on either side of the doorway, was the temple of Athena Polias, which housed the very ancient *xoanon* of the goddess. The west, which was probably developed

130. Ground plan of the Erechtheion, with hypothetical but quite secure division of its interior. Inside the building were the signs of worship of some ten deities and heroes (drawing J. Travlos).

131. Old photograph (pre-1979) showing the porch of the Karyatids with the original statues still *in situ*.

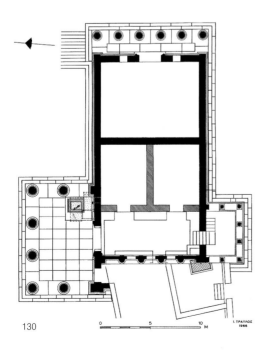

130

on different levels due to the difference in height, hosted many of the other cults. The two porches, on the north and the south side of the building, at once sheltered and enhanced some of the sacred signs, while in an open-air sanctuary to the west, the Pandroseion, all the revered remnants of the Athenian past remained, among them the olive tree of Athena. In the Pandroseion there was a small temple with a small stoa (fig. 127), while lately G. Despinis has attributed to the adjacent little sanctuary of Kekrops an Archaic frieze, and M. Korres an enormous column, about 11 m. high, with the largest Ionic column capital known in mainland Greece, 2.50 m. long and weighing 4.5 tonnes, on which a sculpted *ex-voto* will have stood. This column must have been set up in the late sixth or the early fifth century BC and have fallen during the Persian destruction.

So, the Erechtheion was built expressly to monumentalize and to enhance all the signs that documented the presence of the gods in the city, and which proved the primeval presence of the Athenians in the same land. This fact that they were indigenes or autochthons, was one of their most powerful ideological weapons against the Spartans. They felt proud to be Ionians and to have dwelt from time immemorial in their homeland, whereas their Dorian rivals were accused of being newcomers. With the documentation of their long history, together with the proof of the love and the interest of the gods, the Athenians reinforced their prestige vis-à-vis friends and enemies, employing one more means of ideologically underpinning their claim to the hegemony of Hellas.

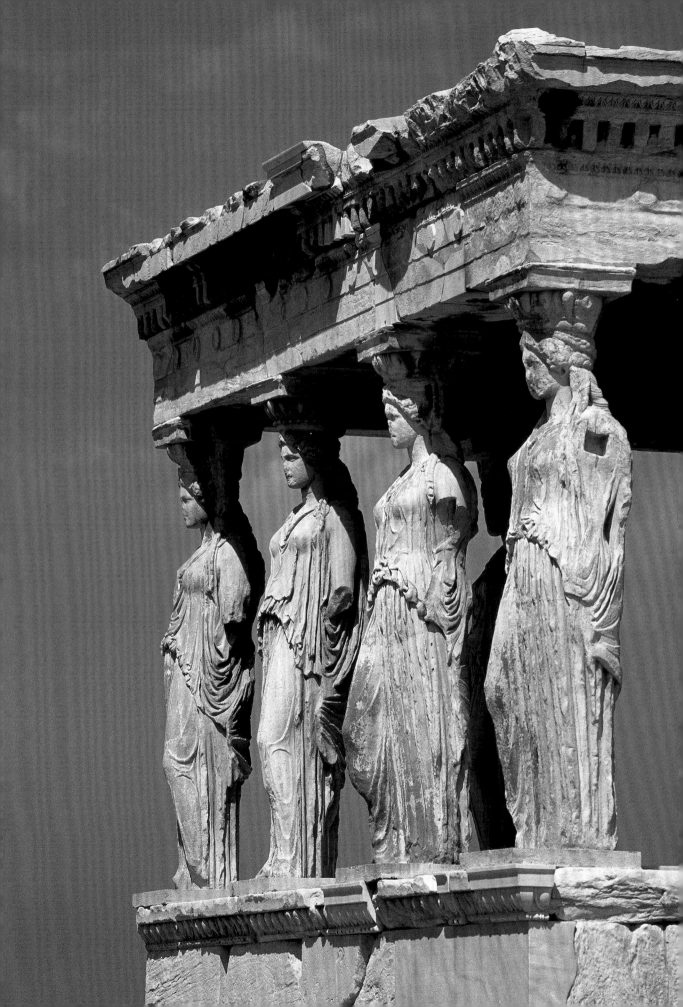

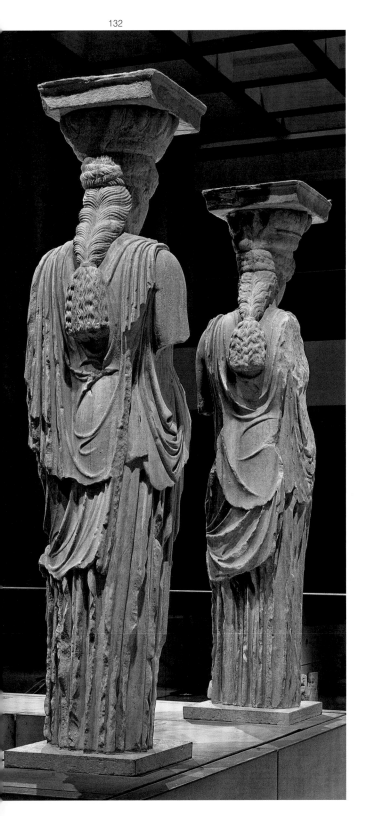

132

The Karyatids and the frieze

Equal in originality to the architecture of the Erechtheion is its sculpted decoration, with most famous representatives the Karyatids, that is the six korai, 2.20 m. high, which instead of columns support on their head the low flat roof of the south porch of the temple. The architectural role of the korai is served by their pose (axial frame), their heavy garments (vertical external pleats of the peplos, like flutes of columns), their elaborate and voluminous hairstyle (to strengthen the neck which is a weak bearing point), and a kind of basket (kalathos) on the head, which functions as a column capital. As can be discerned better in the different rendering of the back, the six statues (one is in the British Museum) are works by different sculptors who copied a model that was created by Pheidias' pupils Agorakritos or Alkamenes, or even Kallimachos. It is quite possible that the garments of each kore were differently coloured, so stressing the polychromy of the building (fig. 127).

Apart from their artistic character, the figures have also a symbolic one, since the south porch stands above the grave of the very ancient king of the city, Kekrops, and the korai are the artistic life-giving expression of the funerary monument. With the slight movement of one leg, they are represented walking ceremonially as if in a procession. This, in combination with the fact that in their right hand they held bowls for libations, as is

132-133. Views of the Karyatids. The female figures, bolt upright like columns, were enhanced as the model of the statue support in the history of architecture. At the same time, they are exquisite sculptural works of the years when Pheidias' pupils were active.

133

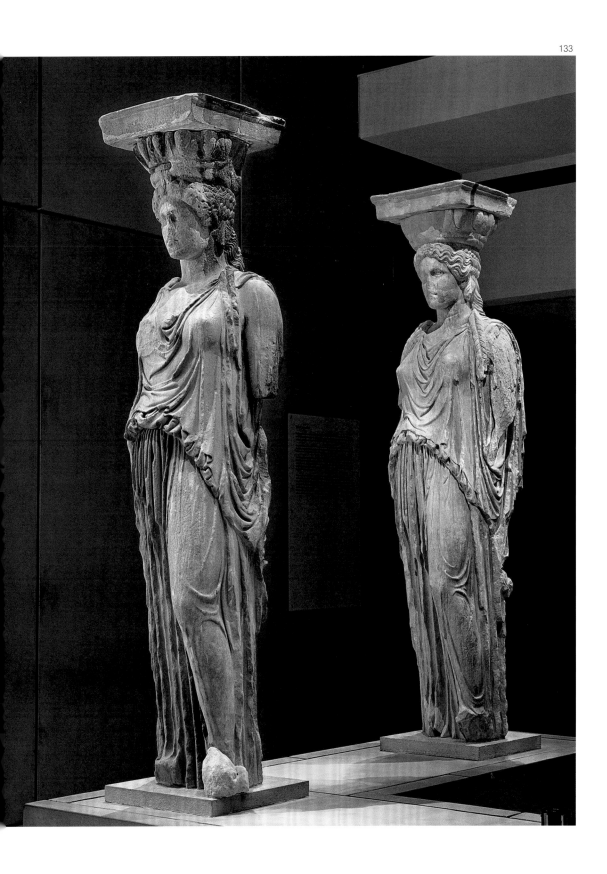

ascertained from Roman copies, denotes that they are libation-bearers (*choephoroi*), that is prominent participants in cultic rituals in honour of the illustrious deceased. Thus, it is possible that they are *arrhephoroi*, the young girls who assisted in the cults on the Acropolis. Their representation on the revered edifice monumentalized the Athenians' devoutness towards their ancestors.

The second sculptural ensemble on the Erechtheion is its **frieze**, 62 m. long, which ran round three sides, excepting perhaps the west, of the temple, thus giving it a sense of unity. The particularity of the frieze lies in the fact that for artistic or economic reasons it is composed of individual figures of white marble, which had been affixed by nails to slabs of dark-coloured Eleusinian stone (figs 127, 134-135). Although parts of it have survived – over one hundred figures (mainly of females) – it has not been possible to identify the subject of the representation, which was perhaps not just one. It has been suggested that scenes from the myth of Erechtheus, the hero who gave his name to the temple, were depicted, or that it was

134

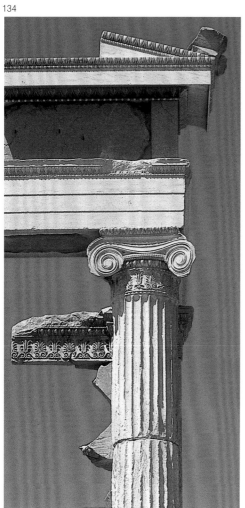

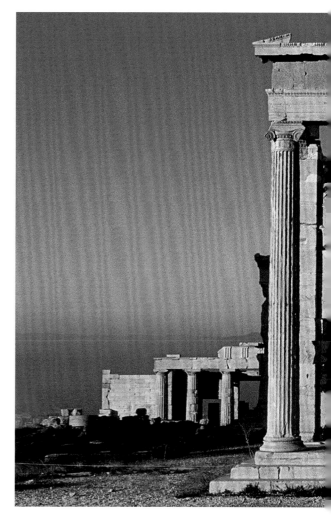

related to the provenance of the many cults in this *locus sanctus*.

The last of the sculptural decorations of the temple are the many and varied relief ornaments that adorned specific parts of it, such as the column capitals and the column bases, the frame of the north doorway and the zone surrounding the building at the height of the column capitals (fig. 134). The diverse decorative motifs and their selected places not only enhance the grace of the Ionic building, but also are masterpieces in their own right, in terms of design and workmanship.

134. View of the northeast corner of the Erechtheion, as formed after the restoration and the placing of the plaster cast of the end column, which had been stolen by Lord Elgin and is presently in the British Museum.

135. View of the east side of the Erechtheion, with the hexastyle Ionic prostasis, in which was the entrance to the temple proper of Athena Polias.

135

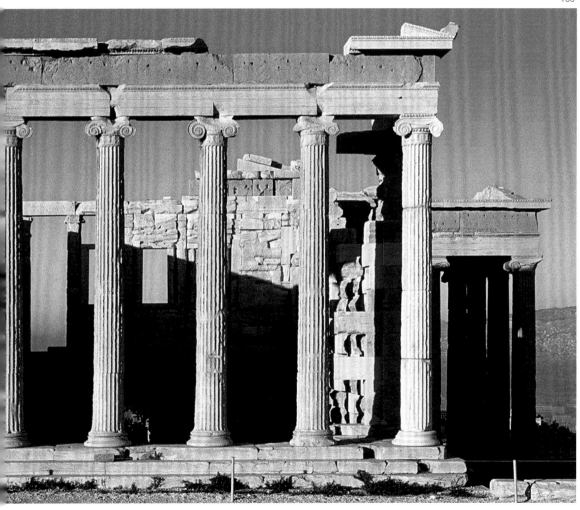

136

136. One of the most important works of free-standing sculpture, which is exhibited in the north wing of the first storey of the museum, is that of Prokne and her son Itys, an original creation and possibly a personal votive offering of Pheidias' pupil Alkamenes, *ca* 430 BC.

EX-VOTOS ON THE ACROPOLIS

Before we go up to the third floor of the museum, with the Parthenon sculptures, it is worth wandering through the north wing of the first floor, where important statues, reliefs, marble bases, inscriptions and other works of ancient Greek art found on the Acropolis are exhibited. The sanctuary of Athena, as central sanctuary of the city, as well as because of its splendour and fame, received a host of *ex-votos*, both public, from the Athenian State itself, and private, from eminent Athenians as well as foreign dedicators.

The most important of the fifth-century BC works is the statue of Prokne with her son Itys, sculpted by Pheidias' pupil Alkamenes (fig. 136). Outstanding from the fourth century BC are the head of the cult statue of Artemis Brauronia from her sanctuary on the Acropolis, work of Praxiteles (fig. 104), as well as several statues of Athena, mainly of Roman times. Among the many portraits of illustrious men, it is worth pausing at the Roman copy of Miltiades (fig. 137) from a many-figured *ex-voto* by Pheidias at Delphi, the portrait of the youthful Alexander the Great (fig. 138), as well as portraits of Roman emperors.

Impressive among the reliefs are the one with the representation of the Athenians' sacred ship, the *Paralos* (fig. 141), as well as the pedestals with scenes from athletics games and events of the Panathenaia (figs 142-143). Also, there are many inscriptions referring to decisions of the *demos* of Athenians on alliances and treaties with other cities, as well as to

137

138

139

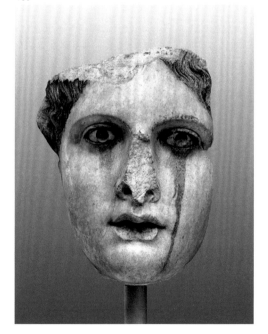

140

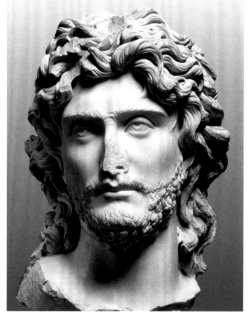

137-140. Four heads, exhibits in the same gallery:
137. Miltiades, a Roman copy of a public *ex-voto*, at Delphi, worked by Pheidias.

138. Youthful portrait of Alexander the Great, of the period when he visited Athens after the battle of Chaironeia (338 BC), perhaps a work by the sculptor Leochares.

139. Head of an acrolithic statue of a goddess, perhaps Aphrodite, with inlaid eyes, the 'tears' shed by which are due to oxidation of the bronze eyelids (2nd c. AD).

140. Portrait bust of a barbarian ruler, found in the theatre of Dionysos. It is dated to the end of the second century AD.

honorary decrees for persons who offered benefactions to Athens.

Unique and difficult to interpret is a marble sphere from the theatre of Dionysos, of the second-third century AD, on which are various magical symbols (fig. 144). These are perhaps spells relating to gladiatorial contests and other such activities that took place in the theatre during Roman imperial times.

Last, associated with the city's history in Late Antiquity are a portrait of a Neoplatonic philosopher of the fifth century AD and a marble throne of the second century AD, which was used as an episcopal throne when the Parthenon became a church.

141

142

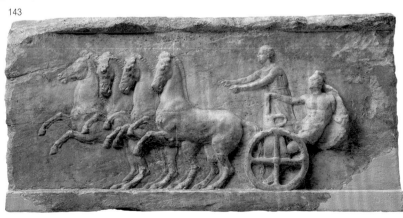

143

141. Part of a relief with representation of the sacred ship of the Athenians, the *Paralos* (late 5th c. BC).

142-143. Two pedestals of *ex-votos*, with relief representations of contests of the Panathenaia, the *pyrrhichios* dance in which competitors were armed, and the *apobates* race in which contestants mounted and dismounted a moving chariot, which reflects a scene on the Parthenon frieze.

144. Marble sphere with representation of the god Helios and unintelligible magical symbols, which was found in the theatre of Dionysos (2nd-3rd c. AD).

145. 3-D model of the Acropolis in the second century AD, from the southwest. On the top of the rock there were no major changes from Classical times. However, on the south slope and to the west of the Dionysiac theatre a long stoa was built in the first half of the second century BC. Gift of the king of Pergamon Eumenes II, this was intended to protect spectators at the theatre in the event of bad weather. Even further west (in the foreground), the Odeum named after its donor, the wealthy magnate and sophist Herodes Atticus, was built in AD 160, in order to house the music contests of the Panathenaia.

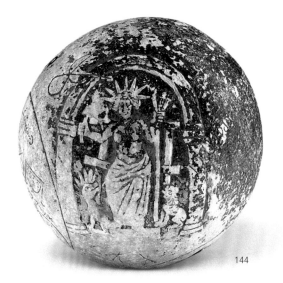

144

145

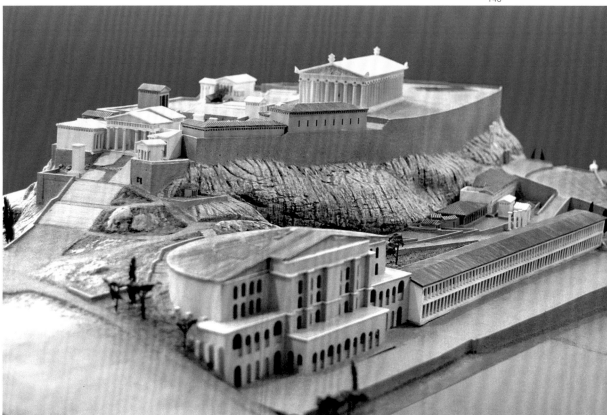

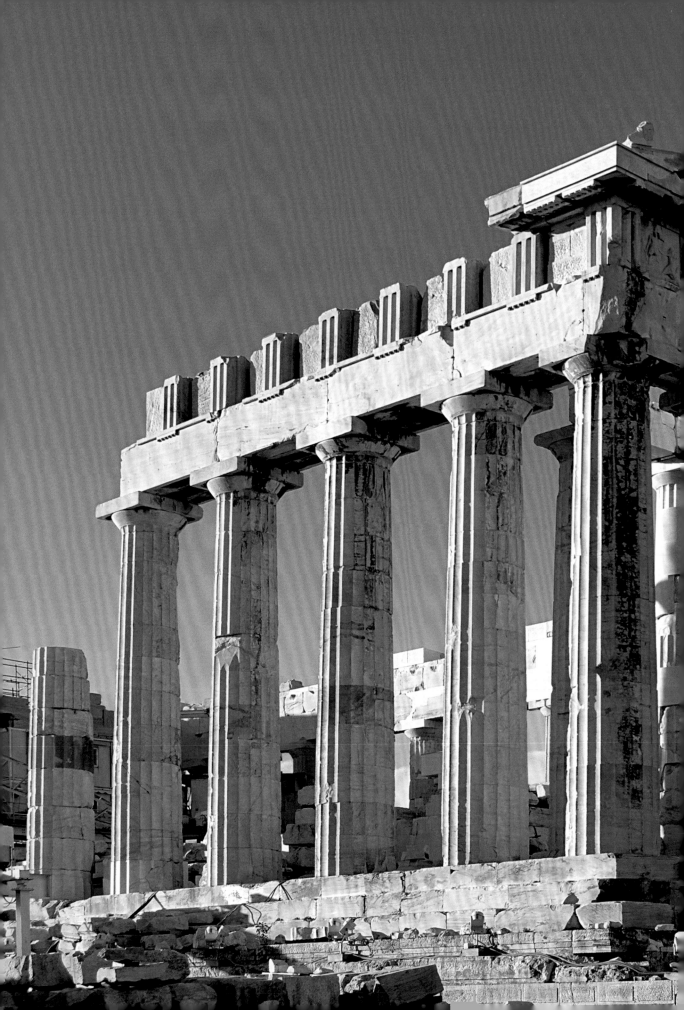

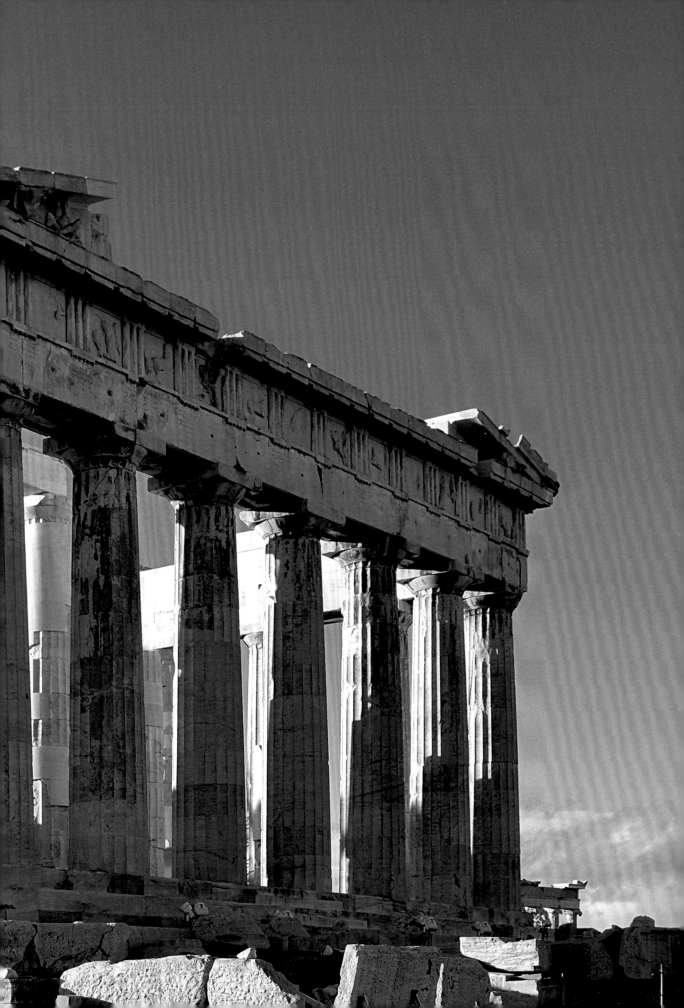

THE PARTHENON

The Parthenon, the temple of Athena Parthenos, is the culminating achievement of ancient Greek architecture, the quintessential work of the so-called 'golden age of Pericles' and one of the most perfect creations of mankind. This axiomatic opinion is based on three ascertainments: (a) the historical and political circumstances in Athens in the period of its creation, (b) its particular architectural features, and (c) its sculptural decoration and the messages this transmitted and transmits.

Historical and political context

The Parthenon is the most characteristic monument of Classical civilization, since it is linked inextricably with the period and the conditions in which it was created. This was a period during which the democratic regime, the enthusiasm and the vision of an entire people for creativity after the victorious wars, the presence of worthy leaders and the abundant economic means all coincided, and in which inspired artists coexisted with excellent artisans.

The project, like all the great achievements of that half-century, is usually accredited to the city's great leader, Pericles. He was, of course, the last link in **a chain of great leaders**, which includes Solon, Peisistratos, Kleisthenes, Themistocles, Aristeides and Kimon. Without these men's contribution to consolidating the power of Athens and the establishing of the First Athenian League, these works would never have been achieved or would not have been realized with the same result.

Despite Thucydides' adage on a government ruled by its leading citizen ἑνὸς

ἀνδρὸς ἀρχή, in that period of the Athenian Democracy, everything relating to the implementation of the Periclean building programme had to conform to the laws and the rules of the Athenian State. So, after Pericles' proposal was approved – not without difficulties – by the Athenian people in the public assembly (*ekklesia* of the *demos*), **Iktinos** and **Kallikrates** were appointed as architects of the temple, while the general supervision of the project was entrusted to Pericles' friend, the **sculptor Pheidias**, who also undertook the creation of the chryselephantine statue of Athena, which would be placed inside the new temple.

Pheidias was already an esteemed artist who, around 460 BC, had executed successfully two major state commissions to commemorate the victory at Marathon: one was the colossal bronze statue of

146. View of the southeast corner of the Parthenon. The Pentelic marble of which it is constructed has a golden hue, due to inclusions of iron oxides and the colours of the setting sun.

147. The Parthenon from the northwest, as it was in the years just after the liberation of Greece. The houses in the Turkish quarter have been demolished but the Muslim mosque is still there in its interior. Watercolour by J.J. Wolfensberger, 1834. Moscow, Pushkin Museum.

147

The impressions of an ancient visitor

The second-century AD philosopher and author Plutarch, in his book on the life of Pericles (*Parallel Lives*, 12-13), describes the creation of the works as follows: '*So then the works arose, no less towering in their grandeur than inimitable in the grace of their outlines, since the workmen eagerly strove to surpass themselves in the beauty of their handicraft. ... For this reason are the works of Pericles all the more to be wondered at; they were created in a short time for all time. Each one of them, in its beauty, was even then and at once antique; but in the freshness of its vigour it is, even to the present day, recent and newly wrought. Such is the bloom of perpetual newness, as it were, upon these works of his, which makes them ever to look untouched by time, as though the unfaltering breath of an ageless spirit has been infused into them*'.

Plutarch saw the monuments some 550 years after they were finished!

148. Part of an inscribed stele with the expenses of constructing the Parthenon in 434/3 BC. Recorded first are the revenues, which consist of: (a) money carried over from the previous year, (b) the State endowment for the specific year and (c) income from the sale of surplus gold and ivory, obviously from the chryselephantine statue of Athena. These are followed by the outlays for purchasing materials, wages, transportation costs from Pentele and sculptors' fees for the pedimental statues. Athens, Epigraphical Museum.

149. Graphic reconstruction of the Parthenon from the northwest corner, with re-composition of its architecture, sculpture and coloration. The image should be considered quite close to the aspect of the temple on the day of its consecration (drawing A. Orlandos - P. Connolly).

148

Athena Promachos, referred to above (pp. 60-61), and the other was the many-figured sculptural group at Delphi, consisting of 13 statues (10 eponymous heroes, Athena, Apollo, Miltiades, fig. 137).

Financial management of the project was overseen by superintendents (*epistatai*), who served for one year and were accountable to the *ekklesia* of the *demos*. Following the specifications, they were responsible for purchasing the materials, paying the daily wages and disbursing all expenses. At the end of their term of service, they handed over the treasury to their successors and inscribed on marble stelai the works carried out and the expenditures made during their tenure, as well as the amount of money in credit.

These stelai were set up on the Acropolis for all to see, so that anyone could monitor the management of public funds (fig. 148). On the basis of these inscriptions, one of which is exhibited in the well-lit antechamber on the third floor of the

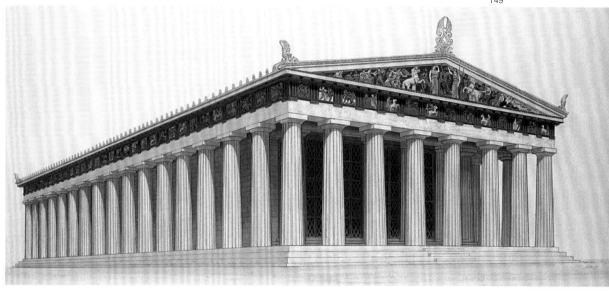

149

museum, it is known that works on the Parthenon began in 447 BC, with the cutting of the first blocks of marble in the Pentele quarry, and that within a period of 10 years the building had been finished, while by 433/2 BC the entire sculpted decoration had been put in place.

It is estimated that about **500-600 skilled labourers** were employed on preparing and transporting the materials, while 150 stone-cutters must have worked on the final dressing and carving of the marble, and some 50 sculptors of various abilities on the sculpted decoration. In general, this was a project in which a great many Athenian citizens toiled body and soul, along with numerous metics, several of whom were artists, and an unspecified number of slaves, either public, who were State property, or private, who helped their masters in their tasks in various ways. It has been speculated that one of those who worked on the Parthenon may have been **Socrates**, who was born *ca* 470 BC

and as a young man had practised his father's trade, that of stone-cutter!

Remarkable, judging by the result, is the high standard of management for a project of this magnitude. The number of specialties, work teams and individuals involved, the fast pace of construction, as well as the final quality of the work, all presuppose perfect organization, flawless coordination and excellent collaboration, which began with the creators themselves and ended at the humblest slave making, for example, ropes for the hoists.

So, the Parthenon is a major work which, in contrast to such works of other ancient civilizations, neither served the glory of the ruler nor was decided upon by him and executed slavishly by his subjects. It is a work that emerged from the common will and decision of all the citizens, who played a conscious and active role in bringing it to fruition, since its aim was to praise and promote the achievements of the State, that is, of the Athenian people as a whole.

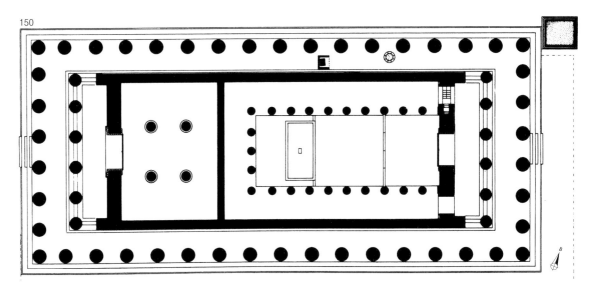

Architectural features

The Parthenon is a Doric peripteral octastyle temple, which has 8 columns on front and back, and 17 on the two long sides. It has too an amphiprostyle hexastyle cella, which means that in front of the cella there is a pronaos and at the back an opisthodomos, each with 6 columns. The size of the temple and the number of columns were the result of a decision to reuse the ready infrastructure and material of the **Preparthenon**, the temple that the Athenians had started to build on the same spot, after the battle of Marathon (490 BC), and which, unfinished, was destroyed by the Persians in 480 BC.

The cella of the Parthenon, that is, the interior of the temple, was divided into two unequal parts (fig. 150), consistent with a long tradition for the temples on the Acropolis. Inside the east and bigger part was a two-tier colonnade of Π-shaped plan, which surrounded the statue of Athena Parthenos. The width of this part, almost 20 m., was unprecedented for the time and has been explained as due to the initiative of

Pheidias, who wished to ensure a spacious setting to enhance his great masterpiece, the ivory-and-gold statue of Athena. In order to illumine the statue, for the first time in a temple two windows were opened on either side of the doorway (fig. 152).

The west part of the cella was accessible only from the opisthodomos and had 4 tall Ionic columns upholding the roof. Thus, the Parthenon had a total of **108 columns** of five different heights, of which 4 Ionic ones were isolated in the west part of the cella (fig. 151). This was intended for the safekeeping of precious votive offerings to the goddess, which were part of the public treasury. In epigraphic lists surviving from the period 434 BC to *ca* 300 BC, scores of gold wreaths, items of jewellery, weapons, vases and precious pieces of furniture are recorded, all with their value.

The Parthenon is one of the largest Classical temples. It is 69.50 m. long and 30.88 m. wide, which means that it occupies an area of over 0.02 ha., and **is built of 16,500 architectural members** of assorted sizes: from enormous epistyles of length

4.30 m. and weight 5-10 tonnes to the 9,000 marble roof tiles.

These stones were extracted from the marble quarries on Mount Pentele, where the preliminary roughing out of their shape also took place. Then, they were transported on carts to Athens, where they were perhaps trimmed a little more, so as to lighten them to facilitate getting them up to the Rock, via the ramp of the Propylaia, without too much effort (fig. 153). One further stage of working took place on the worksite next to the monument, from which, with the help of cranes operated manually by slaves, the stones were hoisted into position and joined to those adjacent to or underlying them (fig. 154). Last, the finishing touches, such as fluting the column drums and adjusting the surfaces of the rest of the parts, were made using the appropriate tools and emery.

The highly competent stonecutters and craftsmen who carried out these tasks took the standard of marble-working to new heights. The air-tight joins and the perfect fit of the different members with each other, as well as the absolute precision and

151

152

150. Plan of the Parthenon. Noted in the middle of the north pteron are the remnants of an earlier little temple of Athena Ergane (?), which was incorporated in the new building. Outside the northeast corner stands the pedestal that held the *quadriga* of Attalos II (see fig. 106) (drawing M. Korres).

151. Perspective reconstruction of the Parthenon proper, that is the room at the back of the temple, the roof of which was upheld by four soaring Ionic columns. The space was intended for the safekeeping of the public treasury, as well as of precious votive offerings to the goddess. The treasury of the Athenian League, which had been transferred from Delos in 454 BC, was housed here too (drawing I. Gelbrich).

152. Perspective reconstruction of the pronaos of the Parthenon, showing the open doorway of the cella, one of the windows admitting light to its interior, as well as the position of the frieze above the hexastyle prostasis (drawing M. Korres).

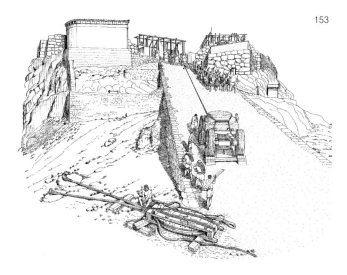

153-155. Graphic reconstruction of three phases in the construction of the Parthenon (drawing M. Korres):

(153) The ascent to the Acropolis as it was in the early fifth century BC and the method of taking up heavy architectural members on an ox-drawn cart.

(154) The lifting device used for placing the architectural members in their final position.

(155) The way in which Pheidias designed the frieze.

156-157. Graphic reconstructions of the two fronts of the Parthenon, enhancing the sculptural decoration of pediments and metopes. The intercolumniations of the hexastyle prostaseis were closed with railings, because the city's treasury was kept in the opisthodomos of the temple (drawing A. Orlandos).

154

155

meticulous detail, even on parts of the building not seen, resulted in the final appearance of the monument being unsurpassed in this respect.

However, what makes the Parthenon unique are two special qualities: one is its **eumetry** (harmonious proportions), that is, the image the visitor passing through the Propylaia has today on beholding it for the first time and apprehending the balanced relationship between its three dimensions (fig. 160). Furthermore, a ratio of 9:4, which is considered a relation of internal harmony, exists in many individual features of the temple, such as the ratio of length to width of the stylobate, of the length of the narrow sides to their height, as well as of the intercolumniation between the two middle columns to their lower diameter.

The other quality that distinguishes the Parthenon is its **refinements**, the name given to the subtle and imperceptible deviations from regularity, mainly curvatures of the horizontal surfaces and inclines of the vertical members. Truly, there is not one straight line or one flat surface in the edifice (fig. 158).

157

The curvatures commence at the temple's stylobate, which curves gradually along the length of all four sides, as a result of which the midpoint of the long sides is 0.11 m. higher than the corners and the midpoint of the narrow sides 0.07 m. The slight curvatures of the surfaces of the stylobate are followed by corresponding curvatures of all the horizontal members of the entablature (epistyle, frieze, cornices), on all four sides, and indeed not only on the peristasis but also on the walls of the cella.

This phenomenon can, of course, be seen on the monument itself, but it is detectable too in the museum exhibit, if we look carefully at the end of the west frieze, which survives *in toto* and has been fully restored.

Similar deviations are observed in the Doric columns, a phenomenon much older than the Parthenon. The columns are not regular cylinders but display diminution (meiosis) from the lower part upwards, but not uniformly as at about 2/5 of their height they swell slightly (entasis) and then taper

158

159

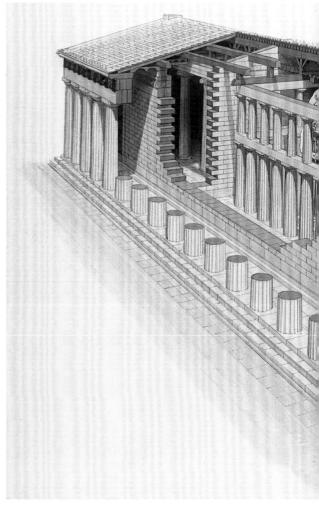

158. Simplified linear reconstruction of a Doric temple, exaggerating for the sake of clarity its distinctive architectural features. Many of the curvatures and the refinements had been achieved by ancient Greek architecture of earlier periods, but in the Parthenon they found their ideal expression (drawing J.J. Coulton).

159. Graphic reconstruction of the Parthenon in partial cross-section from the southeast corner, in order to reveal all the architectural and sculptural features in its interior. To the right are the altar of Athena and the Erechtheion (drawing P. Connolly).

160. View of the Parthenon from the northwest corner, indicating clearly the metrical harmony of the edifice, that is the balanced relationship between its three dimensions, length, width and height.

gradually up to the capital. Moreover, the columns do not stand vertically on the stylobate but incline slightly inwards, while the corner columns have a double inclination. These corner columns are in fact 2.5% larger in diameter than the other columns. Last, the distances between the columns are not equal; the columns near the corners are closer together, while the central ones are further apart, which phenomenon is known conventionally as 'pacing'.

It is improbable that this entire nexus of features, invisible on first glance, was of the nature of visual adjustments or a way of neutralizing optical illusion, as had been assumed from Late Antiquity. It is actually a **recondite mesh** enclosing the entire building, even its least accessible parts, and was created deliberately in order to serve purely aesthetic aims. It was intended to insufflate the pulse of life and movement into the monument, to unfetter it from static rigidity, imparting a **covert harmony,** which,

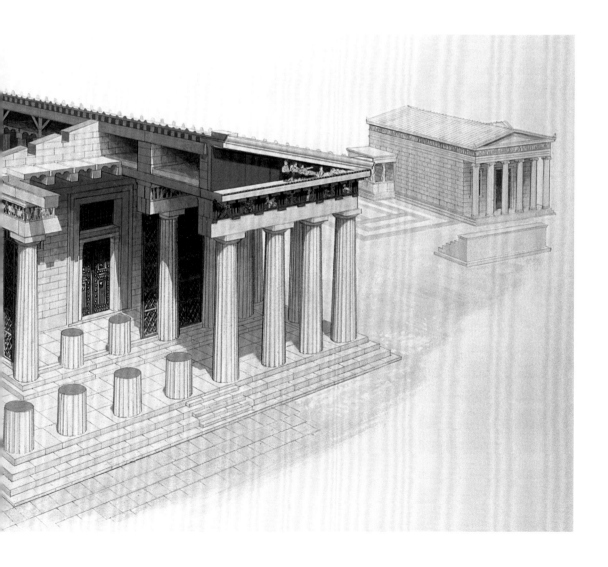

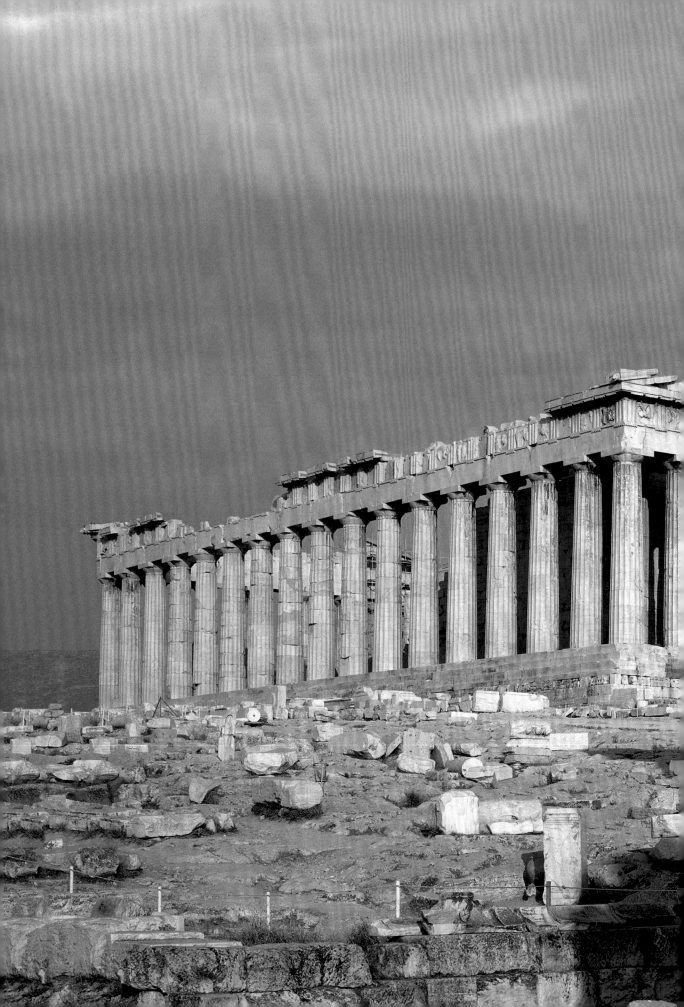

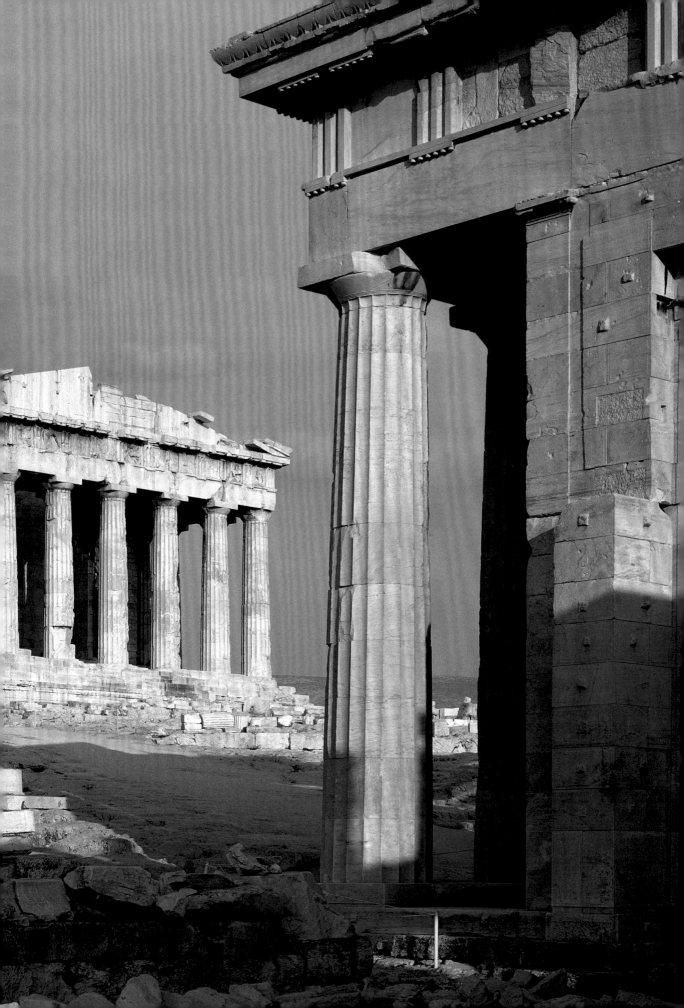

161. View of the inside of the Acropolis from the Propylaia. The ancient Greeks did not have a full picture of the Parthenon as we have today, due to the presence of the enclosure and the propylon of the sanctuary of Artemis Brauronia (drawing G.P. Stevens).

162. Reconstruction of the west (back) face of the Parthenon. In front and upon the rock-cut steps there was a large number of *ex-votos* and statues, the form and position of which is known from the description by the second-century AD traveller Pausanias (drawing G.P. Stevens).

161

according to Herakleitos, was more important than the overt. These contrivances mean that no two stones are exactly alike, even those adjacent to or overlying each other, which fact demanded a remarkable level of planning and execution. They bespeak, of course, a formidable level of mathematical knowledge, as well as the aesthetic demands of the people of the period. Because we cannot accept that they were applied only to satisfy the needs of the monument's creators. Everything must have served also the aesthetic demands of an entire society, to which, in the last analysis, the monument was addressed.

THE SCULPTED DECORATION

The sculpted decoration of ancient Greek temples had a threefold purpose:
(a) religious-cultic, since it usually narrated episodes from the life and feats of the worshipped god, with the aim of reinforcing people's faith, (b) decorative, since it adorned architectural surfaces and points that would otherwise have remained almost unseen, thus upgrading the aesthetic value of the building, (c) political-ideological, since the mythological subjects of the sculpted decoration were often symbolic, in that they were paralleled with significant historical

162

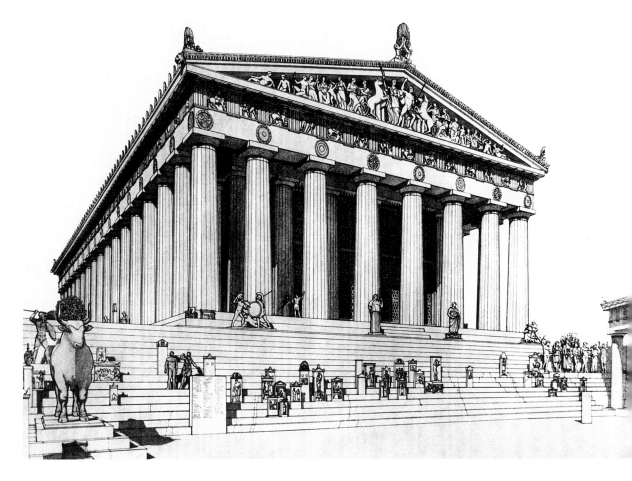

events in the city, thus strengthening the dissemination of its political ideology.

The sculpted decoration of the Parthenon is equal in quantity, quality and content to the architecture of the temple, thus complementing and completing the ambitious project of Pericles and his collaborators. **Pheidias** was responsible for the planning and the overall supervision of the programme but many sculptors collaborated on its execution, among them some of his best pupils. He may have worked personally only until 438 BC, since after that date he went to Olympia to create there the chryselephantine statue of Zeus.

All the possibilities the monument offered

for decoration were exhausted, as the two pediments, the 92 metopes and the 160-metre long frieze were adorned with sculptures. The time sequence in which these works were created can be deduced not only from the sequence of the building of the parts of the temple, but also by drawing information from the inscriptions recording the expenses of its construction (fig. 148). Work on the columns continued until 442 BC, consequently the metopes were put in position a little later, although carving of them in the workshop had started earlier. Since the blocks of the frieze were building material, this must have been put in place before 438 BC, when the temple

was inaugurated. It seems, however, that carving of the reliefs continued and was completed upon the monument. Last, the pedimental figures and the akroteria, which had been prepared in the workshop, were mounted on the monument by 433/2 BC.

The exhibition of the Parthenon sculptures in the Acropolis Museum is innovative in that it combines the authentic marble works or parts of them with plaster casts of those housed in other museums and collections abroad, mainly in the British Museum, where they ended up after their removal from the temple by Lord Elgin in the years 1801-1803. Thus, visitors have the opportunity of seeing, as far as possible, the overall form of the

works, which had been fragmented in the course of the vicissitudes the monument suffered over the centuries. Furthermore, the gallery housing the sculpted decoration has the same dimensions and orientation as the Parthenon, while the direct view of the monument on the Acropolis makes the visit a memorable experience.

163. The west part of the Parthenon gallery, with the image of the sculptures of the west pediment and the west frieze. Above left, the last two metopes of the north side, with pairs of gods watching the Sack of Troy: on the left metope is Zeus seated with winged Iris in front of him, and on the right one Hebe stands in front of seated Hera.

163

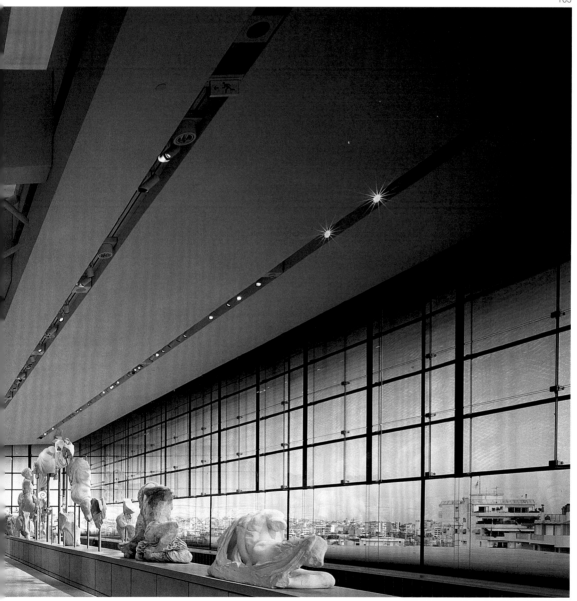

164. The north end of the west entablature of the Parthenon. On the pediment, the sculptural group of Kekrops with his daughter. On the metopes, scenes from the Amazonomachy. In the background, part of the west frieze with the horsemen of the Panathenaic procession.

165. The east façade of the Parthenon, where the main entrance was situated. The recently completed restoration of this side protected the monument from earlier damage, filled in small missing parts and finished the cleaning of the surfaces, thus improving considerably the temple's external appearance.

164

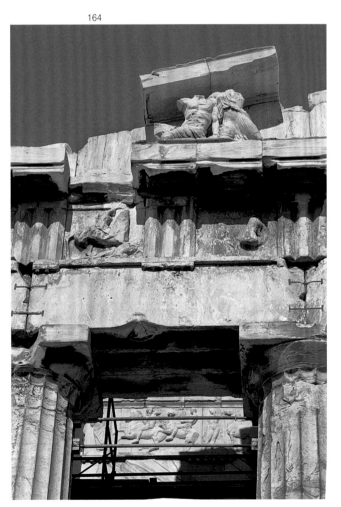

The metopes

Unprecedented for a Greek temple is the fact that all 92 of the Parthenon's metopes (14 on each of the narrow sides and 32 on each of the long sides) were decorated with reliefs. Developed on each side is a mythical struggle, a conflict. Despite their differences, the metopes are interlinked in their meaning. Thus, on the east side, above the entrance to the temple, is the **Gigantomachy**, the battle between the Olympian gods and the Giants who doubted and challenged their sovereignty. Myth has it that Athena played a crucial role in ensuring that the gods prevailed. Presented here in single episodes are the gods of Olympos (from left to right: Hermes, Dionysos. Ares, Athena, Poseidon, Zeus, Apollo, Aphrodite and Hephaistos), the hero Herakles and the deities Nike and Eros. On the last (right) metope, the chariot of Helios must have appeared, signifying the end of the conflict and the victory of the gods of light (fig. 204). Represented on the west side is the **Amazonomachy**, a mythical battle between Greeks and Amazons, in which the Athenian hero Theseus played an important part. Of the north long side of the temple were scenes from the Sack of Troy, the Greeks' first victory over the Asians, with emphasis placed on the presence of Athena, the Athenian heroes Demophon and Akamas, sons of Theseus, as well as of the palladium, the wooden effigy of Athena that was in Troy. This series of metopes, like that on the east pediment, was flanked by the chariots of Helios and Selene. On the south side unfolds the **Centauromachy**, the

battle between the mythical Thessalian tribe of the Lapiths and the Centaurs, hybrid creatures, half man and half horse. Guests at the wedding of the Lapith king Perithos, the Centaurs got drunk and threatened to abduct the Lapith women. In the final victory of the Lapiths, the intervention of Theseus, Perithos' friend, was decisive.

All the metopes of the east and west sides, as well as 12 of the 32 from the north side are exhibited in the museum but are badly damaged because their figures had been deliberately **chipped away**. This action is usually attributed to the Christians, who, during the conversion of the Parthenon into a church, tried to get rid of the pagan 'idols'. A more recent theory attributes the defacement to the Visigoths, led by Alarich, who invaded Athens in AD 396. These fanatical new converts to Christianity and followers of Areius destroyed the metopes and the statues at the centre of the east pediment. For some unknown reason, the metopes of the south side remained unharmed. The middle ones were destroyed in the explosion caused by Morosini in 1687, while the rest were looted by Lord Elgin in 1801-3.

165

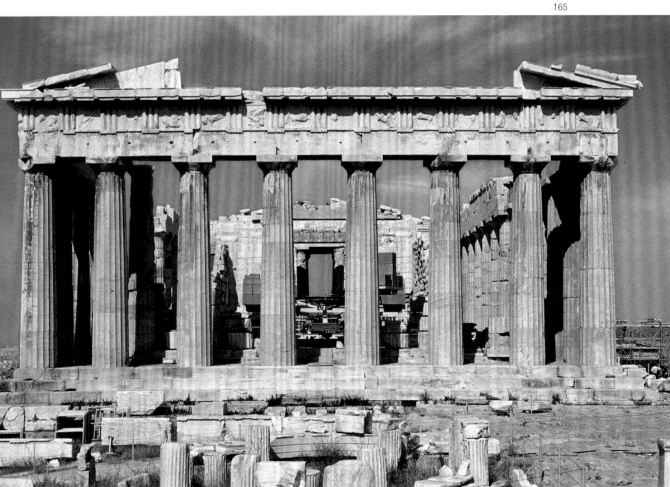

166

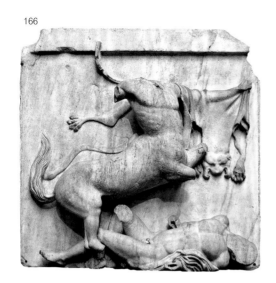

167

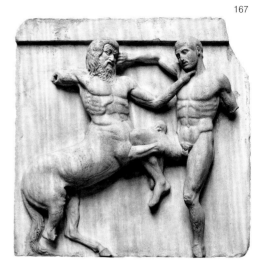

168

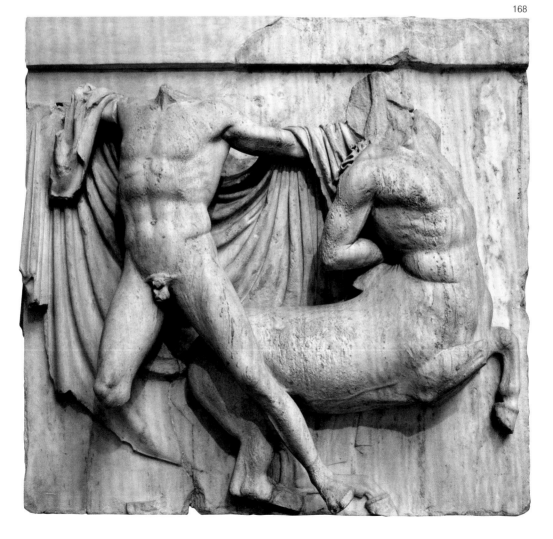

Evident from the extant metopes is the diversity and the differentiation in the arrangement of the two or, very rarely, three figures in the single episodes represented on the rectangular slabs of height 1.20 m. (figs 166-168). That is, despite the strictures of the subject (e.g. the pairs of Centaur-Lapith or Centaur-Lapith Woman are given), the designer has exhausted all possible forms of struggle. Moreover, the stark contrast between the ferocious aspect of the Centaurs and the dignified countenances of the Lapiths succeeds in

166-168. Three of the metopes from the south side of the Parthenon (nos 28, 31, 27), with scenes from the Centauromachy. It is only from the metopes of this side that the quality of the work can be appreciated, because the metopes on the other sides were hacked and disfigured, probably by the Visigoths under Alarich, who captured Athens in AD 396 and set fire to the Parthenon. London, British Museum.

169. The last metope (no. 32) of the north side, subject of which was the Sack of Troy. It is the only intact metope from this side, perhaps because the representation of standing Hebe (left) in front of seated Hera reminded the fanatical Christians of the iconography of the Annunciation to the Virgin.

169

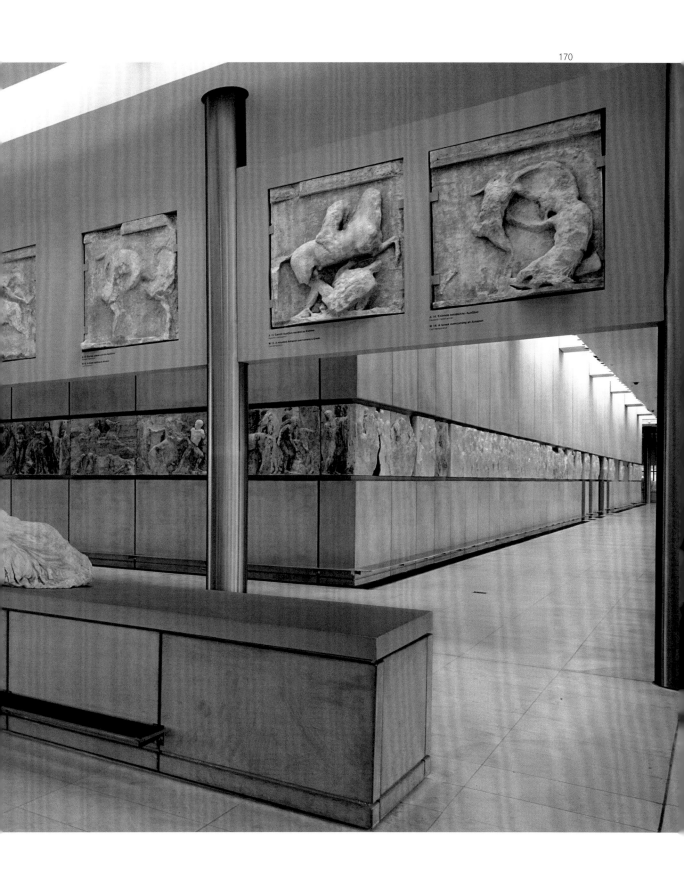

170. The west side of the Parthenon gallery. In the foreground, the original works housed in the museum together with plaster casts of the sculptures of the pediment which are in the British Museum. Above, the metopes with the Amazonomachy, and in the background, the west and the south frieze with the preparation and the progress of the Panathenaic procession.

171

171. The south end of the east entablature of the Parthenon. On the pediment, the heads of the horses of the chariot of Helios and the reclining figure of Dionysos. On the metopes, three episodes from the Gigantomachy. The large holes in the epistyle (under the metopes) were for placing the Persian shields sent by Alexander the Great. The smaller holes (under the triglyphs) were for the letters of the inscription honouring Nero, which was put up in AD 61/2.

172. The west side of the Parthenon photographed from an angle at which its three successive levels are visible: First, the external columns with the entablature, on which the destroyed metopes of the Amazonomachy can be discerned. Further in, the prostasis of the opisthonaos, on which is the west frieze with the preparation of the Panathenaic procession. On the third level, the wall of the cella of the temple, with the large portal of the Parthenon proper.

transforming a violent quarrel of drunkards into a noble struggle between civilized people and barbarians. However, what is striking in all the representations on the metopes, excepting the Gigantomachy on the east side, is the fact that nowhere is the victor clearly seen. In these scenes the struggle is still in progress, which is consistent with the Athenians' view in that period that victory is temporary and transient. Therefore the victor, whether a person or the entire city, should be circumspect, because on the one hand victory invariably leads to arrogance, and on the other the victor can easily be found defeated. It goes without saying that the way in which the Athenians read the metopes in 431 BC will have been different from how they read them in 404 BC. All these views alluded to here are known to us better through the erudite and didactic works of the great tragic poets, which were performed in the same period in the theatre of Dionysos, which too was reconstructed under the auspices of Pericles.

In general, the mythical conflicts on the metopes of all four sides of the temple have been interpreted as an **allegory of the clash between the Greeks and the Persians**. Because ancient Greek art avoided representing historical events, these were presented symbolically, with mythical parables and allegories. Exactly as in the tragedies, deliberation on problems of the period is expressed through tales of the heroes of the mythical past. In other words, we have a paralleling of historical battles with mythical ones, and therefore a correlation of their historical weight and importance. Specifically, the Gigantomachy

symbolized the consolidation of universal order, while the Centauromachy denoted the punishment of the barbarians' hubris. The Amazonomachy on the west side is considered a mythical parallel of the battle of Marathon and symbolized the defence of the city against foreign invaders. In general, the pairs of opponents on the metopes are, on the one hand, barbarians, foreigners, invaders, claimants (Giants, Amazons, Centaurs, Trojans), and on the other, gods, Greeks, Athenians, civilized men. That is, we could see here an artistic symbolism of the eternal opposition between the forces of light and civilization, and those of darkness and barbarity.

172

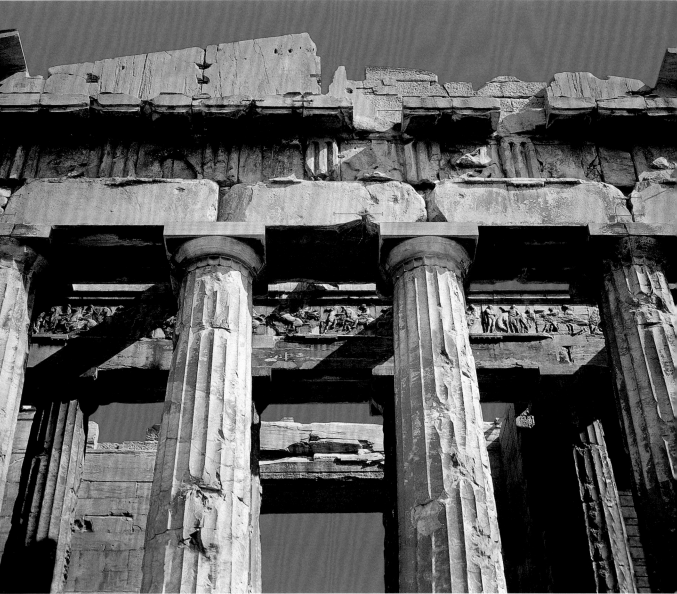

The frieze

The Parthenon frieze, of total length 160 m.
and approximate height 1 m., comprises
115 stone blocks. It differs from the rest of
the temple's sculpted decoration in terms of
its subject. Depicted here is an actual event,
the **procession of the Panathenaia**, the
city's greatest festival, which was celebrated
every four years in honour of the patron
goddess Athena. This was a very ancient
festival, which was renewed in 566/5 BC and
in addition to its cultic character was initially
a means of incorporating all the citizens of
Attica in the Athenian State. The whole
population of Athens, men, women and
children, participated in the Panathenaic
procession, which set off from the
Kerameikos and terminated at the altar
of Athena on the summit of the Acropolis
(fig. 107). Everyone followed the priests and
the archons, who were accompanying the
new peplos embellished with scenes of
Gigantomachy, which was to be placed
on the very ancient cult statue of Athena
Polias in the Erechtheion. The renewal of
the peplos every four years was a ritual act
with magical roots lost in the mists of time,
through which the ancient Greeks believed
that their city would be renewed and
strengthened with new powers.

173. Block XXXIV of the north frieze, with two horsemen,
three horses and a master of ceremonies (*teletarches*) who
turns backwards. The most splendid event in the Panathenaia
festival, the procession, is depicted on the Parthenon frieze,
with men, animals and gods in harmonious coexistence.

174-177. Full drawings of the surviving parts of the Parthenon
frieze, which are displayed in the Acropolis Museum and
various foreign museums, mainly the British Museum
(drawings E. Berger).

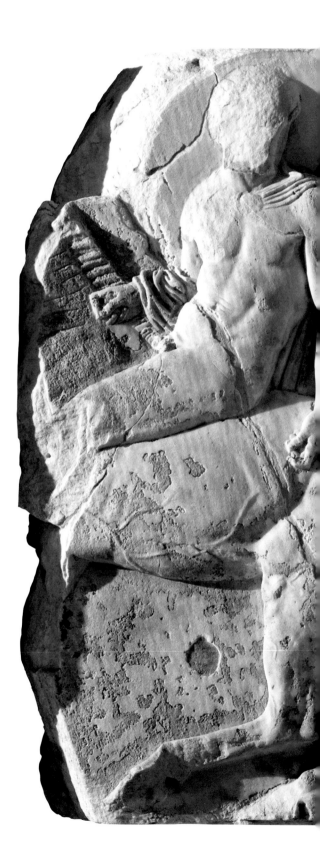

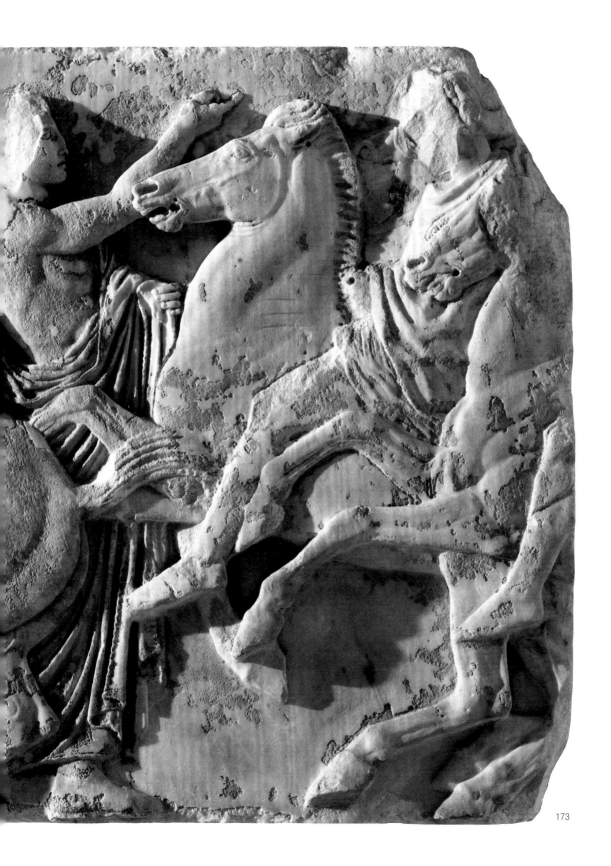

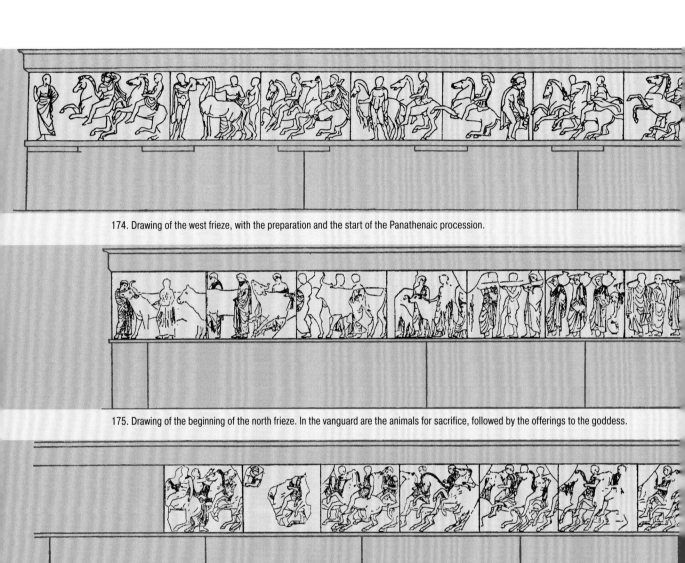

174. Drawing of the west frieze, with the preparation and the start of the Panathenaic procession.

175. Drawing of the beginning of the north frieze. In the vanguard are the animals for sacrifice, followed by the offerings to the goddess.

176. Drawing of the end of the north frieze. The squads of the Athenian cavalry in lively gallop.

177. Drawing of the east frieze, with its two parts approaching the middle, where, in the sight of the gods, the ritual of delivering the peplos of Athena t

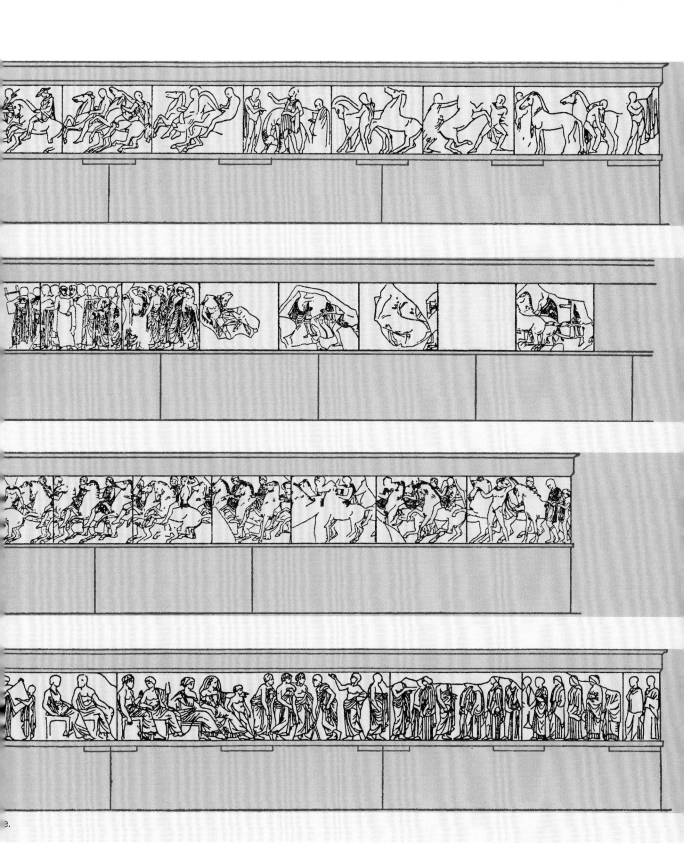

3.

124

The frieze presents three stages of the procession, in an idealized rather than a realistic depiction. To this end, 378 human figures are deployed and over 220 animals, primarily horses. On **the west side** is the preparation and the formation of the procession, which, according to one proposal, includes also the *dokimasia*, the official inspection of the battle-worthiness of the Athenian cavalry, which is mentioned by Aristotle in the *Athenian Constitution*.

Represented at the start of the procession are 26 horsemen, horses and pedestrians in various poses and movements, as well as intimate moments such as conversations, stroking the horses, and so on, which convey the atmosphere of getting ready for the event. The most impressive scene is in the middle of the west side, where one horseman, stepping forcefully on a rock, tries to hold in check his startled steed (figs 181-182).

On the two long sides, **the north** and **the south**, is the full unfolding of the procession with the **horsemen and the chariots**, which occupy 70% of the frieze's length (figs 176, 178).

The horsemen and chariots on the north side move to the left, while those on the south, where there are the most gaps because blocks were destroyed in the explosion caused by Morosini's

178

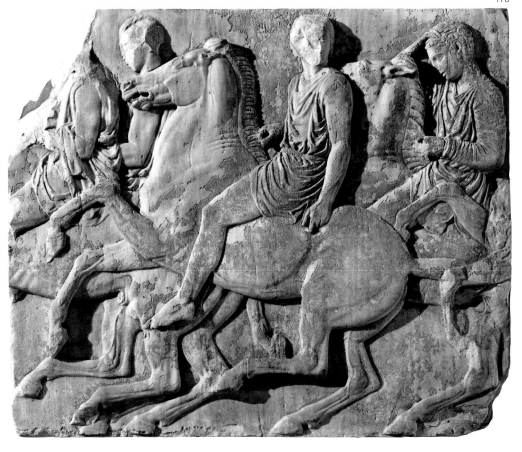

bombardment, are directed rightwards. The organization of the scenes is similar on both sides and they are almost mirror images. The representations begin with a procession of 60 horsemen in diverse compositions and movements. In about the middle are the scenes with one of the most popular contests of the Panathenaia, the *apobates* race, a chariot race held in the Agora (fig. 179). The *apobatai* (11 on the north side and 10 on the south), armed with helmet and shield, leapt on and off a moving chariot, driven by a charioteer. This is a purely local contest, characteristic of Athenian identity, which is why it was shown in such a conspicuous position on the Parthenon frieze.

178. Block XXXVI of the north frieze: Four horsemen cantering to the left, with the legs of men and animals rhythmically superimposed. Despite the density of the figures, nowhere on the frieze is crowding or confusion observed.

179. Block XXIII of the north frieze, with scene of the *apobates* contest. Left, the back of the chariot, from which the *apobates* is about to dismount. Beside him, the charioteer concentrates on handling his horses with the reins. Right, a master of ceremonies (*teletarches*), in a superb chiastic movement, gives instructions to the followers by gesturing with his hands.

180. Block IX of the west frieze, with two of the horsemen in trot. The variety of the figures, the poses and the gestures of all the participants in the procession, who are depicted on the Parthenon frieze, is unrivalled.

179

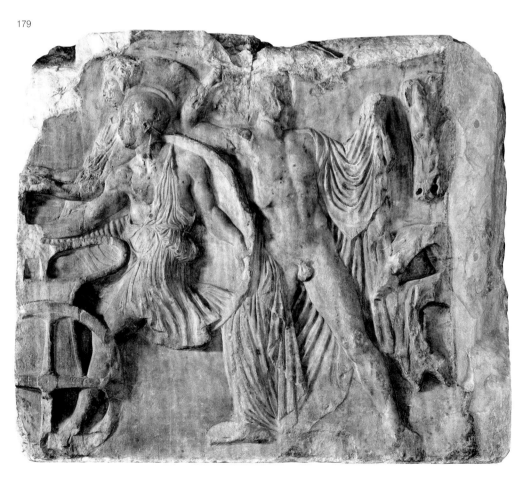

180

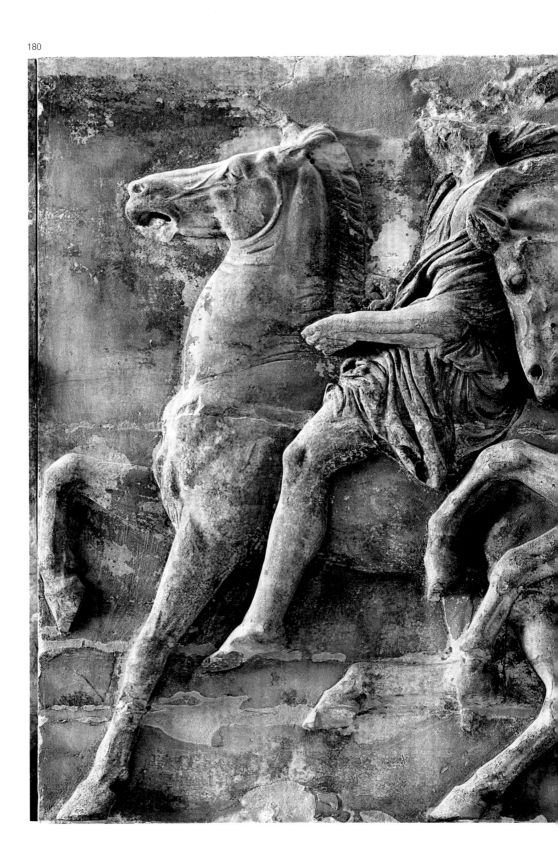

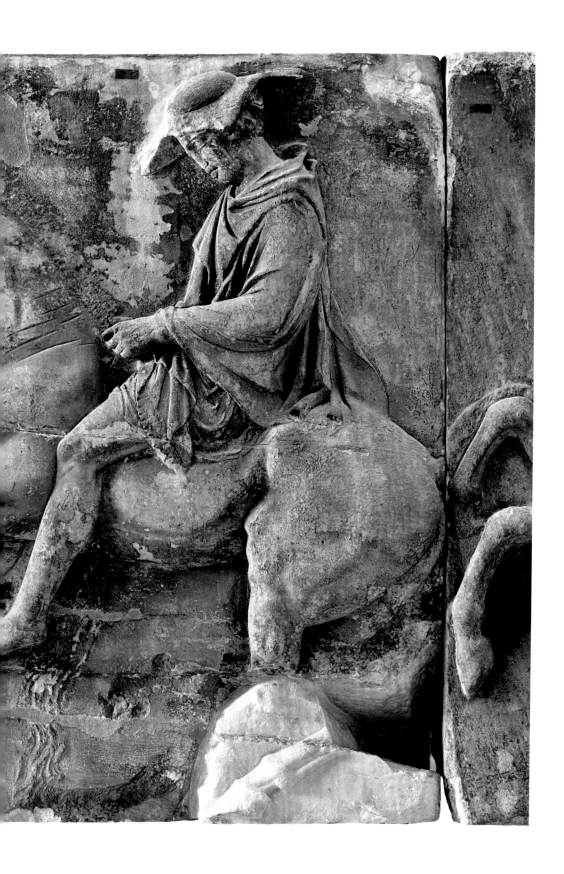

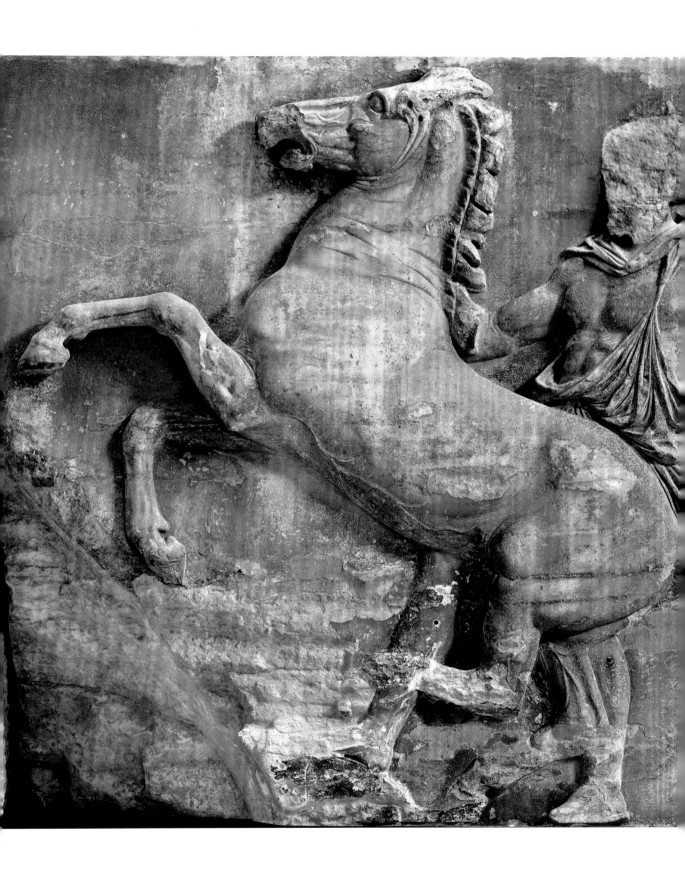

181

182

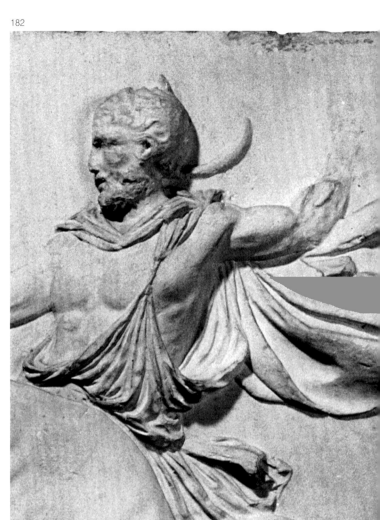

181-182. Block VIII of the west frieze. A horseman, perhaps an officer (hipparch?), tries to keep his startled horse in check. Impressive are the open movements of rider and steed, as well as the flimsy folds of the garments. The head on the original has been destroyed, but the figure is restored from a plaster cast which had been taken in the early nineteenth century for Lord Elgin and is in the British Museum. The replicas of the frieze that are exhibited in the Acropolis Metro station have been made from this cast.

At intervals, the progress is interrupted by dressed male figures, the *teletarchai* (marshals or masters of ceremonies), who stand facing in the opposite direction to the procession and with gestures of the hands regulated its pace (figs 173, 179).

On both the long sides of the frieze, the tension of the chariot race is followed by calmer and more human aspects of the procession, as it nears the east side (figs 175, 183). Immediately after the chariots is a group of mature men (16 on the north side, unknown number on the south), who are referred to as *thallophoroi* because they carry *thalloi* (leafy olive branches) (fig. 184). They converse with one another or turn backwards and are usually considered as officials of the city, mainly *hieropoioi* or *athlothetai*, who were responsible for the organization and the preparation of all the events of the Panathenaia festival.

Particularly interesting is the pronounced presence of animals in the Parthenon frieze, whether the superb horses of the riders and the chariots, or the oxen and the rams for sacrifice.

183

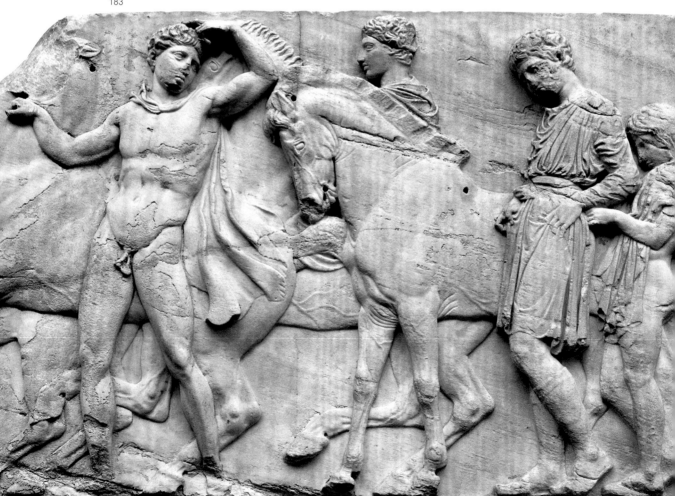

183. Block XLVII (last) of the north frieze, with a moment in the preparation of the Panathenaic procession. Horsemen stand beside their horses, while the slave-boy on the right ties the belt or tidies the garment of his master. Noteworthy is the frontal rendering of the naked body of the figure on the left. London, British Museum.

184. Block X of the north frieze, with six of the so-called branch-bearers (*thallophoroi*), mature men who are interpreted as elders or officials. They are relaxed, conversing with one another and turning backwards, awaiting the rest of the procession.

184

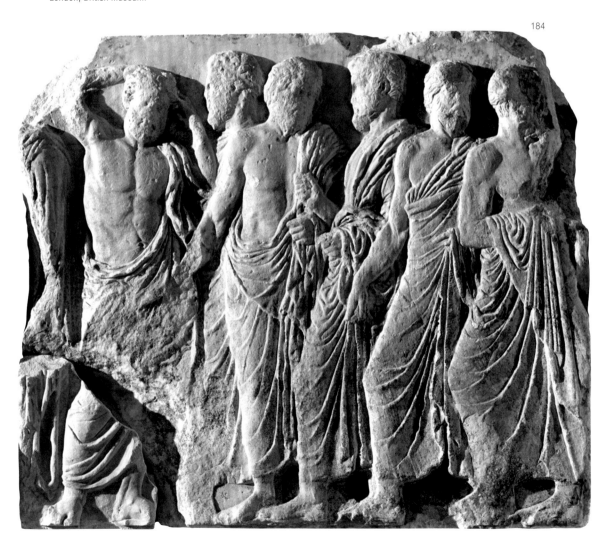

185. Block II of the north frieze, with three youths driving two of the oxen for the sacrifice. The second ox is unsettled and with its raised head lets out a moo.

186. On block IV of the north frieze, badly eroded, the presentation of the sacrificial animals continues. Preserved are three rams, led by young men. On the right, one more male figure, dressed in a himation, whose pose opposite to the course of the procession indicates that he is yet another *teletarches*, who separates the section with the sacrificial animals from the group of youths with offerings, which follows.

This denotes first of all the special role of animals in the early agricultural and stock-raising societies, as well as their special role in the ancient celebratory and cultic practice. However, in the artistic expression of the frieze, and mainly on the west, north and south sides, animals participate on an equal footing with humans, both numerically and as complementary components of the messages of the splendour and power that the Athenian State desired to transmit.

Characteristic too are the relations between men and animals. In parallel with the movements and actions of dominance and

185

submission, addressed mainly to animals that misbehave, there are also several expressions of tenderness, in gestures and gazes of riders to their horses, as well as to the animals destined for sacrifice.

Among the essential elements of the processional process were the musicians, mainly *kithara*-players and *aulos*-players, the strains from whose instruments not only set the rhythm of the procession, but also accompanied the sacrifice. The sacrifice is not shown but is implied by the presence here of the sacrificial animals, in all 14 oxen and 4 rams on both sides (figs 185-186).

The sacrifice is accompanied also by water, which is carried in hydrias by four young male *hydriaphoroi* (figs 187-188), as well as by other offerings to the goddess carried in capacious trays (*skaphai*) on the shoulders of the *skaphephoroi*, who were perhaps metics.

On both the long sides, as indeed on the entire frieze, we have the opportunity to admire the faces of the figures, either of the bearded mature men or the beardless youths. Most figures are rendered in profile, but there is also a range of angles to three-quarter pose, while none is shown *en face*, looking at the viewer (fig. 183). Serene and

186

187-188. Block VI of the north frieze, with the pitcher-bearers (*hydriaphoroi*), and right, an enlarged detail of it. The first three figures already carry the hydria on the shoulder, while the fourth figure is about to lift up the vase from the ground. Although the bending figure is secondary and almost hidden behind the shadow of the preceding one, if we look at it closely (fig. 188) we are astonished by the immediacy of the body movement and the vitality of the very lightly carved visage. Next to it, an *aulos*-player provides musical accompaniment for the procession.

dignified, they are unaltered by the force of the movements. All seem to be engrossed in their action, but simultaneously some gazes meet, revealing a literal and metaphorical introspection. As if they are in a virtual state, just as they have been petrified in one of the greatest moments in the history of art.

On the **east side** the procession continues at both ends with the ten eponymous heroes of the Athenian tribes and two groups of females holding sacred vessels (fig. 177).

187

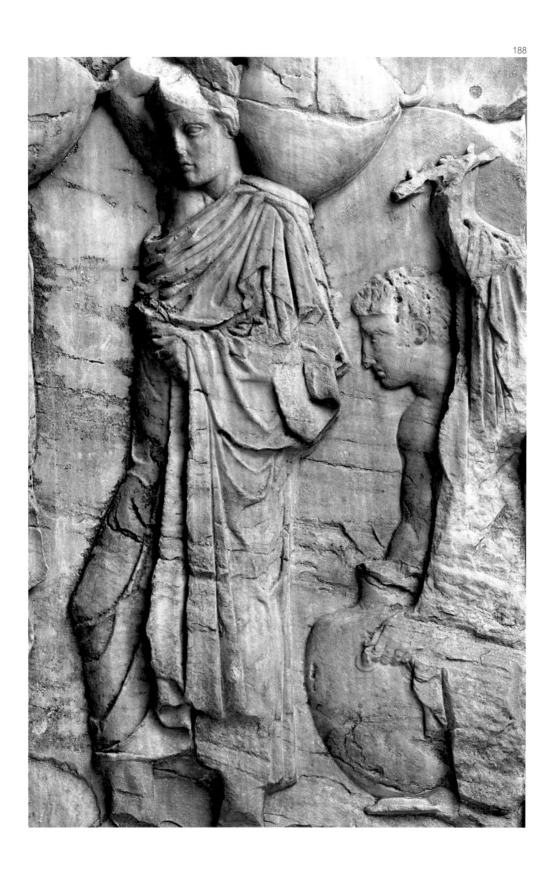

189

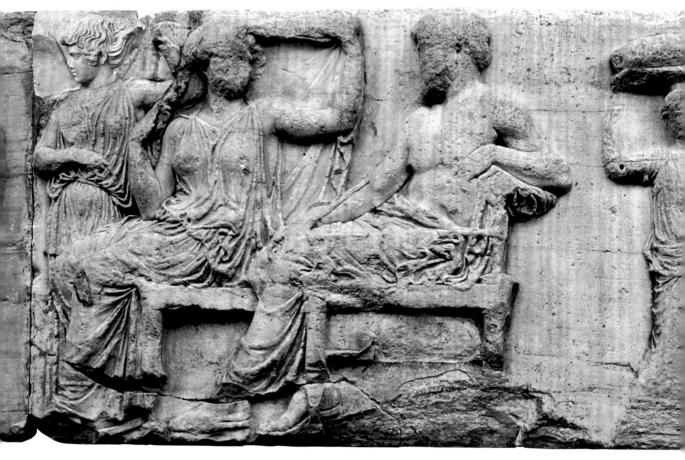

The symbolic meeting of the two parts takes place above the doorway to the temple, with the most important moment of the whole festival: the **handing over of the new peplos of Athena**. The religious archon of the city, the *archon basileus*, and a child have just folded the textile of the peplos, which moment declares the end of the procession and the start of the cultic events on the Sacred Rock. Alongside, two girls, perhaps Arrhephoroi, carry on their heads stools, which will be received by the priestess of Athena (figs 189, 191).

This process takes place in the presence of the Olympian gods, who, divided into two groups, appear to be nonchalantly conversing among themselves. They are represented sitting on stools (*diphroi*), excepting Zeus who is enthroned, their backs turned on the procession, a rendering which perhaps denotes that the gods are sitting in a semicircular formation or that they are invisible to the mortals (fig. 191). On the left are Hermes, Dionysos, Demeter, Ares, Hera (with the small Iris or Hebe) and Zeus. On the right are Athena, Hephaistos, Poseidon conversing with Apollo, Artemis touching the hand of Aphrodite, and little Eros. Thus, the gods closest to the ceremony are Zeus and Athena, the pair occupying the central position also on the east pediment.

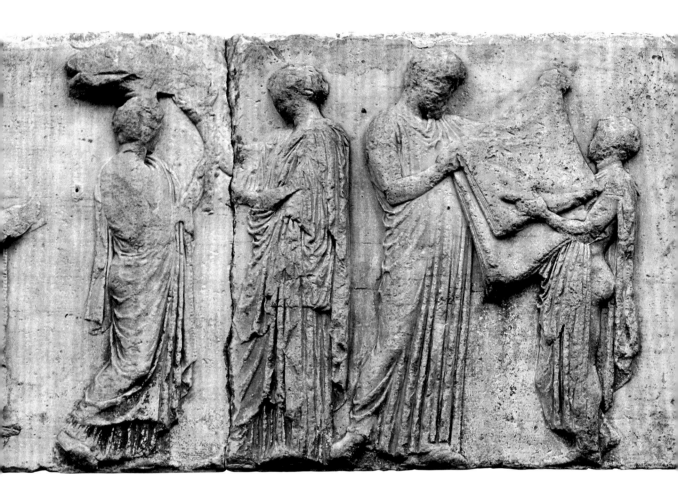

189. Part of block V of the east frieze. Represented sparely on the right part is the most hallowed moment of the festival, the delivery of the new peplos of Athena. A mature man (probably the *archon basileus*, the official responsible for religious affairs) folds the peplos, assisted by a child. Adjacent, a priestess takes a stool from a little girl, a scene difficult to interpret. On the left part, two of the seated 12 gods, Zeus and Hera, with Iris standing in front of her. Block V is in the British Museum and only the head of Iris, which was found later, is in the Acropolis Museum. We observe here the application of the principle of isocephaly, that is, the way in which the ancient Greeks distinguished gods from mortals in the same representation. If they were unable to depict the gods as taller, they rendered them seated – as here – but with their heads at the same height as those of the standing mortals.

190. Part of block VI of the east frieze, one of the best preserved. Three gods, Poseidon, Apollo and Artemis, were distinguished by their now lost attributes. Poseidon held a trident in his raised left hand, Apollo a laurel branch in his left hand, and Artemis a bow in her right hand. London, British Museum.

191. Graphic rendering of blocks IV, V and VI of the east frieze, with the scene of the delivery of the peplos and, on either side of it, two groups of gods. The representations on the frieze link the world of men with the world of the gods and have at once a religious and a political content (drawing M. Korres).

190

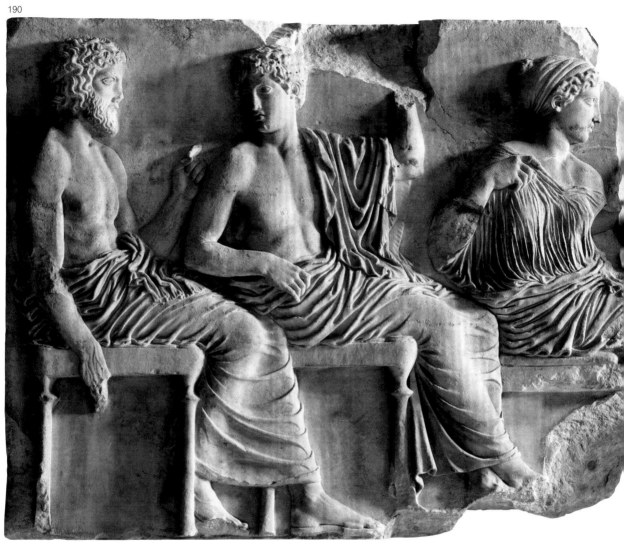

191

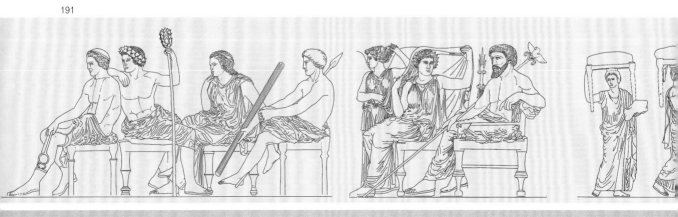

| Hermes | Dionysos | Demeter | Ares | Iris | Hera | Zeus |

The role of the frieze

For the first time in the history of architecture an Ionic frieze was placed inside a Doric temple. As the latest studies by M. Korres have shown, the creators' original intention was to put the usual Doric zone of triglyphs and metopes in this position. However, as the project got underway, the plan changed. A revolutionary change of this kind could only have resulted from the decision of those responsible to expand the iconographic programme of the temple, so as to include the representation of the Panathenaic procession. The decision was taken because this event was for the Athenian State the fullest expression of its religious, political, social and cultural life. And the splendid Pan-athenaia festival could not be omitted from a building that was destined to serve **Athenian political propaganda**. But because there was no other available space on the monument for the representation of the procession, it was decided to transcend established architectural conceptions and to place the frieze, which moreover depicted mortals, in this particular position. Faith in the achievements of the State emboldened those responsible for the Parthenon not only to surpass architectural tradition, but also to overturn traditional iconography, which rendered the relation between gods and mortals.

There where it was finally placed, the continuous zone was never visible in its entirety. It could be seen in parts and only between the intercolumniations of the peristasis, from outside the building and at a distance of about 20 m. (fig. 172). That is why Pheidias organized the representation in characteristic sections, which he fitted, as it were, between two columns. In this way, whoever wished, walking at a steady pace, with specific halts and an uncomfortable upwards tilt of the head, was able to follow the whole development of the frieze. We do not know, of course, whether all the Athenians or the ancient visitors to the Acropolis diligently perused all the representations. At any rate, they do not seem to have been interested in understanding everything they saw. Undoubtedly they took pride in the aura of grandeur emanating from their magnificent

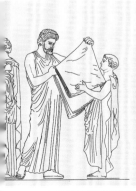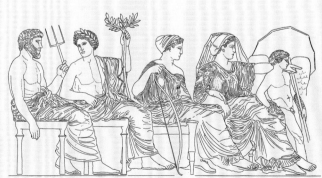

...ene of delivering the peplos Athena Hephaistos Poseidon Apollo Artemis Aphrodite Eros

140

achievements. And subconsciously they were aware of the beneficent influence the great works had in all periods. Certainly, the possibility we have today of viewing the frieze, as well as the rest of the sculptural decoration, in the museum, is a privilege that the ancient Greeks never had.

The Panathenaic procession should be understood as something between **a litany and a parade**, since it included both religious-cultic and political-military-'national' manifestations. The religious manifestations were the festive context, the ranking of the participants, the carrying of sacred paraphernalia and offerings, the delivery of the new peplos to the goddess. The political-military ones were the inspection and the appearance of the

squads of the Athenian cavalry, with horsemen from the upper classes of citizens. Boldness and bravery were extolled in the exclusively Athenian contest of the *apobates* race, in which audacious young men, mounted and dismounted a moving chariot driven by a charioteer. Emotive was the progress of the 'splendid youths', of the ephebes and of the fair maidens with offerings in their hands. All these instilled pride in parents and fellow citizens, boosting Athenian policy and 'national' identity, but simultaneously functioning as a means of displaying Athenian might to all, allies and foes alike. The Panathenaia were a festival in honour of the goddess, but also a display of the power and glory of the State.

192

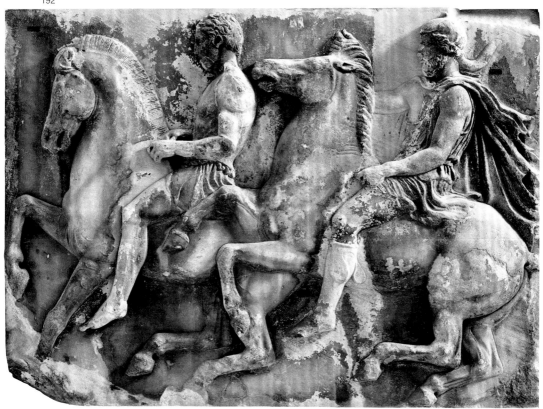

Frieze and art

The frieze, from an artistic viewpoint, is a work *non-pareil*: the procession starts on the west side, with small controlled movements, then follows its full unfolding on the long sides, with the climax of the action epitomized by the cavalry and the chariots. Last, everything terminates in the divine serenity of the east side, which perhaps denotes that the procession was already inside the sanctuary on the Acropolis. But on each side separately the perfection in the treatment of the figures, down to the last detail, the variety and the alternations of subjects (pedestrians, riders, chariots, animals), the different ways of rendering similar figures (poses, movements, attire), the concealed correlations through curtailed movements and mute gestures, the trotting, cantering, galloping of the horses, the admirable superimposition of multiple figures in very low relief; all these artistic artifices of the one or, according to others, the two designers, not only avoid the traps of repetition and monotony, but, quite the opposite, they have rhythm, they form a perpetual wave, a musical flow with crescendos and diminuendos, which with controlled freedom runs through the whole representation from one end to the other. Here we ascertain an ideal balance of organization and grace, a harmonious combination of law and order on the one hand, with the diversity and beauty of life on the other.

Detailed studies of all the figures have identified the hands of about one dozen or, according to other researchers, over one score of sculptors, who rendered in marble the initial design. Some of these may be the great sculptors of the period known from other works, but it cannot be ruled out that we have here too the same case as that encountered in the Erechtheion, where the figures of the frieze were carved by artists unknown to us. However, it should be borne in mind that a sculptor who started working on a figure or a group of figures did not necessarily finish them. It seems that sculptures were worked in three phases. The first two, namely the roughing out of the figure and the chipping away of the marble, could have been done by ordinary stonecutters, whereas the final elaboration was surely done by accomplished artists.

192-193. Block IV and part of block VI of the west frieze. Left, two horsemen with their galloping steeds, while right, a third horseman gets ready, tying his sandal. The rhythmical movement and the variety of alternating scenes in the frieze have been likened to a musical composition.

193

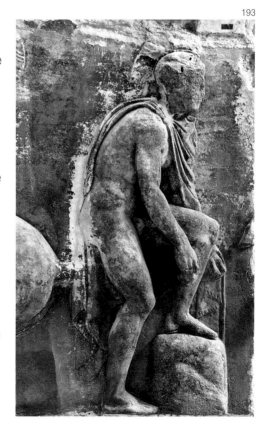

Frieze and politics

A great work is usually open to many and different interpretations, and even more so in the case of the Parthenon frieze, which is one of the works most charged with multiple symbolisms and meanings in the history of civilization. As early as 1753, the European antiquarian travellers Stuart and Revett had interpreted the representation on the frieze as a depiction of the Panathenaic procession. Since then and at various times, there have been many attempts to interpret and detect other parameters of it. It has been argued, for example, that the Parthenon frieze depicts the first, the mythical Panathenaic procession, which was founded by Erichthonios, and that not one but two different processions are represented, which are related to two different cults. It has been suggested too that the number of about 192 male figures on the frieze corresponds to the 192 Athenian dead in the battle of Marathon, and lastly that the central subject of the east side is not related to the procession but depicts preparations for the sacrifice of Erechtheus' daughter. Other scholars, on the basis of details in the dress, considered that the horsemen on the south, long side of the frieze were organized in groups of ten, while those on the north were in groups of four or twelve. From this observation they postulated that on the frieze there is a dual depiction of the social constitution and organization of the Athenian State: the north side, with the groups of four or twelve, reflects the old organization of the Athenian people in the 4 Solonian tribes or the 12

pre-Kleisthenian phratries, whereas the south side, with the groups of ten reflects the new organization of the Athenian State with the 10 Kleisthenian tribes, that is the democratic organization of the city. So, the dual rendering of the Panathenaic procession denotes simultaneously the past and the present of Athens, the origin as well as the continuity of the democratic regime, in an effort to reconcile and placate political passions. In other words, it is **a hymn to the Athenian Democracy**. Others counter-propose that the variety in the dress of the horsemen (some are naked, some wear a short chiton, some an ankle-length garment and others are with panoply) are no more than an artifice of Pheidias to differentiate and to variegate the same kind of figures in the procession.

Latest researches add a further dimension. Because the frieze obviously presents an idealistic and not an actual rendering of the procession, some aspects of it are silenced, such as the parade of armed soldiers and the allies, while others are over-emphasized, such as the cavalry, which occupies 46% of the zone. Moreover, there is no apparent unity of place and time in the procession, since the representation includes events such as the *apobates* contest, which took place on another day.

194. Block VII of the west frieze, with horseman whose torso is covered by a panther skin. The diversity of the horsemen's attire has given rise to numerous interpretations of political character. However, the possibility that this is due to the multiplicity of artistic expression of the creator cannot be ruled out.

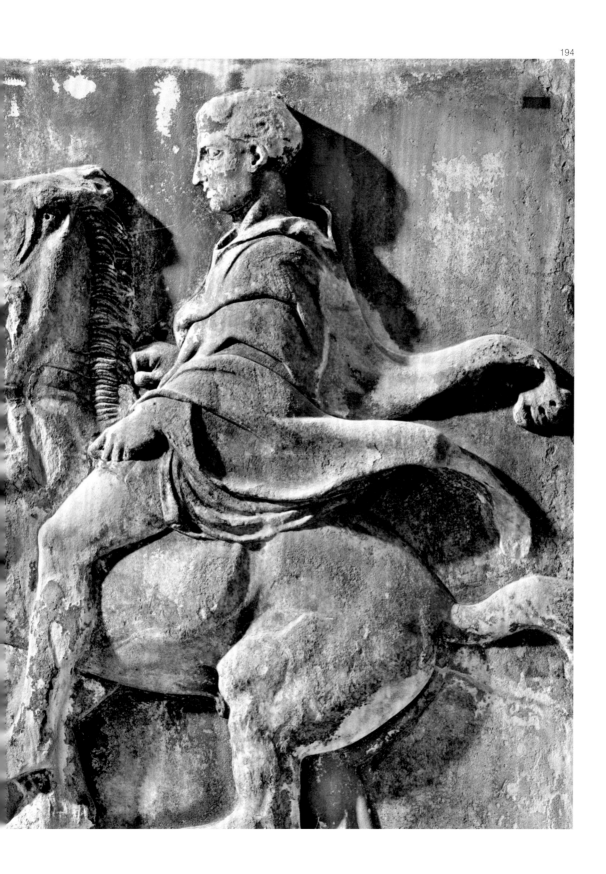

195

On the basis of these data, it is proposed that represented in the frieze, excepting the east side, is not only the Panathenaic procession but also the selective conflation of cultic events from all the city's festivals, and therefore the expression of the piety of the Athenian *demos* to all its gods, who attend assembled in the middle of the east side. Indeed, by placing all the gods to watch the Athenian festival, not only did they include this and themselves in the sphere of the exalted, but also they emphasized the Olympians' constant presence in the city, which thus was placed under their protection.

Concurrently, the inordinately high profile of the cavalry is perhaps related to the founding of this corps by Pericles a few years earlier, a corps manned predominantly by young men of aristocratic families. This datum, in combination with the total absence of the lower classes from the frieze, led some scholars to doubt the view that the frieze hymns the absolute democratic character of the State. However, if we look at the representation in the framework of the idealistic expression of Classical art, we would say that we have here 'the most aristocratic image of the Athenian democracy', an image that presents the whole body of citizens without discriminations, so inviting the viewer too to join in this event.

Of course, the possibility that the popularity of the equestrian contests held in the ancient Agora during many festivals contributed to the prominence accorded the cavalry, or even that this was a purely artistic choice in order to 'fill' the 58.50 m. of the long sides of the frieze, cannot be precluded. It was surely easier and more effective to fill a zone with scores of

horsemen in a variety of movements and poses than with, for example, hundreds of monotonous figures on foot.

Independently of the interpretative approaches, there is no doubt that the frieze is the *par excellence* **monument of Athens' achievements**, a paean of praise for the ideals and the works of the Athenian State. It is a unique expression of the religious, political and social identity of the city.

The coloration of the monuments

The original image of the Parthenon, as well as of the other works of ancient Greek architecture, would be incomplete if their polychromy were not restored too. All the upper part of temples, above the epistyle, was coloured, in an effort to emphasize and enhance the architectural as well as the sculptural elements. The triglyphs were blue, while the ground of the metopes was blue or red. The ground of the pediment, as well as of the frieze, was blue.

We should imagine the figures of humans and animals as multicoloured. The flesh of the males was light brown, while that of the females was left white. By contrast, the female figures wore very colourful garments, thus giving the most splendid polychromy to the representations.

Last, all the decorated zones of temples were surrounded by colourful cymatia, which created a masterly frame for the representations.

196

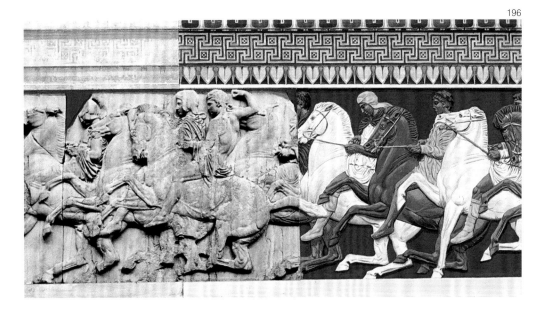

195. Painting by the Dutch-British artist L. Alma Tadema (1868), depicting an imaginary incident, which, however, may well have happened. Pericles and Aspasia visit the worksite of the Parthenon, where Pheidias guides them to the just-finished frieze. The present form of the last block on the north side can be seen in fig. 183.

196. Part of the north frieze, with horsemen, as it survives (left) and in an attempted rendering of it with coloration (right). The ground of the frieze was blue, while the animals and the garments of the horsemen were varicoloured, thus imparting liveliness and naturalness of expression to the white marble. Colour was a basic component of sculptural decoration and completed the final impression (drawing P. Connolly).

197

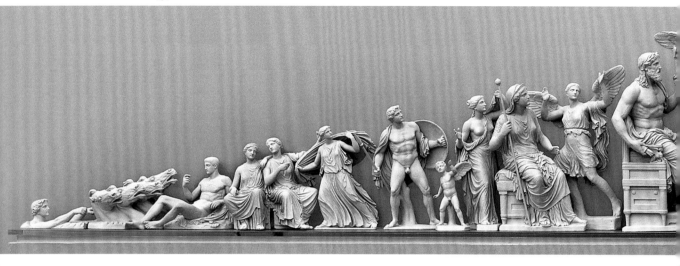

| Helios | | | Dionysos | Persephone-Demeter | Eileithyia | Ares | Eros-Aphrodite | Hera | Iris | Zeus |

The pediments

The pedimental compositions of the temple can be seen first in the scale models exhibited in the well-lit antechamber of the third floor, prior to visiting the actual works, which survive in fragmentary condition. Displayed in the same antechamber are a three-dimensional model of the Parthenon, along with inscribed stelai with the *comptes-rendus* of the *epistatai*, who oversaw the building of the temple and the expenses for making the chryselephantine cult statue, with honorific decrees, and so on.

The 48 figures in the round, on the two pediments, which were sculpted between 437 and 432 BC, featured in mythical scenes relating to the great goddess who was worshipped in the temple. Represented on the east pediment, on the entrance side, was **the miraculous birth of Athena** from the head of her father, Zeus. The subject is known from ancient descriptions but the exact poses of the figures elude us, since these have been lost, probably in Early Byzantine times. Of the many proposed restorations, it seems most plausible that we have here not the moment of birth but rather a form of 'epiphany' of the great gods, since Athena appears already full-grown and in panoply, of equal status beside her father, who was probably seated on a throne, with a small Nike between their heads. To left and right of them are the other gods, separated into two groups: those who are closer have realized the event of the birth and ecstatically behold the miracle, the rest have not yet learnt of it and remain apart, obliviously chatting among themselves. Certainly, Hera with Iris should be placed next to Zeus and Hephaistos next to Athena, for it was he who, according to the myth, struck open Zeus' head with his axe. After, them were the other gods, standing or sitting (right, Poseidon, Apollo, Artemis, Hermes; left, Aphrodite, Ares, Demeter, Persephone and Dionysos) in various positions with numerous proposed

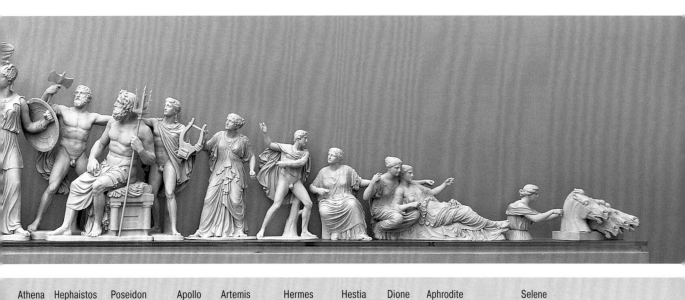

| Athena | Hephaistos | Poseidon | Apollo | Artemis | Hermes | Hestia | Dione | Aphrodite | Selene |

permutations. Last, represented in the two cunei of the pediment are Helios rising in his *quadriga*, in the left, and Selene sinking her chariot into the sea, in the right, which not only define the episode temporally but also include it in the cosmological canons of global harmony.

Represented in the middle of the west

197. Reconstruction of the east pediment of the Parthenon, as created by the sculptor K. Schwerzek in 1904 and exhibited in the museum. Although outmoded and with several differences from the views of modern research, it presents admirably the remarkable grandeur and fullness of the pedimental composition.

198. Coloured graphic reconstruction of the composition of the three female divinities of the east pediment, usually interpreted as Hestia, Dione and Aphrodite (drawing P. Connolly).

198

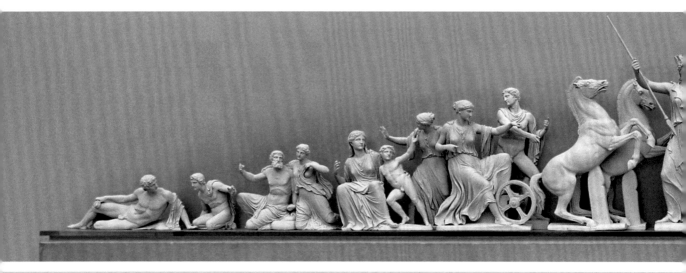

Kephissos (?) Erysichthon (?) Kekrops-Pandrosos Kekropids Nike Hermes Chariot of Athena Ath

pediment, for the first time in ancient Greek art is **the quarrel between Athena and Poseidon** as claimants of the city. The choice of Athena is self-evident, while that of Poseidon as her rival should not be considered as antagonistic but as a polite way of honouring, as claimant, a god protector of the sea and consequently of the naval role of the Athenian League in the Aegean. Next to the gods were their gifts, the olive tree, probably of metal rather than of marble, and the water, which gushed from a rock at the god's feet. Between them, most probably, was the thunderbolt of Zeus, which on the one hand stopped the dispute and on the other generated the impressive

artistic scheme of the two divergent divine figures, which is called the Pheidian V. To left and right of the central composition are the chariots of the two gods, the rearing horses of which react to the central 'explosion', drawing up with them their charioteers. In between appear the two messenger gods, Hermes and Iris, who bring news of the outcome of the contest to the city's mythical heroes and ancient kings, who sit serenely at the edges. Depicted are Kekrops towards the side Athena and probably Erechtheus towards the side of Poseidon, with their respective families. In the cunei of the pediment are kneeling or reclining personifications of rivers or fountains of the city.

We could say that on the east pediment we have a parallel of heaven or the peak of Olympos with the summit of the Acropolis, while on the west one we have a parallel of the area of the Erechtheion, where according to the sacred signs pointed out by the ancient Greeks (e.g. olive tree), the divine dispute had taken place.

199. Reconstruction of the west pediment of the Parthenon, as created by the sculptor K. Schwerzek in 1898 and exhibited in the museum.

200. The west pediment, with the quarrel between Athena and Poseidon, as exhibited today in the museum. Above, the west metopes with the Amazonomachy and in the middle the west frieze.

199

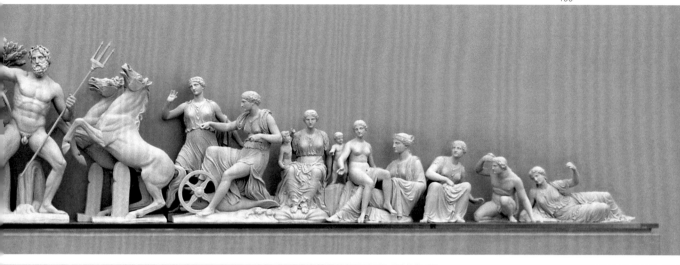

Poseidon Chariot of Poseidon Iris Amphitrite Oreithyia Ion (?) Kreousa (?) Praxithea (?) Ilissos (?) Kallirrhoe (?)
with Kalais and Zetes

200

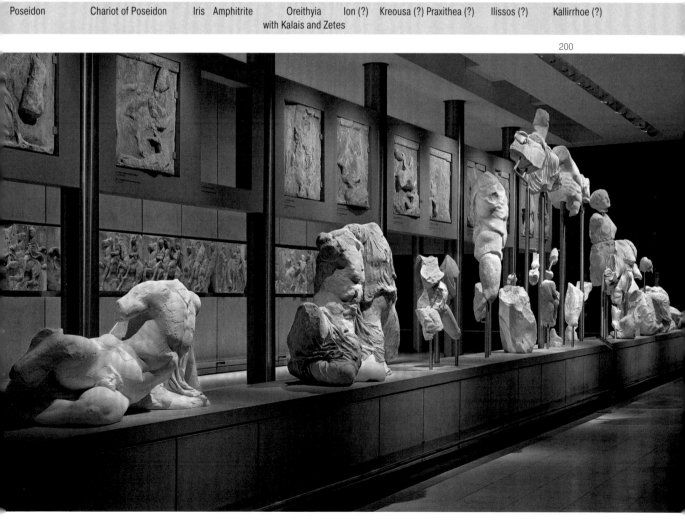

201

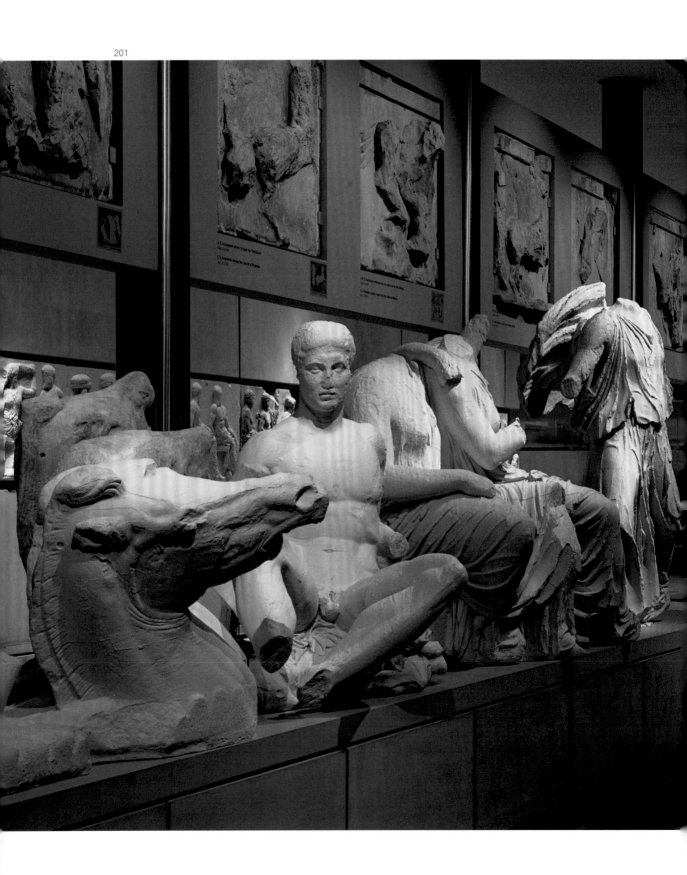

Stylistic and interpretative approach

The composition of the pedimental sculptures is many-figured and rather dense. And yet, not only are the figures easily accommodated in the awkward triangular space, but also the gifted creator transforms the shortcomings of the space into a virtue, so successfully including the gods, in various poses and movements, within the triangle that they give the impression that they are in their natural space and that these are their natural poses. Most of the central figures were lost at an early date. Nevertheless, it

seems that those of Zeus with Athena, on the east pediment, and of Athena with Poseidon, on the west, were over 3.20 m. high and had a hegemonic majesty that only Pheidias could give them. From the centre outwards the tension of the central figures passes gradually like a wave to the figures closest to them and from one point onwards the composition becomes calmer, with figures of all ages and genders simply present but not participating, while those in the angles, either Helios and Selene on the east pediment, or the recumbent heroes and personifications of waters on the west, close the compositions actually and symbolically.

So, we have here two mythological episodes, but ones that could be given **a new symbolic conceptual content**, so as to be incorporated in the political-ideological

201-202. Two views of the exhibition of parts of the east pediment of the Parthenon in the museum. The beholder's direct visual contact with the monument on the rock allows the possibility of artistic and historical correlations.

202

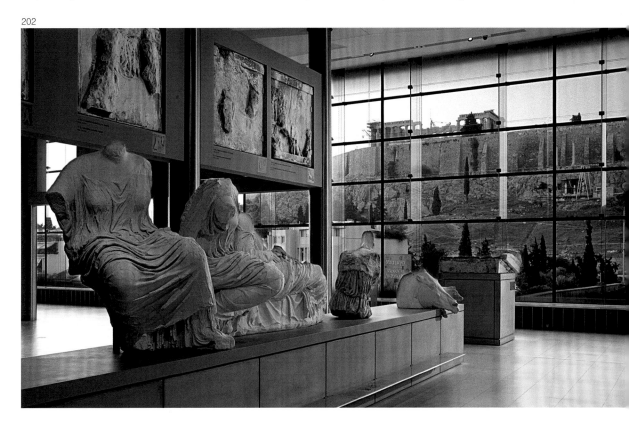

programme of the sculpted decoration. What is emphasized is, first of all, the presence and decisive role of Athena in the city's history. From the dynamic creative moment of her birth, on the east pediment, to her decisive clash with Poseidon, on the west, everything that happens on the divine level aims at glorifying Athens. The Athenians are intent on showing that the panhellenic Athena was more their goddess or only their goddess.

At the same time, it is striking that, whereas in other cases of pedimental compositions the chief consideration was the central presence of the deity worshipped, on the Parthenon, on both the east pediment and the east frieze, all the gods are present, **in the most splendid appearance of the family of Olympians** in the whole of ancient Greek art. The Athenians demand the attention of all the gods, because they are at the centre of the cosmos. They want to show that the gods are born, care, suffer, quarrel for this beloved city of theirs. Indeed, by attributing to Athena the gift of the olive tree, they claim for their city also the invention of olive cultivation, which was one of the most important agricultural activities in the Hellenic world.

On the west pediment, the divine dispute is accompanied emphatically by the presence of the old kings and *archegetai* of the city, who with their judgement in the choice of deity denote their might. Furthermore, the presence there of all the old mythical and historical ancestors refers to the Athenians' historic fate and stresses the axiom of their autochthony. And this because in the political argumentation of the ancient Greeks, basic factor was always the reduction of every kind of claim to ancestors and gods or heroes, whose presence they had to document.

The akroteria of the Parthenon

In concluding the discussion of the temple's sculpted decoration, reference should be made to its akroteria, that is, the sculptures decorating the apex and the angles of the pediments. The two apexes were crowned by vegetal akroteria in a combination of acanthus shoots and palm leaves, forming curves in the form of an anthemion-palmette (fig. 203), so that they extended the fronts of the temple a further 4 m.

203

into the sky (figs 149, 156-157, 162). The four corner akroteria played the same role, except that these were not in the form of anthemia-palmettes, as was earlier believed, but are considered now to have been large marble Nikai which, with outstretched limbs and upturned wings, not only created dynamic figural extensions of the sculpted decoration, against the backdrop of the blue sky, but also symbolically signified the victorious dimension of the monument and of the city.

204

203. One of the two central akroteria of the Parthenon, as this has been reconstituted in the museum, on the basis of the few surviving original fragments. It is a combination of acanthus shoots and palm leaves.

204-205. Graphic reconstruction (drawing M. Korres) and elevation of the north end of the east façade of the Parthenon. Above are the hacked metopes of the Gigantomachy (represented on one was the chariot of Helios), visible on the pediment are the heads of the horses of Selene's chariot. Further up, the base for the corner akroterion, perhaps a statue of Nike, flying against the backdrop of the bright blue sky.

205

206

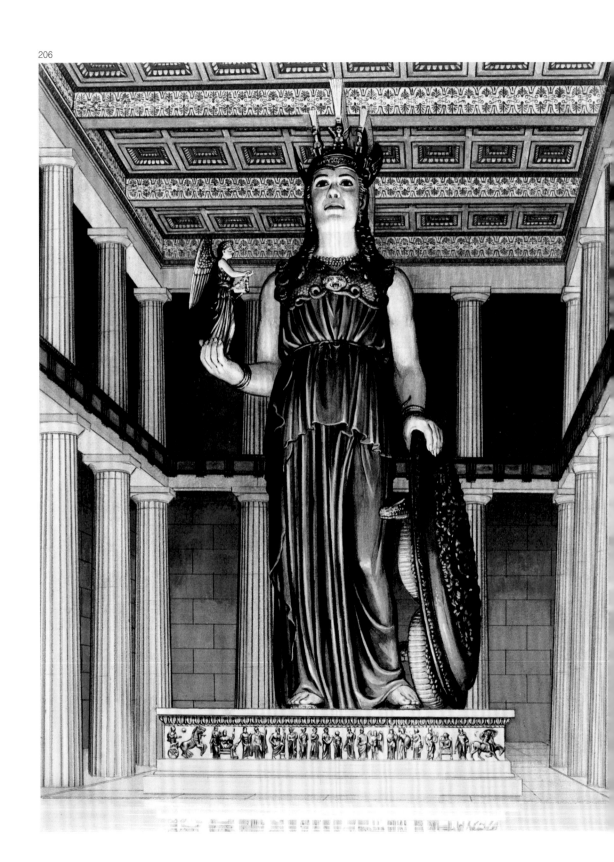

The cult statue

Last, it would be remiss not to mention the 12.75 m.-high chryselephantine statue of Athena Parthenos, *work of Pheidias*, which was placed at the far end of the cella, framed by the two-tier Doric colonnade. Nothing has survived of the statue itself, except the concavity in the floor of the Parthenon, to receive its central wooden shaft. Nonetheless, its form is well known from detailed descriptions by ancient authors and from some 200 later small copies and depictions of it in all genres of art. The best-known copy is the so-called Varvakeios Athena, about 1 m. high, which came to light in Athens, near the foundation trenches for the Varvakeion mansion, and is dated to the first half of the third century AD (fig. 207).

The original work consisted of a wooden core, to which were affixed the face and the limbs of the goddess, which were of ivory, while her garments were of gold sheet and weighed 1,150 kilos. It is interesting that on both the divine figure itself and its secondary elements (Nike in the hand, helmet, shield, sandals, base) there was rich sculpted decoration presenting the same subjects as those of the sculpted decoration on the exterior of the temple. This fact bolsters significantly the view that Pheidias, the creator of the statue, was also the artist who conceived and designed the decoration of the entire edifice. The decorative elements of the statue explained the essence of the goddess and annotated her importance for Athens.

206. Graphic representation of the chryselephantine statue of Athena. The goddess's helmet had a sphinx in the middle and two griffins at either side. On her chest was the aegis with the head of Gorgo. In the right hand she held a statue of Nike, and with the left she steadied her shield, on the inside of which were representations of Gigantomachy and on the outside of Amazonomachy. On the pedestal of the statue were reliefs showing the birth of Pandora, and on the soles of the goddess's sandals Centauromachy (drawing P. Connolly).

207. The so-called Varvakeios Athena, a much smaller and much simpler marble copy of the Pheidian work. It was made some 600 years after the original, an example of the enduring admiration for the great creation.

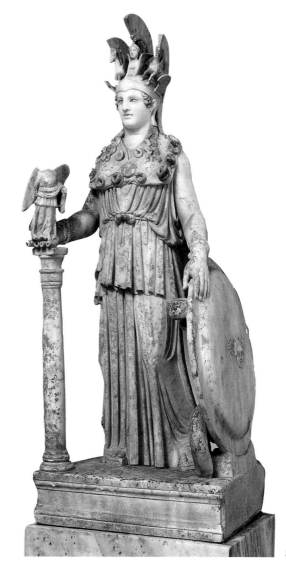

207

Ideology and politics in the Acropolis monuments

Despite the evident innovations in the Athenian State's building programme upon the Acropolis, under the leadership and with the inspiration of Pericles, both the architecture and the sculptural decoration of the buildings took into account the whole tradition of the Sacred Rock and the preceding sanctuaries. Now, however, all these old figures, traditions and values not only acquired a new image at an artistic and ideological level, but also increased their symbolic force, in such a way that they transmitted dynamically **the new messages of power and hegemony** that the city wished to project.

In the Parthenon, as in all the major projects, nothing is accidental. This is demonstrated remarkably by the study of the sculpted decoration, in which the single conception and the integrated mesh that binds together motifs, groups and figures are apparent. It contained very clear political messages, aimed at: (a) proving that Athens was the beloved city of the gods, (b) documenting the autochthony of the Athenians and (c) extolling their role in the struggles against and the victories over mythical and historical enemies, thus justifying their panhellenic hegemony. These two values, *agon* (struggle) and *nike* (victory), are two motifs which sometimes explicitly and sometimes allusively connect the figures and the subjects on all the monuments.

Specifically, the sculpted decoration of the Parthenon was organized from the top downwards, with **axiological distinction**. At the same time, there is also a lengthwise hierarchy from east to west, because the east side of the temple was more important than the west one. So, on the pediments, which correspond to the heavenly level, the gods dominate. On the east pediment there are only gods, some of whom are protagonists and the rest spectators. On the west one too there are gods as protagonists, and heroes as spectators and judges. A little lower down, on the metopes, which correspond to the heroic level, mythical subjects are depicted. On the east side, with the Gigantomachy, gods are involved, while in the remaining conflicts only heroes. Last, at the earthly level, on the frieze, we have, for the one and only time in ancient Greek art, mortals, the Athenians, as

protagonists, on three sides. On the east side all the gods are assembled, and indeed as spectators of the human action! This is **a conscious coexistence of the divine and the human sphere**, which here is expressed in an allusive manner but with no disposition for modesty, which fact led also to interpretative versions on the Athenians' arrogance. Whatever the case, there is no doubt that these are works of art in the service of politics, which could perhaps justify some excesses. However, this fact in no way diminishes the majesty and the value of these works.

It should be noted that on the basis of some indications, such as that the Parthenon lacks an altar and there is no reference in the sources to a priest or priestess or to a sacrifice for a specific cult, it has been suggested that the Parthenon **was not a functional temple** but a work-dedication of the Athenians to the goddess, through which they aimed to enhance the glory and splendour of their city. However, the Parthenon, like the Erechtheion too, used the earlier altar of the Archaic temple of Athena (figs 107, 159), while use of the great temple for worship is documented by the long succession of temples on the same site. In all probability it was a building of many functions and roles, as well as a bearer of multiple messages. It seems that the religious-cultic character of the monument was used also as a pretext for promoting and publicizing the city's political and ideological messages, and indeed with the highest artistic means.

Whatever the case, and beyond the sometimes exaggerated interpretations, which perhaps surpass the true intentions of their purporters, one thing is absolutely clear: these wonderful conceptions of Pericles and his coterie of advisors, as well as their implementation by the Athenian Democracy, not only fulfilled their aim of enhancing Athens as hegemonic capital of the Hellenic world, but also succeeded in something their creators could never have imagined: they have transcended time and have proved themselves unrivalled works of climactic moments of intellectual and artistic expression in the history of civilization worldwide.

208. Coloured representation of the zone defining the Parthenon frieze from above (see fig. 196). It is crowned by a Doric cymatium, followed by a wide band with a variation of meander pattern and ending in a Lesbian cymatium.

208

209

210

BIBLIOGRAPHY

Α. Ορλάνδος, *Η αρχιτεκτονική του Παρθενώνος* (1977).

Α. Παπανικολάου, *Η αποκατάσταση του Ερεχθείου, 1979-1987* (2012).

J. Boardman, *Greek Sculpture. The Classical Period* (1985).

Μ. Κορρές, *Από την Πεντέλη στον Παρθενώνα* (1993).

Χ. Μπούρας, Μ. Κορρές, Ν. Τογανίδης, *Μελέτη αποκαταστάσεως του Παρθενώνος* (I-V, 1983-1994).

Τ. Τανούλας, *Μελέτη αποκαταστάσεως των Προπυλαίων* (1994).

Δ. Ζιρώ, *Μελέτη αποκαταστάσεως του ναού της Αθηνάς Νίκης* (1994).

R. Economakis (ed.), *Acropolis Restoration. The CCAM Interventions* (1994).

P. Tournikiotis (ed.), *The Parthenon and its Impact in modern times* (1994).

R.F. Rhodes, *Architecture and Meaning on the Athenian Acropolis* (1995).

Μ. Κορρές, Τοπογραφικά ζητήματα της Ακροπόλεως, in Μ. Γραμματικοπούλου (ed.), *Αρχαιολογία της πόλης των Αθηνών* (1996), 57-106.

Μ. Μπρούσκαρη, *Τα μνημεία της Ακρόπολης* (1996).

Ι. Τριάντη, *Το Μουσείον Ακροπόλεως* (1998).

O. Palagia, *The Pediments of the Parthenon* (1998).

M. Korres, G. Panetsos, T. Seki (eds), *The Parthenon. Architecture and Conservation* (1996).

J. Hurwit, *The Athenian Acropolis. History, Mythology, and Archaeology from the Neolithic Era to the Present* (1999).

G. Gruben, *Heiligtümer und Tempel der Griechen* (2000).

Μ. Κορρές, Κλασική αθηναϊκή αρχιτεκτονική, in Χ. Μπούρας et al. (ed.), *Αθήναι. Από την κλασική εποχή έως σήμερα* (2000), 5-45.

Κ. Χατζηασλάνη, *Περίπατοι στον Παρθενώνα* (2000).

J. Neils, *The Parthenon Frieze* (2001).

B. Holtzmann, *L'Acropole d'Athènes. Monuments, cultes et histoire du sanctuaire d'Athéna Polias* (2003).

J. Hurwit, *The Acropolis in the Age of Pericles* (2004).

Α. Δεληβορριάς, *Η Ζωοφόρος του Παρθενώνος* (2004).

M. Cosmopoulos (ed.), *The Parthenon and its Sculptures* (2004).

J. Neils (ed.), *The Parthenon from Antiquity to the Present* (2005).

Στ. Ελευθεράτου (ed.), *Το Μουσείο και η ανασκαφή. Ευρήματα από τον χώρο ανέγερσης του νέου Μουσείου της Ακρόπολης* (2006).

Κ. Χατζηασλάνη, Ε. Καϊμάρα, Α. Λεοντή, *Τα γλυπτά του Παρθενώνα* (2009).

209-210. Heads of Poseidon and Apollo, from block VI of the east frieze of the Parthenon.

A. Scholl, Τα αναθήματα της Ακροπόλεως από τον 8ο-6ο αι. π.Χ. και η συγκρότηση της Αθήνας σε πόλη-κράτος, *Αρχαιολογία και Τέχνες* 113, Dec. 2009, 74-85.

Χρ. Βλασσοπούλου, Στ. Ελευθεράτου, Α. Μάντης, Ε. Τουλούπα, Α. Χωρέμη, *Ανθέμιον* 20, Dec. 2009, 6-34.

Dialogues on the Acropolis. Scholars and Experts Talk on the History, Restoration and the Acropolis Museum, Σκάι βιβλίο (2010).

E. Greco, *Topografia di Atene. Sviluppo urbano e monumenti dalle origini al III secolo d.C.* (2010).

Χρ. Βλασσοπούλου, *Ακρόπολη και Μουσείο. Σύντομο ιστορικό και περιήγηση* (2011) (3rd edn).

SOURCES OF ILLUSTRATIONS

ARTISTIC DESIGNER: RACHEL MISDRACHI-KAPON
ARTISTIC ADVISOR: MOSES KAPON
COPY EDITOR: DIANA ZAFEIROPOULOU
DTP: ELENI VALMA, MINA MANTA
PROCESSING OF ILLUSTRATIONS: MICHALIS TZANNETAKIS
SECRETARIAT: MARIA KATAGA
PRINTING-BINDING: PRINTER TRENTO (Trento), ITALIA